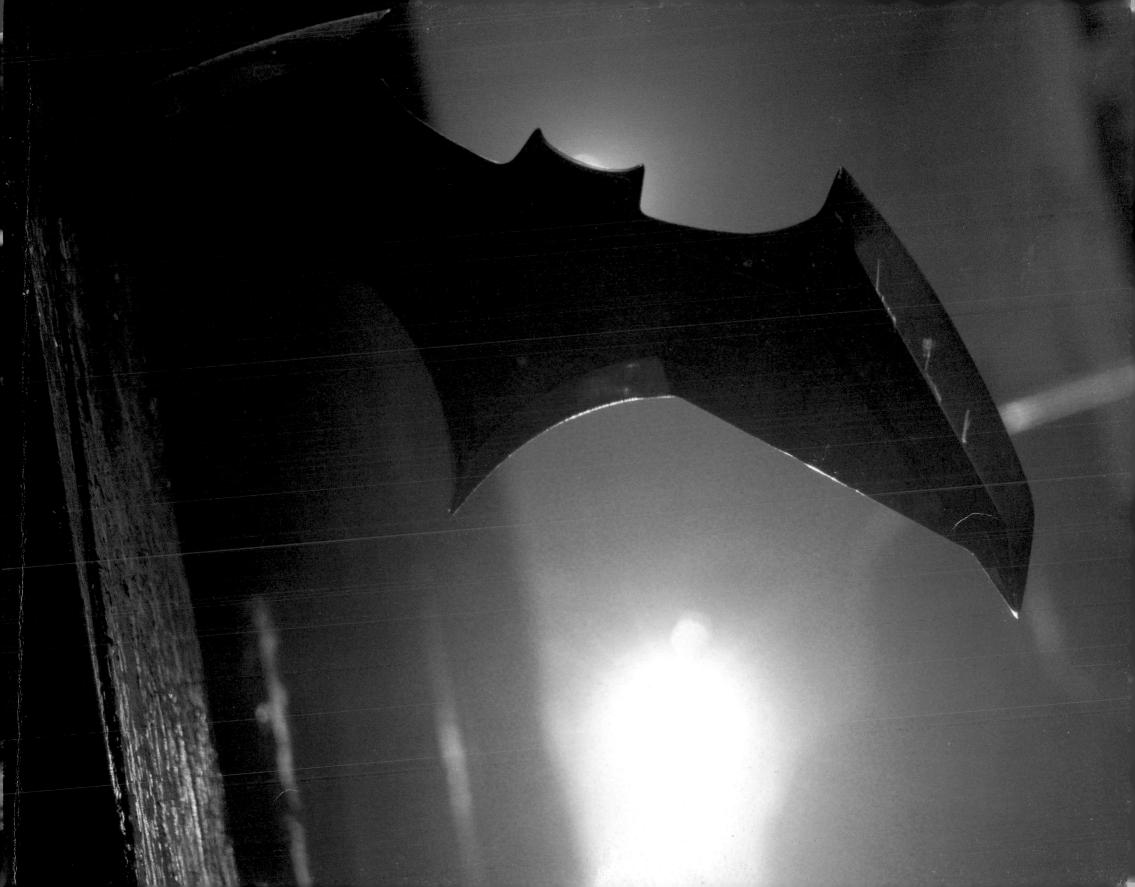

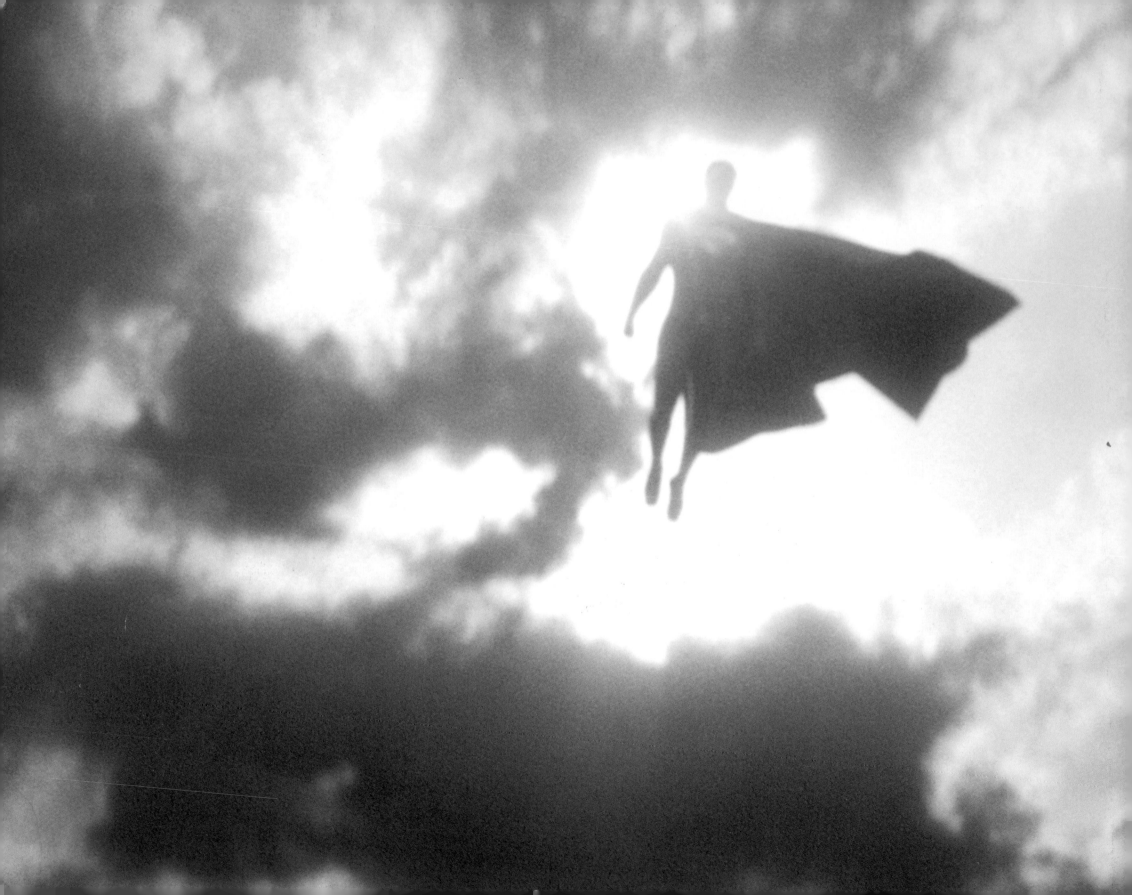

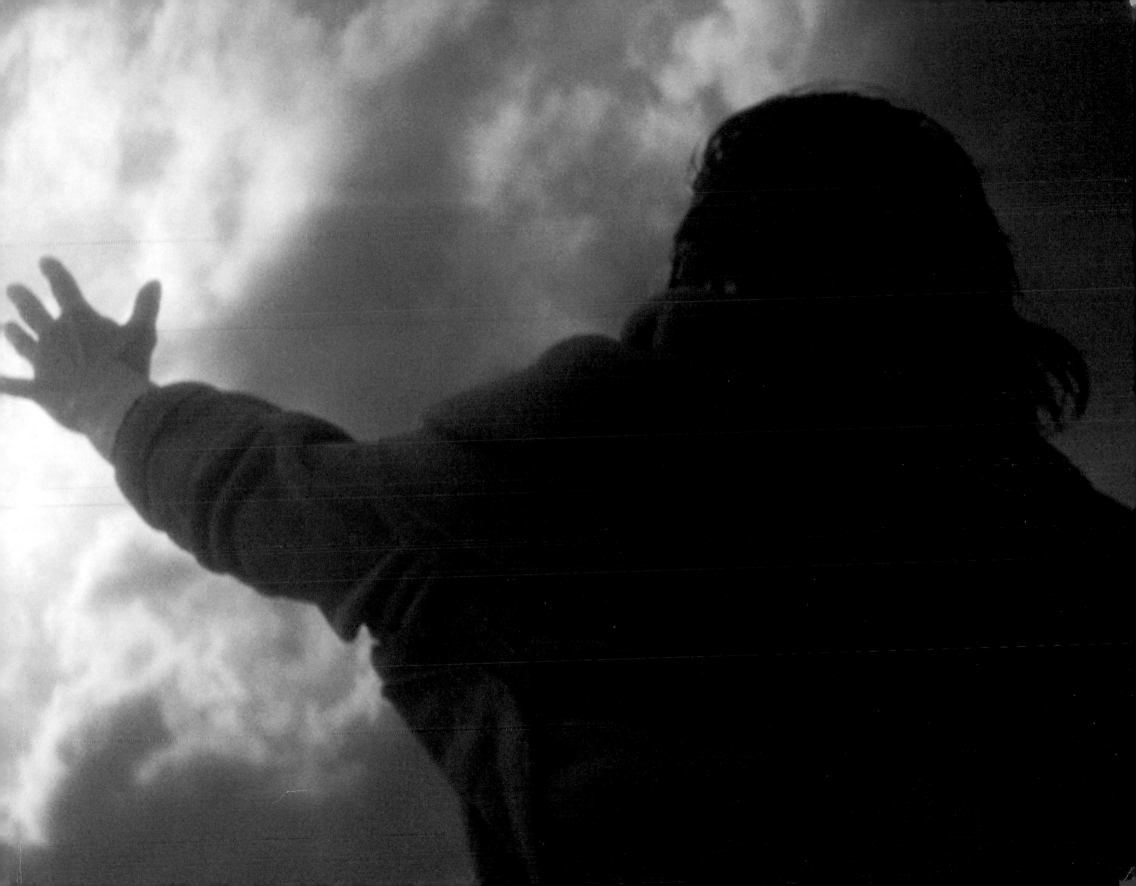

SUPERMAN

JUSTICE

THE ART OF THE FILM

PETER E. APERLO

FOREWORD BY GEOFF JOHNS

TITAN BOOKS

6A23835.

Batman v Superman: Dawn of Justice: The Art of the Film
ISBN: 9781783297498
Limited Edition ISBN: 9781785652790
Super Hero Edition ISBN: 9781785652806

Published by Titan Books
A division of Titan Publishing Group Ltd.
144 Southwark St.
London
SE1 0UP

First edition: March 2016
10 9 8 7 6 5 4 3 2 1

To receive advance information, news,
competitions, and exclusive offers online,
please sign up for the Titan newsletter on
our website: www.titanbooks.com

Did you enjoy this book?
We love to hear from our
readers. Please e-mail us at:
readerfeedback@titanemail.com
or write to Reader Feedback at
the above address.

A CIP catalogue record for this title is
available from the British Library.

Printed and bound in the
USA and China.

CONTENTS

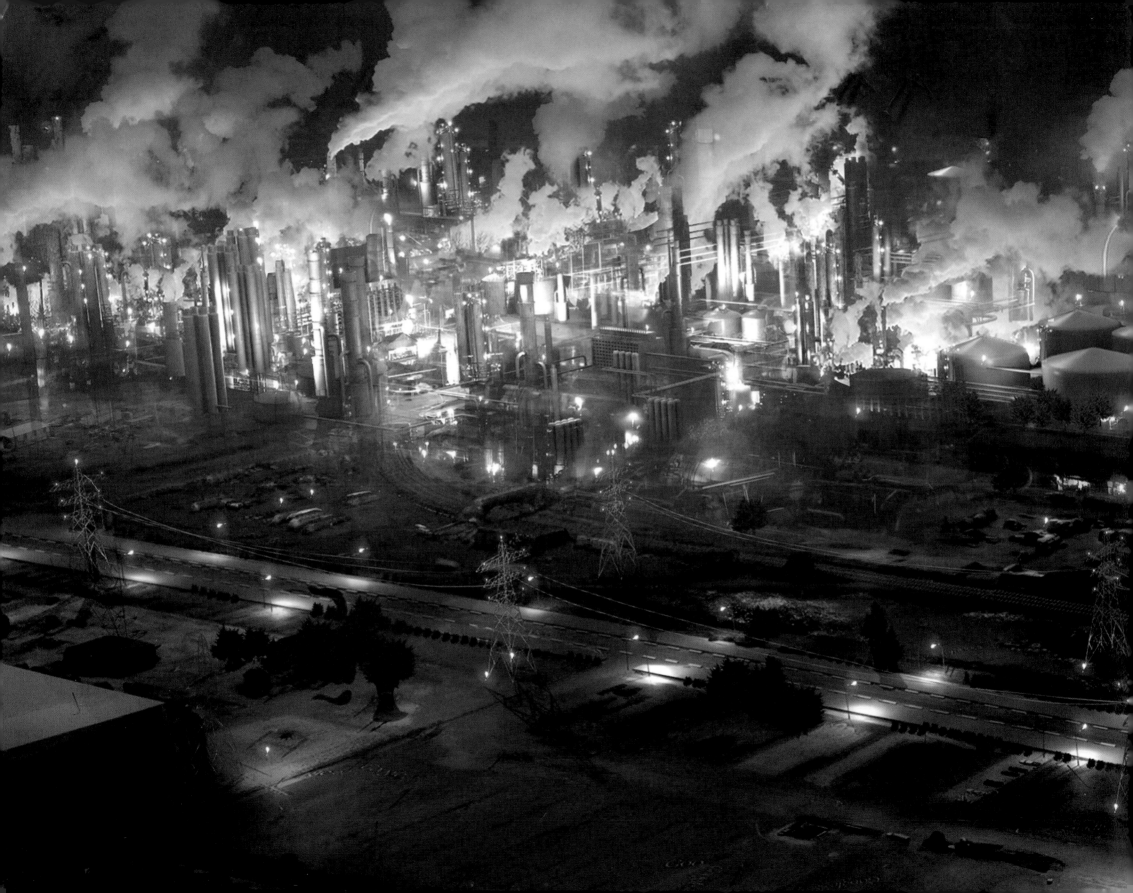

FOREWORD

LIKE ALL OF YOU, I'VE BEEN WAITING FOR THIS TO HAPPEN MY ENTIRE LIFE.

We've seen BATMAN and SUPERMAN on the big screen individually, but seeing them *together* for the first time is absolutely seismic. The Dark Knight and the Man of Steel are the most iconic Super Heroes in the world – Bruce Wayne; a man driven by horrible loss, fueled by his intellect and physical prowess, cleaning up his crime-filled streets and Clark Kent; an alien with incredible powers, protecting the adopted world he was raised on. One hiding behind a mask and working in the shadows, the other showing his face and soaring through the bright skies. Their respective worlds are as visually different as their abilities, methods and ideologies. Now, finally, with this film we're seeing it all collide. But this isn't only about Batman and Superman.

This is about the entire DC UNIVERSE.

As a kid, I could only dream of the day we would see Batman and Superman meet on film, let alone Wonder Woman tangling with Doomsday. There's an intangible magic to seeing this universe up on screen, living and breathing and interacting. Modern day myths becoming flesh and blood.

Not only a brilliant director, but also an amazing artist, Zack Snyder is a true world builder. Zack leads by example, storyboarding every sequence of the film himself, panel-by-panel – like the pages of the comic books these characters were born within. He doesn't put boundaries on the scope of story and character, he embraces the mythic quality of the DC pantheon. His vision is truly epic. And *epic* is the one-word description of DC Comics. It's Zack's passion – along with the talent of all our artists and crew – that has truly opened the cinematic door into the DC Universe for the first time.

Within this book, you'll see an in-depth look at the heroes and their respective worlds beyond the costumes. You'll see the brilliant art and design of Zack Snyder, Patrick Tatopoulos, Michael Wilkinson, Larry Fong, Doug Harlocker, John 'DJ' DesJardin, Dennis McCarthy, Clay Enos and the countless others who help to shape the aesthetic and design of the film. You'll see the dawn of the JUSTICE LEAGUE.

The wait is over.

GEOFF JOHNS

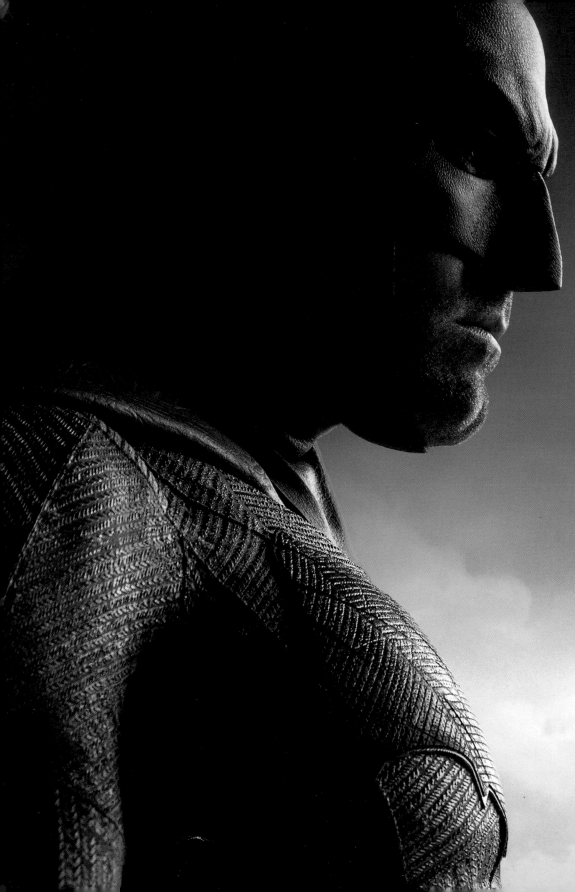

INTRODUCTION

"THEY COME TO BLOWS BECAUSE THEY'RE TRYING TO ACHIEVE THE SAME THING, BUT THROUGH ENTIRELY DIFFERENT METHODS."
HENRY CAVILL

At its core, *Batman v Superman: Dawn of Justice* is an exploration of the unintended consequences of the traumatic clash between Superman and Zod in Metropolis two years ago–chronicled in *Man of Steel* (2013) and dubbed the Black Zero Event–as well as the continued presence of Superman on earth and what he represents.

It should come as no surprise that looking at the ramifications of superpowers and vigilantism is familiar ground for the filmmakers. "These films are certainly more grounded in reality than they are fantastical," says Deborah Snyder, producer. "So, for us it was really important to see that there are ramifications to these actions. It definitely draws some parallels to *Watchmen* (2009), where we see if there is a god on earth and he has absolute power, what does that mean? What does it mean for religion? What does it mean for politics?"

Rather than simply carrying on with the career of Superman alone after the success of the first film, all involved knew it was time to expand the stage to include other members of the DC Universe. The obvious first candidate to add to the equation was Batman–a matchup of icons decades in the making–something Zack Snyder campaigned hard for. "Originally it was going to be a straight Superman movie," says Snyder. "One of the ideas was that at the end of the movie, a crate of kryptonite would be delivered to Wayne Manor. That didn't happen, but once Batman was mentioned, he wouldn't go away. It couldn't be undone."

"That's the thing about Zack," says Deborah Snyder, "he's not just a director. He's a huge fanboy as well, and he loves comics. So for him, the thrill of seeing Batman and Superman together on the big screen for the first time was even greater." And if they

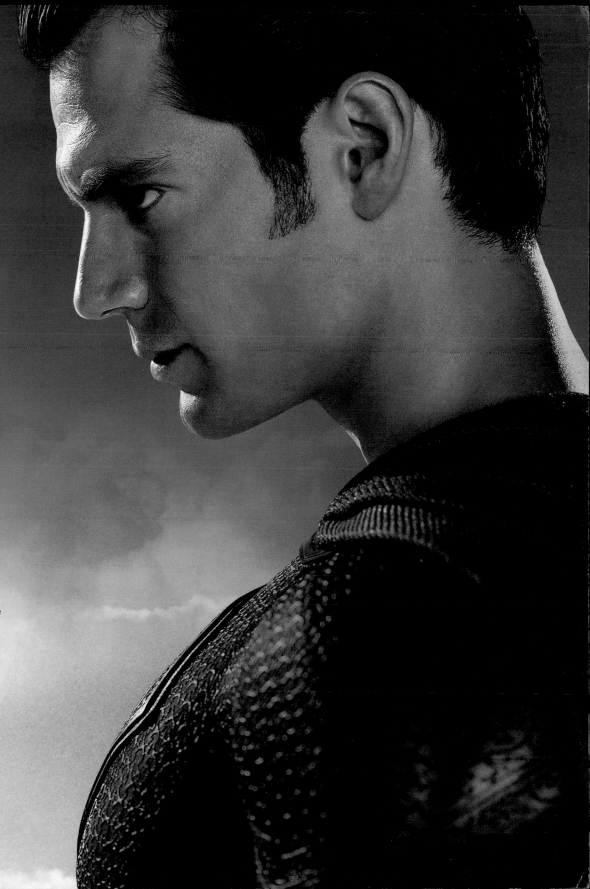

could include the third part of DC's Trinity–a certain Amazon princess–wouldn't that be every fanboy's dream?

But perhaps even more intriguing from a story standpoint, was getting Bruce Wayne's perspective and reaction to the Black Zero Event. He's not a man who gives his trust easily, especially to an alien with incredibly destructive powers. It was a situation primed for conflict.

"One of the great, epic stories that was told in the comics was when Batman and Superman squared off against each other," explains producer Charles Roven, "and we felt there was a compelling reason to tell that kind of story today. You have two individuals, one almost a god and the other being the best humanity has to offer in terms of how he's honed himself physically and mentally for a specific task. On the one hand it might seem that they should be allies, actually their approach is so different to a similar cause that it makes them enemies."

And the fact that both men live in a world still in shock from the attacks helped nudge them toward battle. The talking heads of the 24-hour news cycle, the posturing of politicians, and the string pulling of a certain mad genius, all play their parts in fanning the flames of suspicion and insecurity. "The big theme of the movie is, at the end of the day, are we too quick to judge sometimes?" says co-producer Curt Kanemoto. "Do we act on impulse? Do we act on disinformation? Do we have all the facts before we do something? That's the takeaway of the film." Chris Terrio (Academy Award winner for *Argo*) and David Goyer (*Batman Begins, Man of Steel*) shared the task of scripting this mammoth collision of Super Heroes, each bringing their own unique approach to the screenplay.

 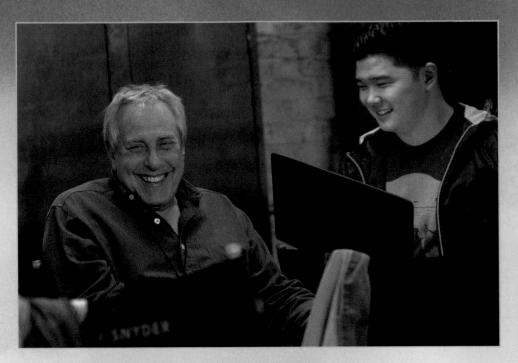

Above, left to right: producer Deborah Snyder, executive producer Wesley Coller, producer Charles Roven and co-producer Curt Kanemoto.

When it was confirmed that the principle actors—Henry Cavill, Amy Adams, Laurence Fishburne—would be returning to continue their roles from *Man of Steel*, it became necessary to cast a Batman. After months of analyzing the needs of the character and all the options among dozens of talented performers, it was clear that Ben Affleck was the right choice for the story the filmmakers wanted to tell. "Besides the fact that he's a great actor, he has the maturity and can pull off a Batman who's seen a lot," says Snyder. "It was really just a perfect storm with Ben to be the Batman that I was looking for." For Affleck's part, what drew him to the role was the commitment to anchoring a movie about Super Heroes with actual consequences. "This is really taking a more nuanced view at how these type of characters may exist in the real world and what sorts of complications it might create," says Affleck.

"Lex, played by Jesse Eisenberg, was such an exciting choice by Zack for casting. But Zack's sense and intuition were so on the money," says Curt Kanemoto. "Watching Jesse as Lex has been one of the greatest moments that I think I've experienced on this film. When Jesse delivers his lines, I can say everyone–all cast, all crew–they're just captivated by what he has to say."

"Our process, which is very unique, is Zack storyboards the whole movie," explains Kanemoto, "Then he hands them over to our production designer, Patrick Tatopoulos, and

his team goes and has all the concept art developed... On the day of shooting the opening scene, you can go back and look at Zack's first storyboard, and it's literally the same thing. He had such a clear vision back then... You really see the nuance of the storytelling that Zack has already unraveled in his head. It's unbelievably impressive, and I still don't know how he does that."

What was clear to the cast and crew was just how deeply Super Heroes have permeated our collective consciousness over the past 75 years, "They are, in a way, timeless. They never grow old. They're dealing with major themes," says acclaimed actor Jeremy Irons, who plays Bruce Wayne's butler and confidant Alfred. "Shakespeare is the same... timeless because he deals with major themes. So, whether it's Batman or Hamlet, or Wonder Woman or Rosalind, they still speak to us because they can address the issues that affect people in life, whatever age, whether it be 1945 or 2050. Human nature doesn't change."

"You don't have to be a comic book fan to realize they are in your culture," says Zack Snyder. "You are a product of Superman and Batman and Wonder Woman. That is a fact, regardless of how you feel about them. My dad might say, 'Oh, I don't really read comics.' But I'm like, 'We're going to make a movie with Batman and Superman and Wonder Woman,' and he's like, 'That's awesome!' It's our mythology, and to see it come to life, that's exciting for everyone."

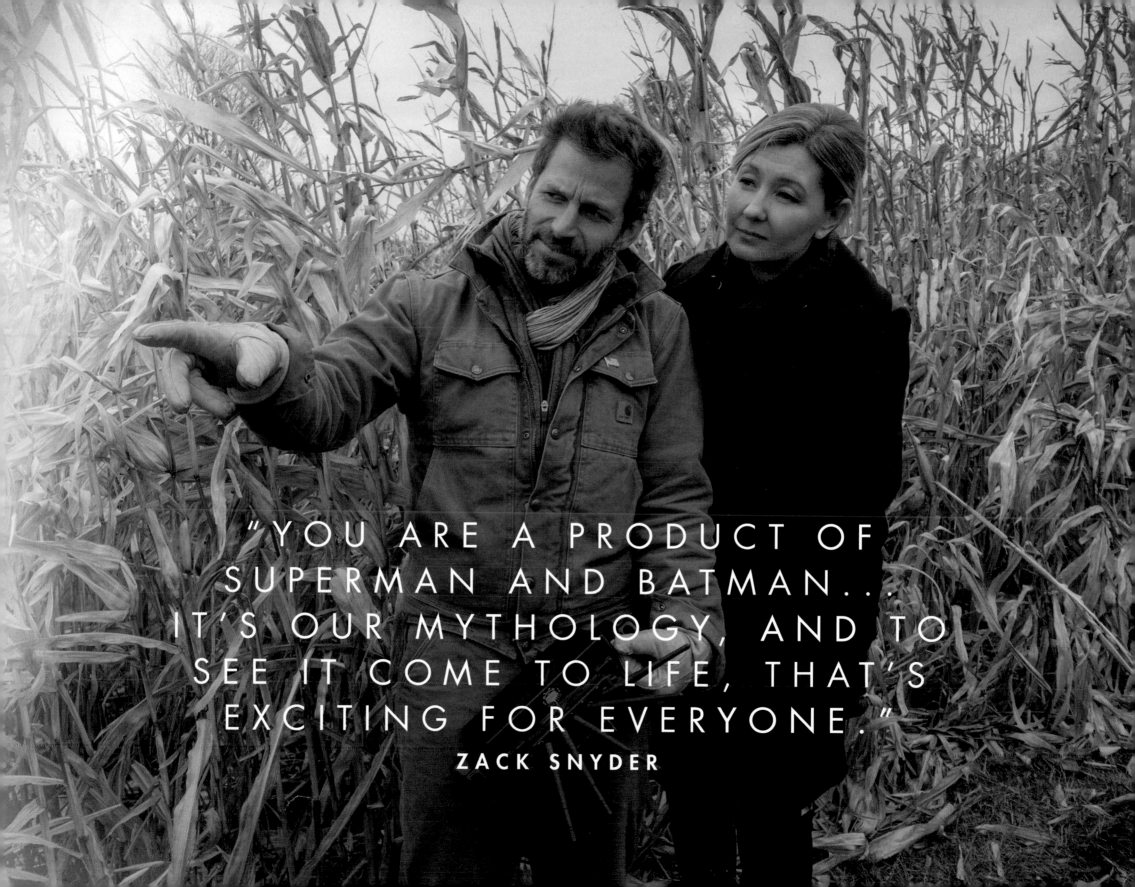

"YOU ARE A PRODUCT OF SUPERMAN AND BATMAN... IT'S OUR MYTHOLOGY, AND TO SEE IT COME TO LIFE, THAT'S EXCITING FOR EVERYONE."

ZACK SNYDER

THE WORLD OF
SUPERMAN

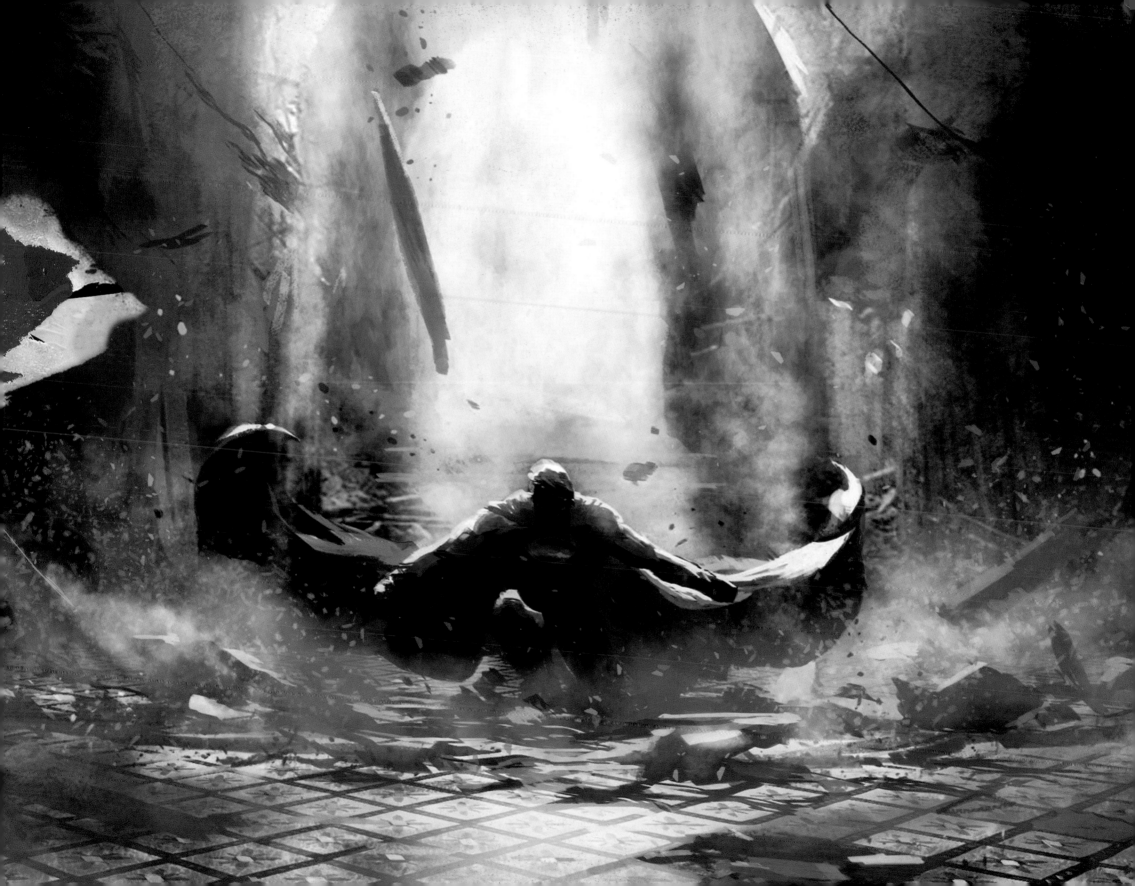

SUPERMAN

"IT'S A WORLD IN TURMOIL,
IN FLUX. AND IT'S THE HUMAN
RESPONSE TO THE EXISTENCE OF
AN ALIEN WHO IS SEEMINGLY
INVULNERABLE."

HENRY CAVILL

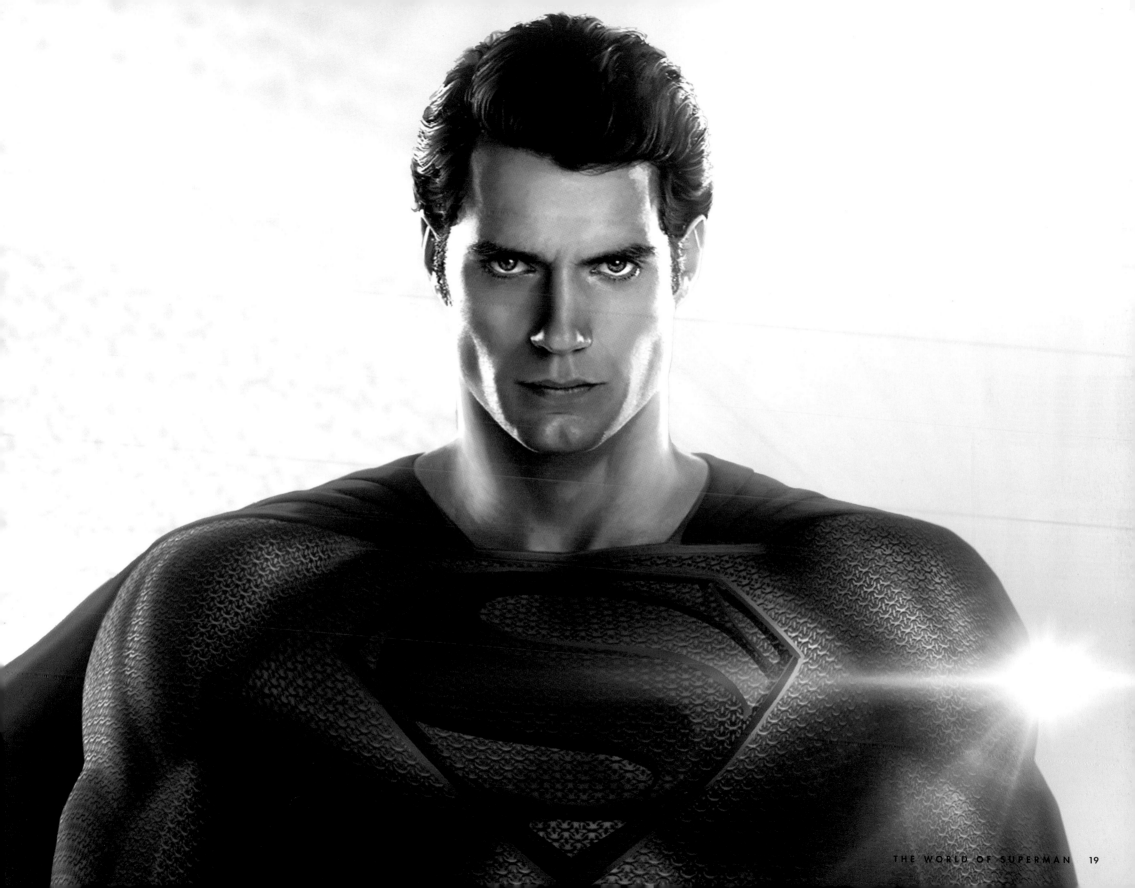

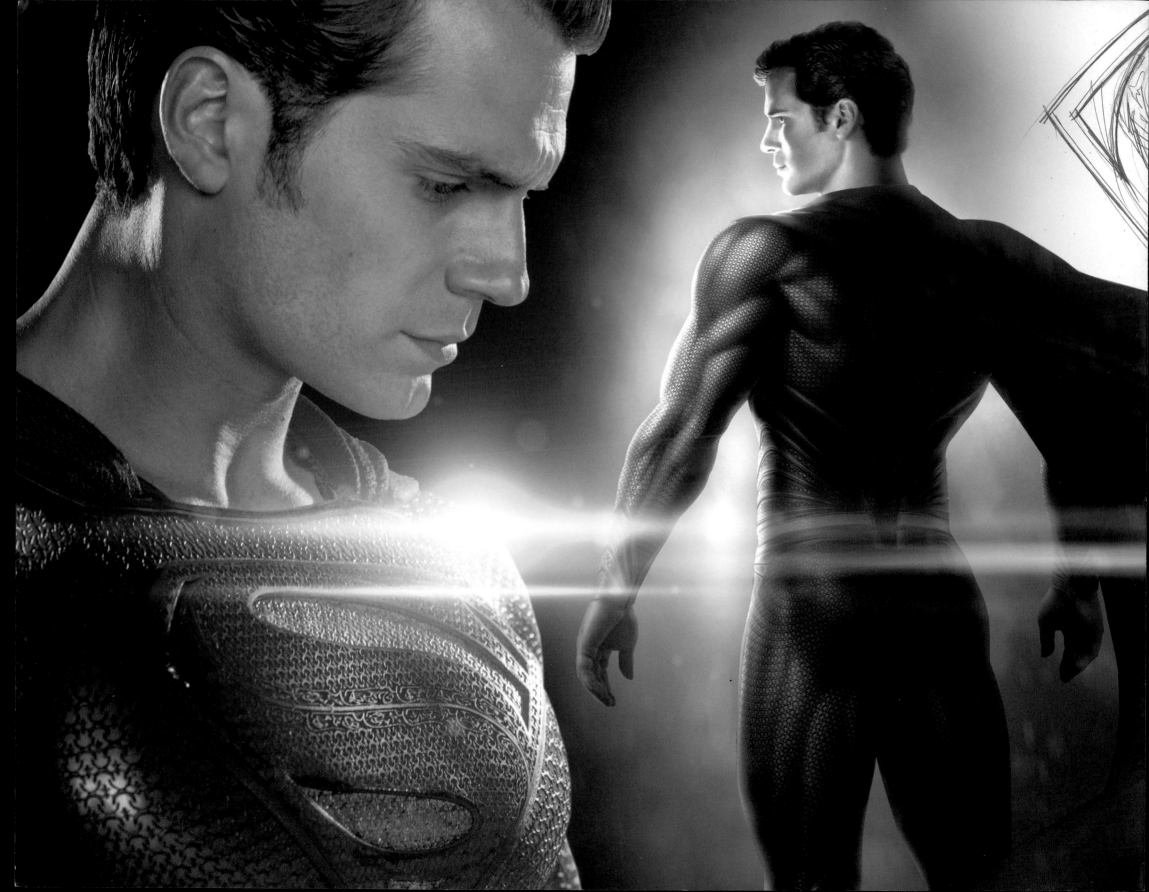

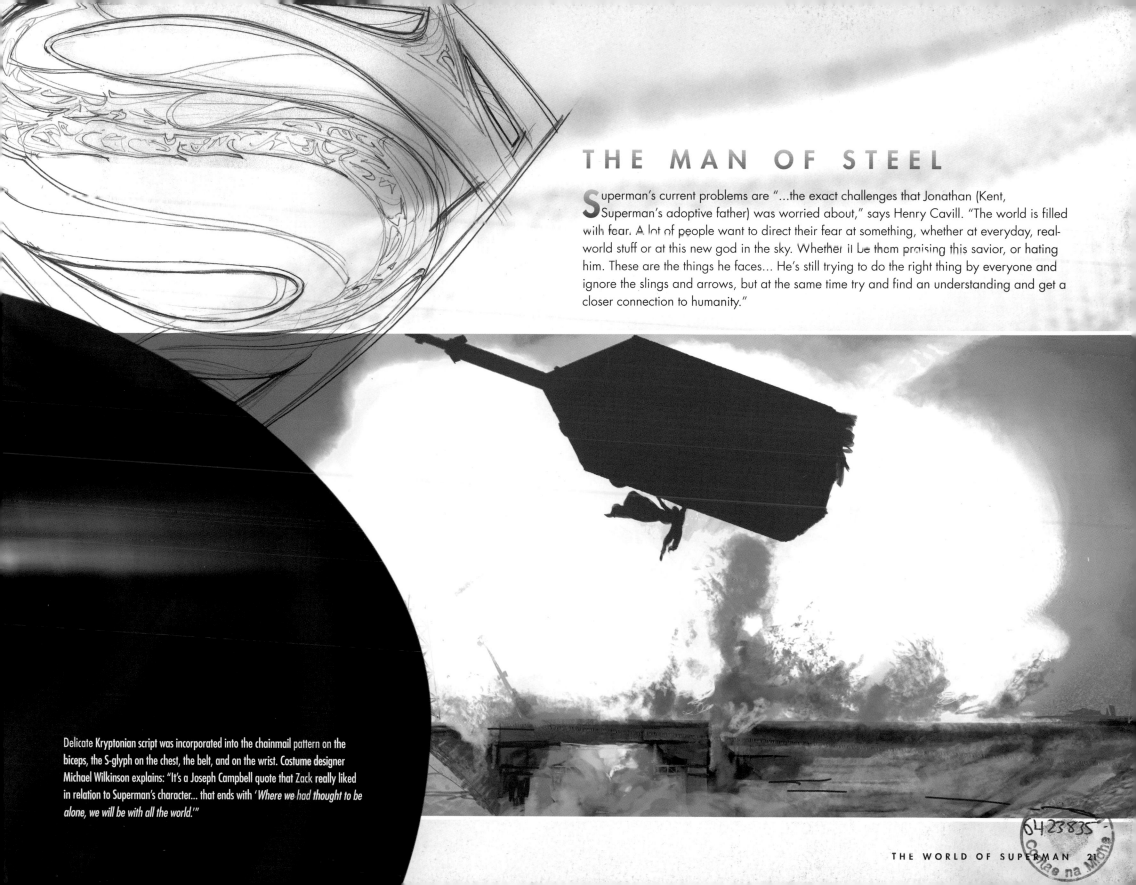

THE MAN OF STEEL

Superman's current problems are "...the exact challenges that Jonathan (Kent, Superman's adoptive father) was worried about," says Henry Cavill. "The world is filled with fear. A lot of people want to direct their fear at something, whether at everyday, real-world stuff or at this new god in the sky. Whether it be them praising this savior, or hating him. These are the things he faces... He's still trying to do the right thing by everyone and ignore the slings and arrows, but at the same time try and find an understanding and get a closer connection to humanity."

Delicate Kryptonian script was incorporated into the chainmail pattern on the biceps, the S-glyph on the chest, the belt, and on the wrist. Costume designer Michael Wilkinson explains: "It's a Joseph Campbell quote that Zack really liked in relation to Superman's character... that ends with '*Where we had thought to be alone, we will be with all the world.*'"

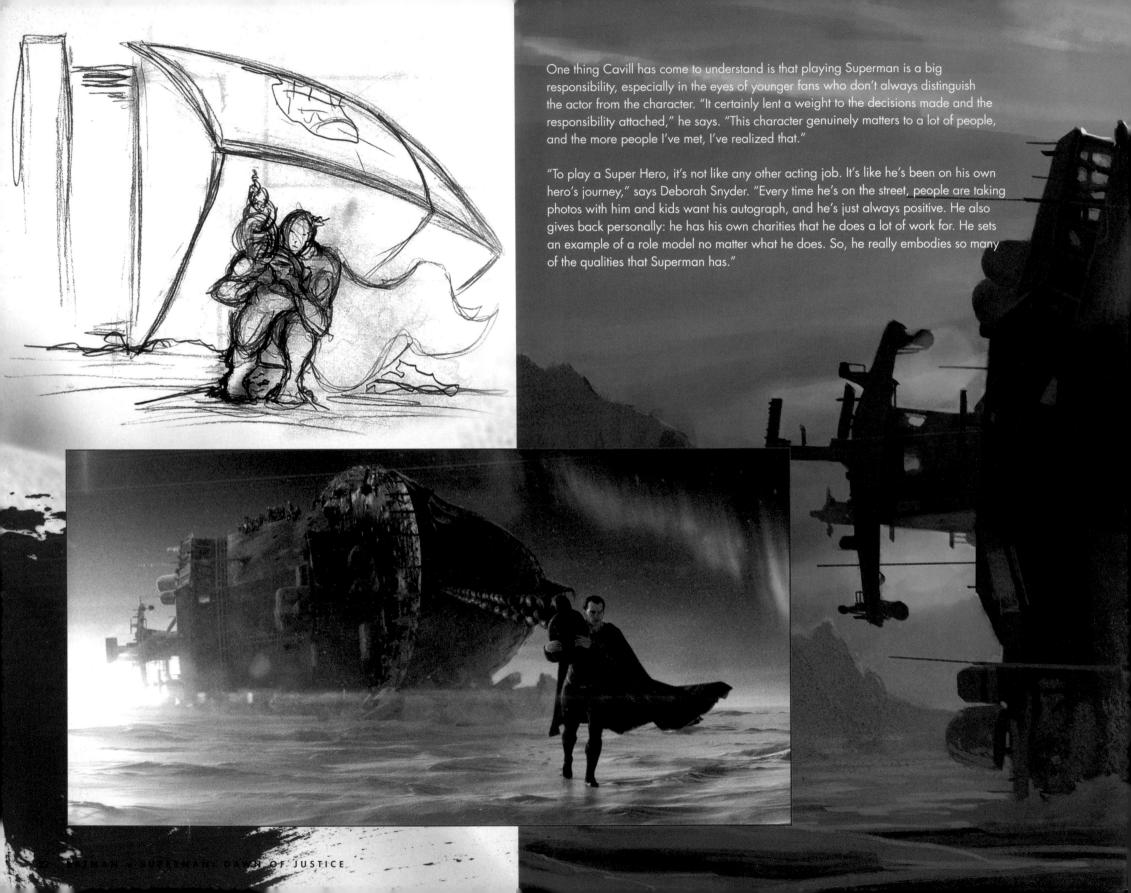

One thing Cavill has come to understand is that playing Superman is a big responsibility, especially in the eyes of younger fans who don't always distinguish the actor from the character. "It certainly lent a weight to the decisions made and the responsibility attached," he says. "This character genuinely matters to a lot of people, and the more people I've met, I've realized that."

"To play a Super Hero, it's not like any other acting job. It's like he's been on his own hero's journey," says Deborah Snyder. "Every time he's on the street, people are taking photos with him and kids want his autograph, and he's just always positive. He also gives back personally: he has his own charities that he does a lot of work for. He sets an example of a role model no matter what he does. So, he really embodies so many of the qualities that Superman has."

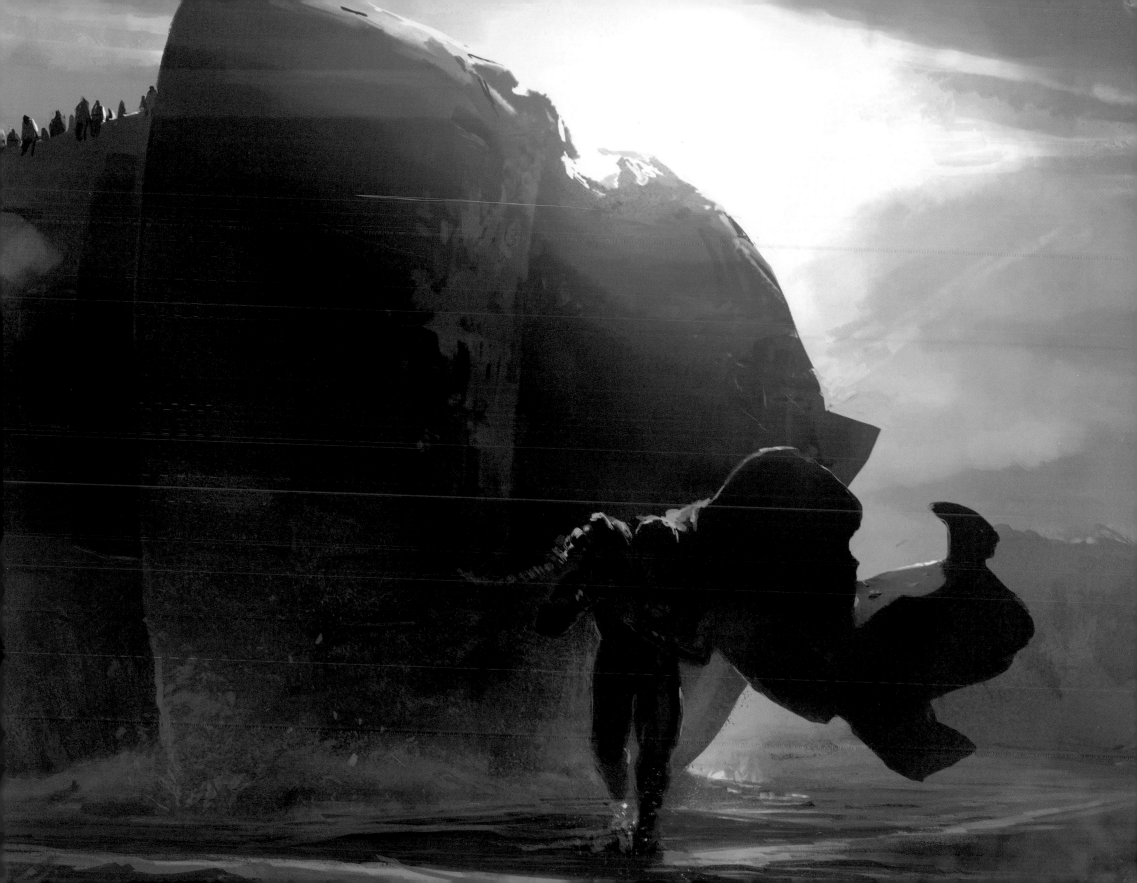

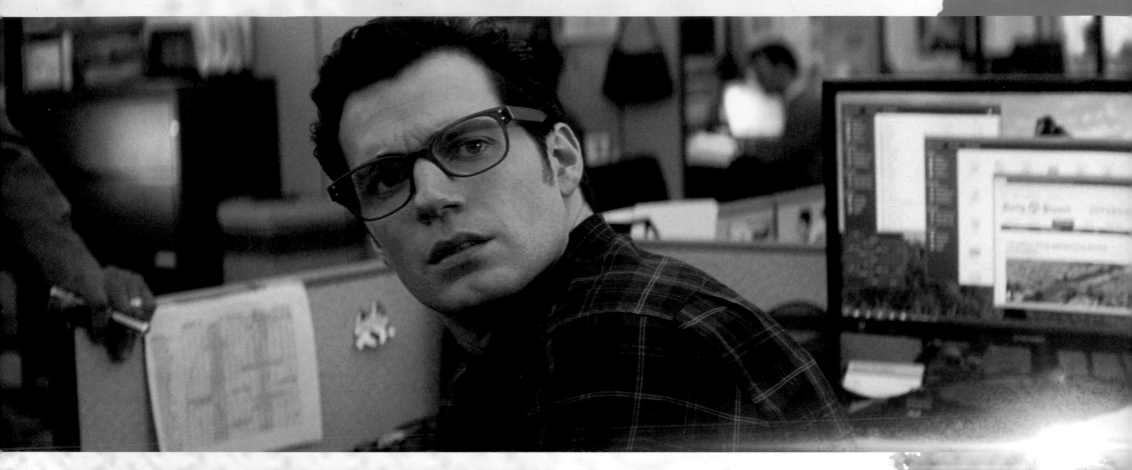

CLARK KENT

Clark started working at the Daily Planet so he could have his ear to the ground listening for crises in the making (and, let's face it, to be close to Lois), but Clark Kent would also love to be taken seriously as a journalist. Reporting on hard news, like exposing corrupt politicians and shedding light on the plight of the destitute and homeless, would give him a sense of doing some good, not covering charity events or writing features on a community's reaction to a football game. But the story that has intrigued him the most lately is the Batman over in Gotham City, whose methods have become increasingly brutal. Clark's insistence on pursuing this investigation will see him butting heads with his editor, Perry White, as well as the Dark Knight himself.

It's only in his Clark Kent persona that Superman truly has the ability to explore his humanity and question his role in an increasingly hostile world. To do that soul searching, he needs to blend seamlessly into human society, and that's where costume designer Michael Wilkinson came to his rescue. "We were very conscious of using fabrics and ways of making clothes that really deemphasize his amazing physique and helped him hide in his clothes."

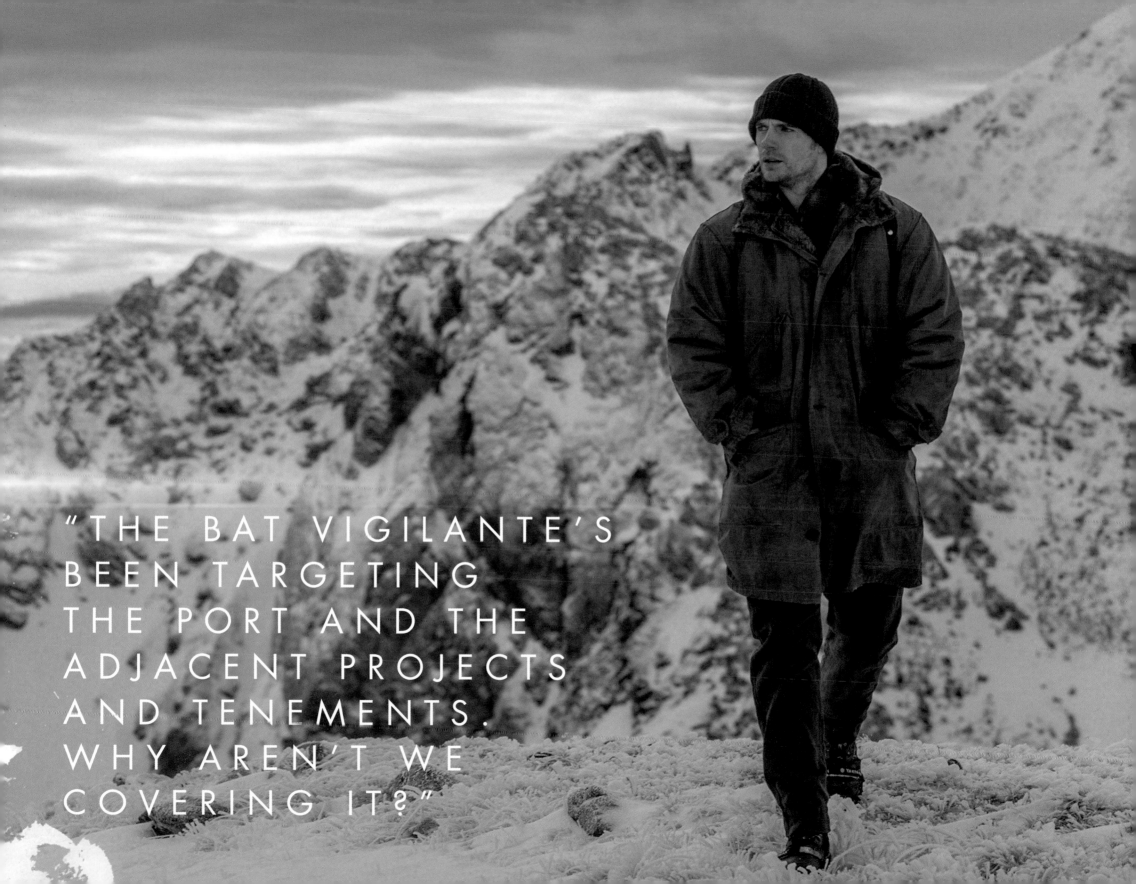

"THE BAT VIGILANTE'S BEEN TARGETING THE PORT AND THE ADJACENT PROJECTS AND TENEMENTS. WHY AREN'T WE COVERING IT?"

LOIS LANE

"YOU'RE THE BEST IN THE WORLD AT WHAT YOU DO, CLARK. SO AM I. LET ME FIND THE TRUTH."

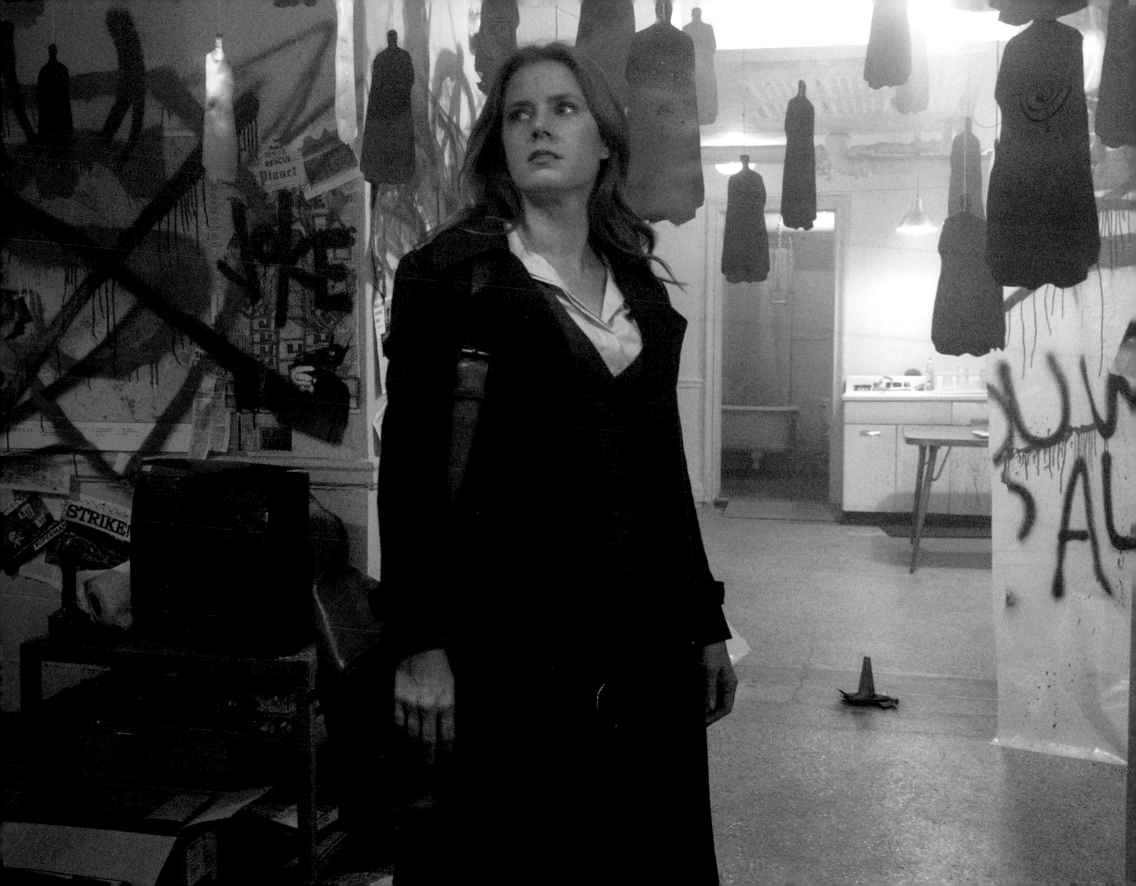

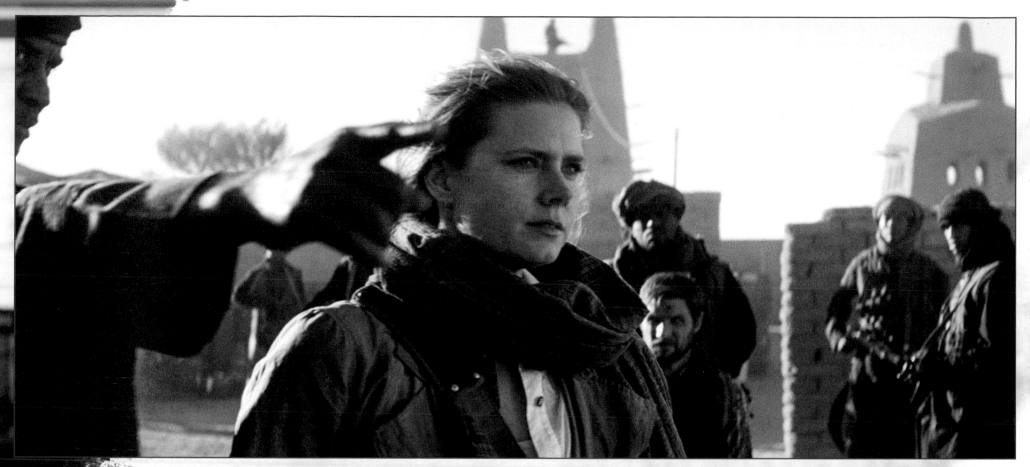

FEARLESS REPORTER

"I like that in this (film) she's coming at it not only as a journalist, but as a woman," says Amy Adams, "and really feeling kind of powerless about what's going on with Clark and wanting to help him in the only way she knows how."

It's her hunger for answers and tenacity that keeps her going and standing by Clark when Superman's many critics emerge. "Lois is in many ways the center and heart of the movie," says producer Charles Roven, "because she is constantly turning over stones to get underneath what is going on that seems to be random, but actually somebody is pulling the strings."

Lois is unafraid to take that investigation straight to the highest corridors of power. Adams found insight into her dogged character from an unlikely source in her past. "When I worked with (screenwriter/director) Nora Ephron," says Adams, "she worked in the Washington Press Corps in the 70s and told a lot of stories about that, [of] feeling like you're in a man's world, and having to rise to the occasion and get your voice heard."

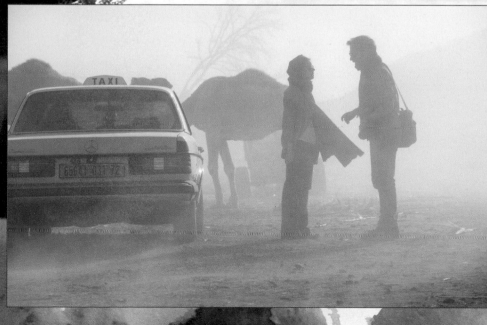

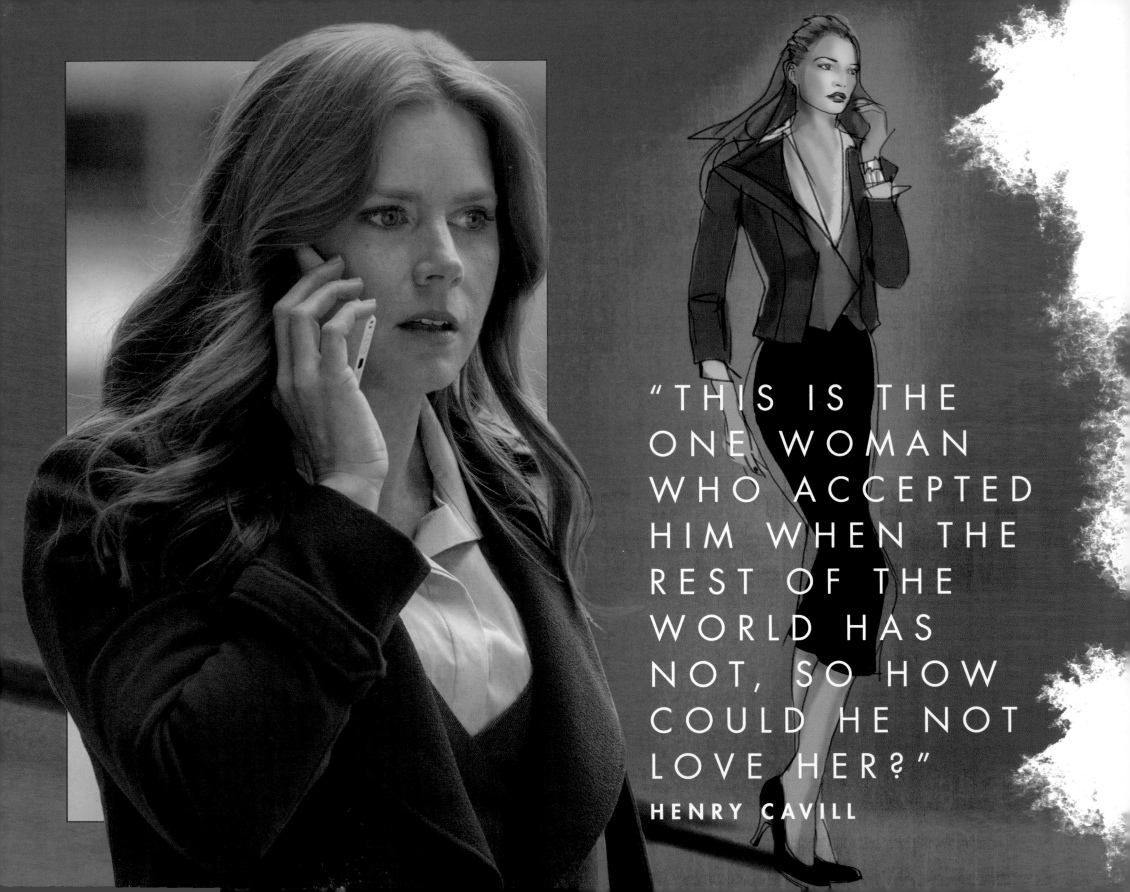

"THIS IS THE ONE WOMAN WHO ACCEPTED HIM WHEN THE REST OF THE WORLD HAS NOT, SO HOW COULD HE NOT LOVE HER?"

HENRY CAVILL

As Adams sees it, Lois' determination is completely warranted, given how close she and Clark have become. "She knows the truth of his soul, and she believes that there's something bigger at play here."

Their bond has naturally progressed over the past two years, to the point where they have moved in together. In her second turn as the intrepid reporter from the Daily Planet, Adams thinks the reason their relationship works is very simple: "The part of him she finds superhuman is his soul, not his strength."

But it doesn't make it easy that they have to keep their home life secret at work, on top of each worrying about the other's dangerous exploits. "A regular relationship is complicated—dealing with a relationship with a god is *incredibly* complicated," explains co-producer Curt Kanemoto. "Lines get blurred between looking out for each other versus doing a job."

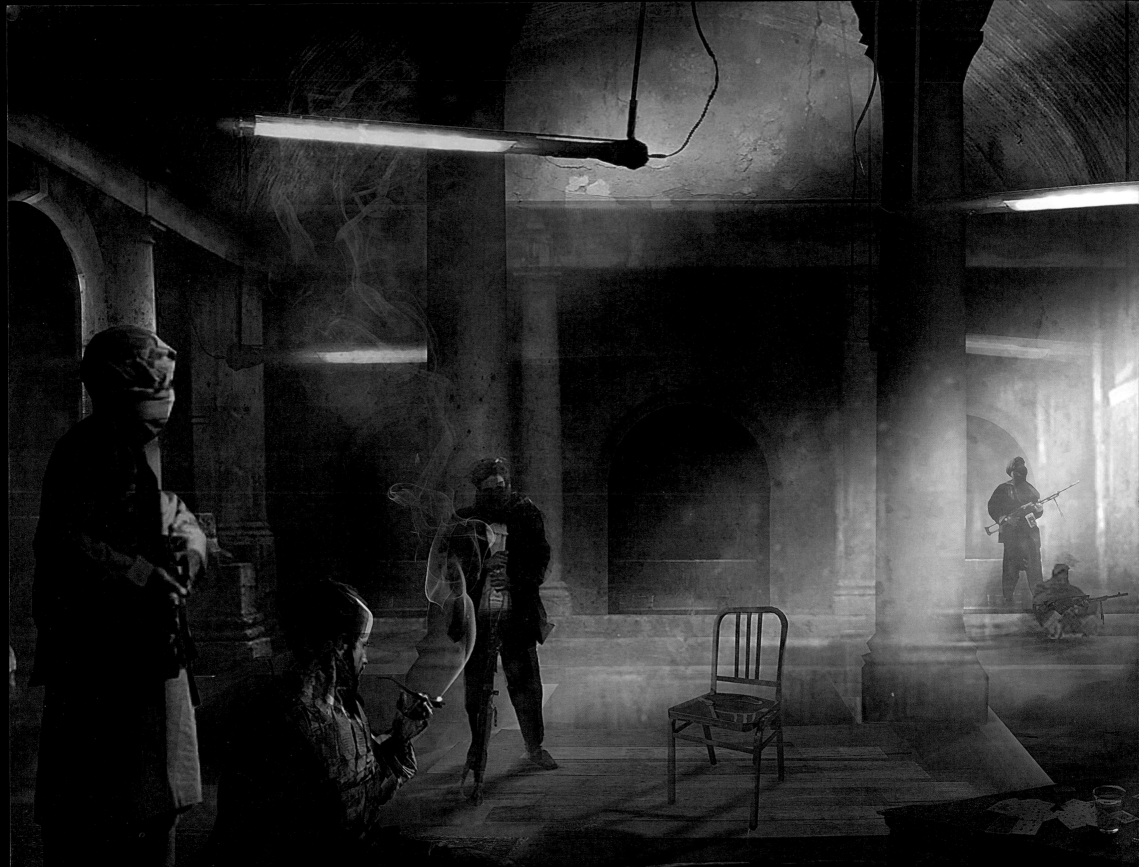

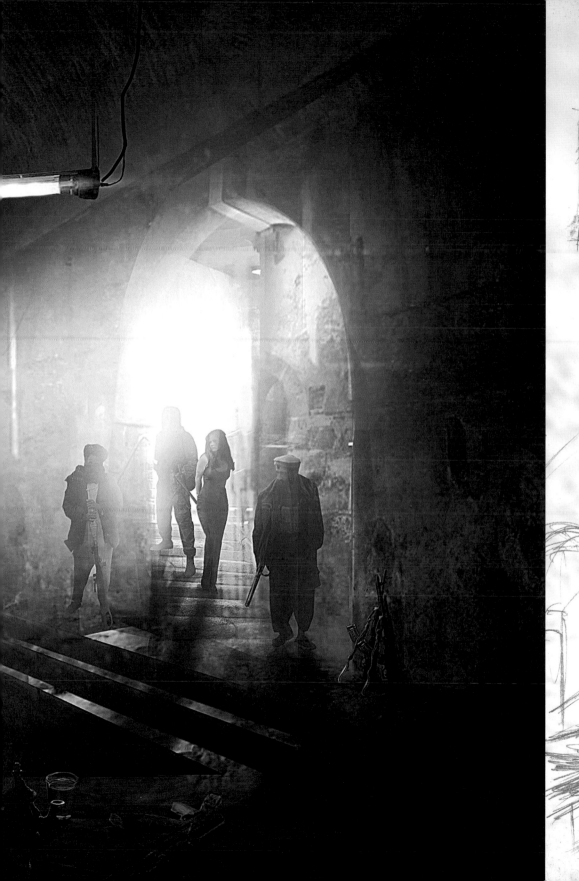

THE NAIROMI REBELS

The Republic of Nairomi in Sub-Saharan Africa is in the midst of a bloody civil war when Lois Lane scores a rare, exclusive interview with the rebel commander, General Amajagh (Sammi Rotibi). Always suspicious of outsiders, the rebels take Lois and her photographer secretly to their remote headquarters, treating them almost as if they are hostages. When the meeting goes awry and bullets start flying, Superman arrives to save his favorite reporter. But that intervention has even his stalwart allies questioning the Man of Steel's methods.

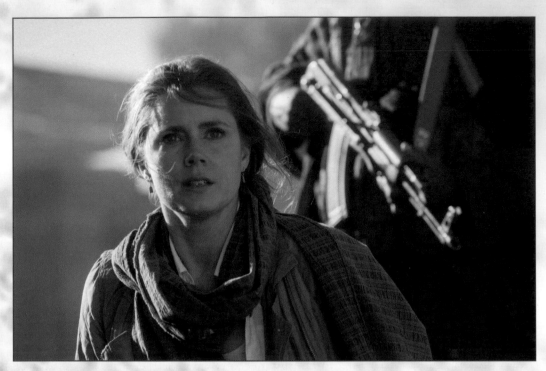

"We looked at New Mexico and found a training compound for the army," explains production designer Patrick Tatopoulos. "Cinderblock walls and places for the guys to train and little huts, but very typical, modern, low buildings. So, what we had to do, I said to Zack, 'We need to create the ancient part of it.' It was an amazing experience, as we created those buildings the way they used to build them with wood and mud, and then starting to decorate it slowly and putting up paintings that they might have on the walls. We started to bring in camels, chickens, motorcycles, mopeds... When you looked around you had no idea where you were."

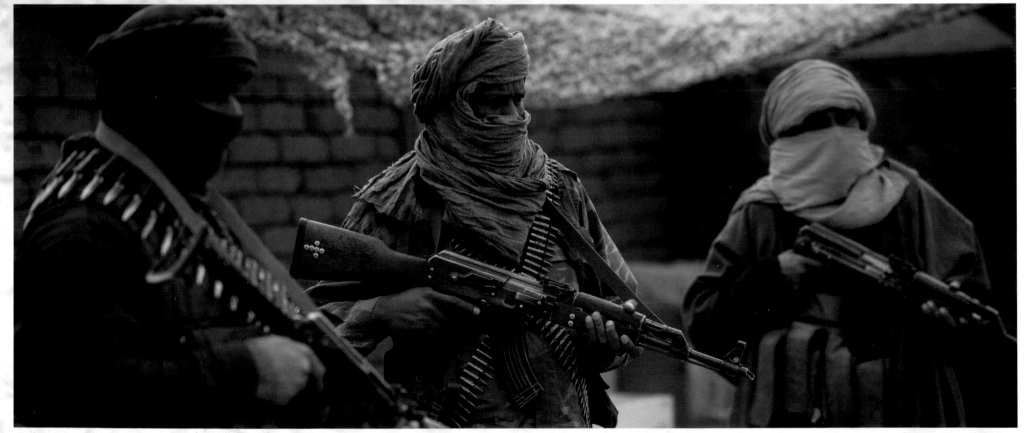

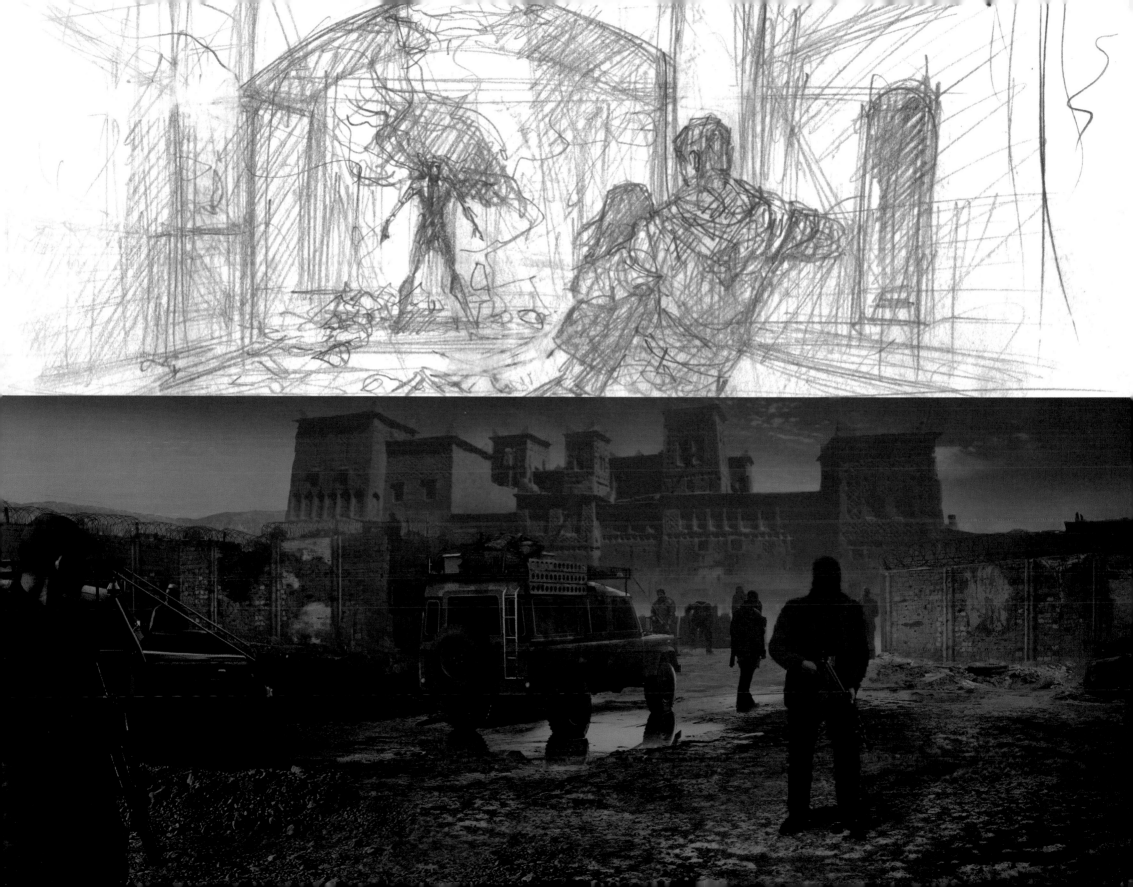

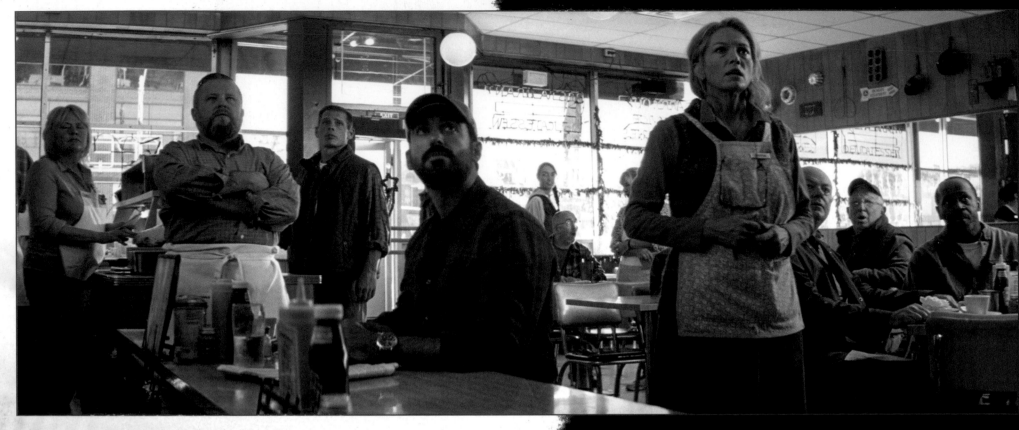

MARTHA KENT

"MY BABY BOY. NOTHING WAS EVER SIMPLE."

Wherever he is, whatever he does, however people feel about him, Superman knows he can always fly home to Smallville if he needs a sympathetic ear. That ear would belong to his mother, Martha Kent, played by Diane Lane. "The relationship between Martha and Clark is the one constant, it's the one thing which hasn't changed," says Henry Cavill. "She will always see him as every mother does, as a little baby, as a boy growing up. He may be a lot bigger and stronger, but he's still her little boy. And I think he will always see her as the mother figure, as the one to go to, the one to ask, 'Why doesn't it make sense?'"

But she's more than just a fount of wisdom. Martha has a critical and unexpected part to play in the saga that is unfolding. "If the first movie was about fathers—we had Jor-El and we had Jonathan—I think that this movie is about mothers," says Deborah Snyder. "The importance of the relationships that these characters had with their mothers is really important to the story."

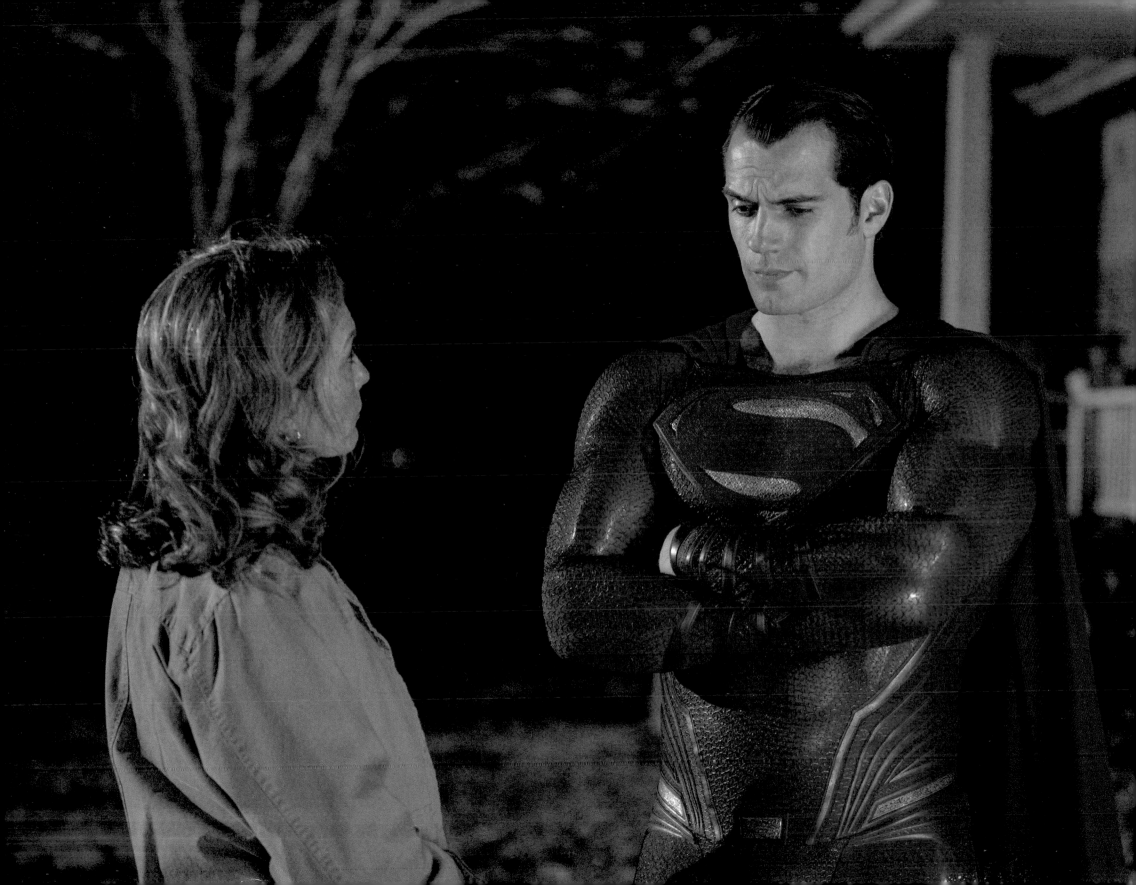

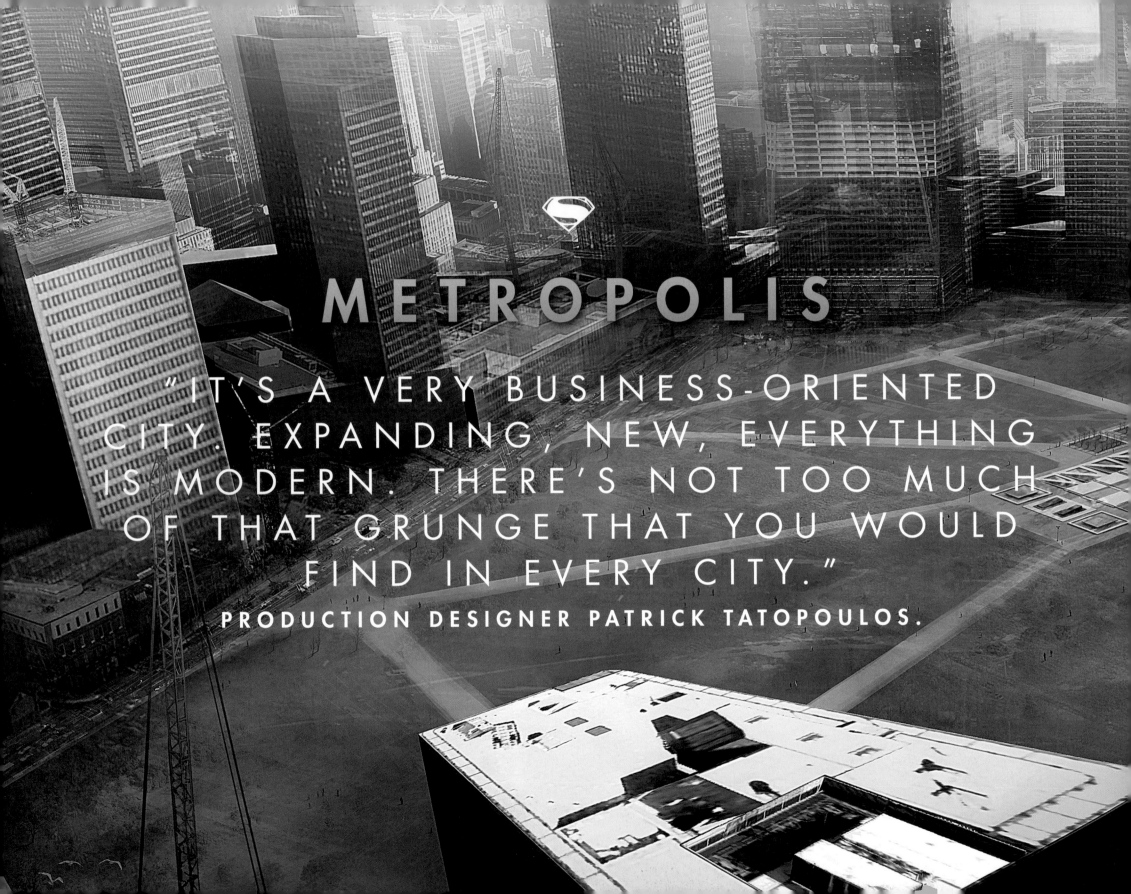

METROPOLIS

"IT'S A VERY BUSINESS-ORIENTED CITY. EXPANDING, NEW, EVERYTHING IS MODERN. THERE'S NOT TOO MUCH OF THAT GRUNGE THAT YOU WOULD FIND IN EVERY CITY."

PRODUCTION DESIGNER PATRICK TATOPOULOS.

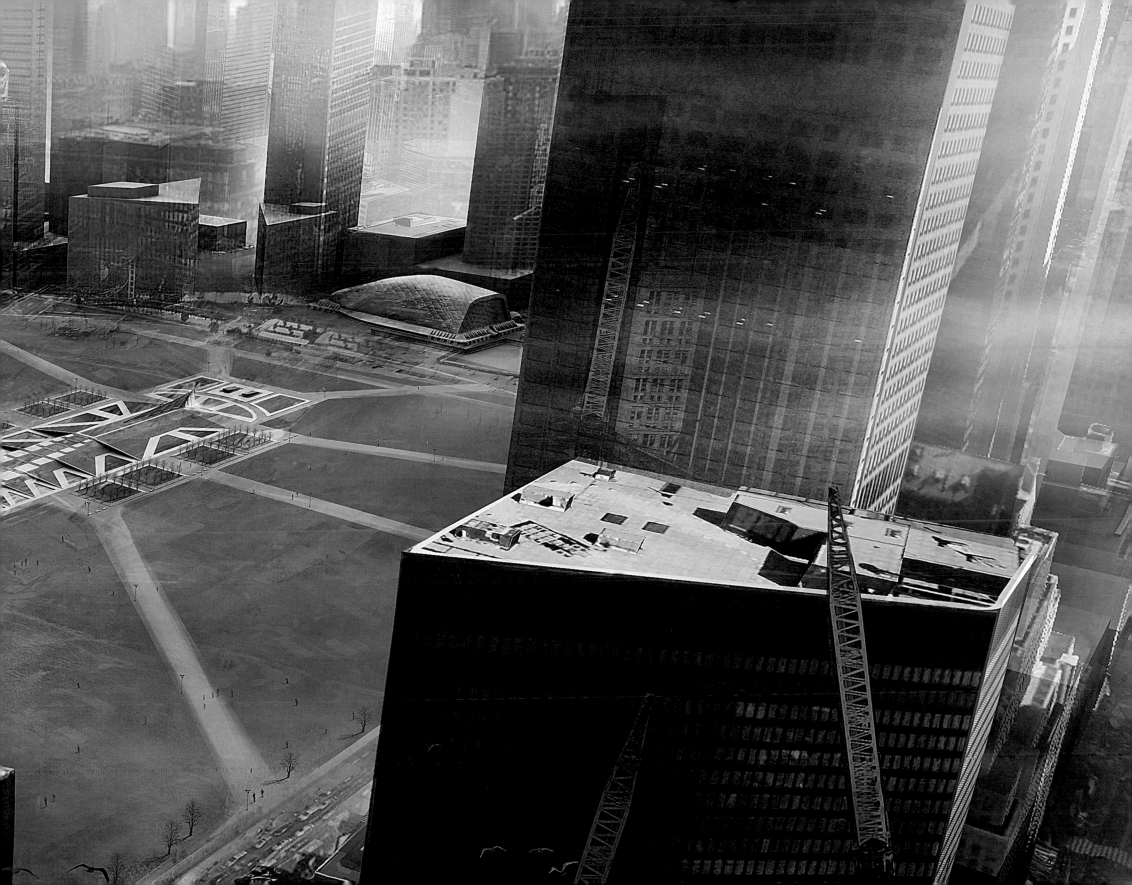

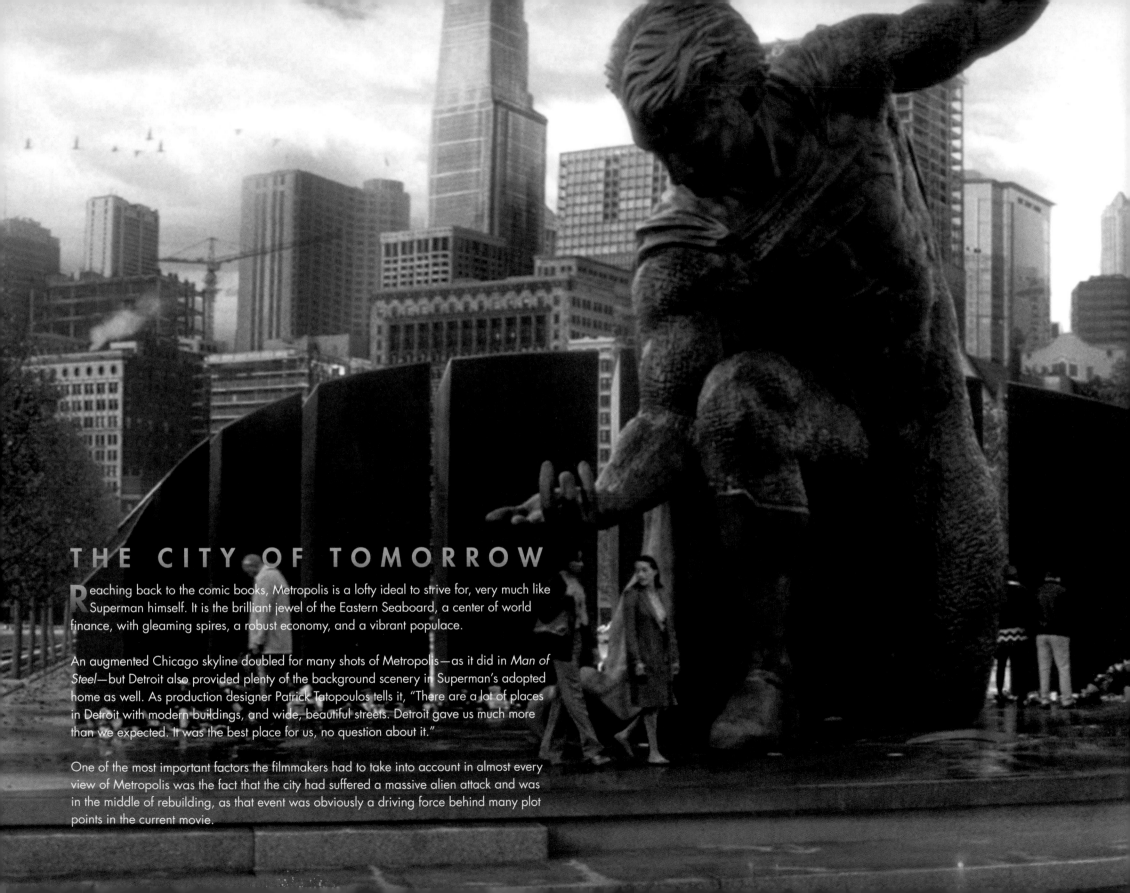

THE CITY OF TOMORROW

Reaching back to the comic books, Metropolis is a lofty ideal to strive for, very much like Superman himself. It is the brilliant jewel of the Eastern Seaboard, a center of world finance, with gleaming spires, a robust economy, and a vibrant populace.

An augmented Chicago skyline doubled for many shots of Metropolis—as it did in *Man of Steel*—but Detroit also provided plenty of the background scenery in Superman's adopted home as well. As production designer Patrick Tatopoulos tells it, "There are a lot of places in Detroit with modern buildings, and wide, beautiful streets. Detroit gave us much more than we expected. It was the best place for us, no question about it."

One of the most important factors the filmmakers had to take into account in almost every view of Metropolis was the fact that the city had suffered a massive alien attack and was in the middle of rebuilding, as that event was obviously a driving force behind many plot points in the current movie.

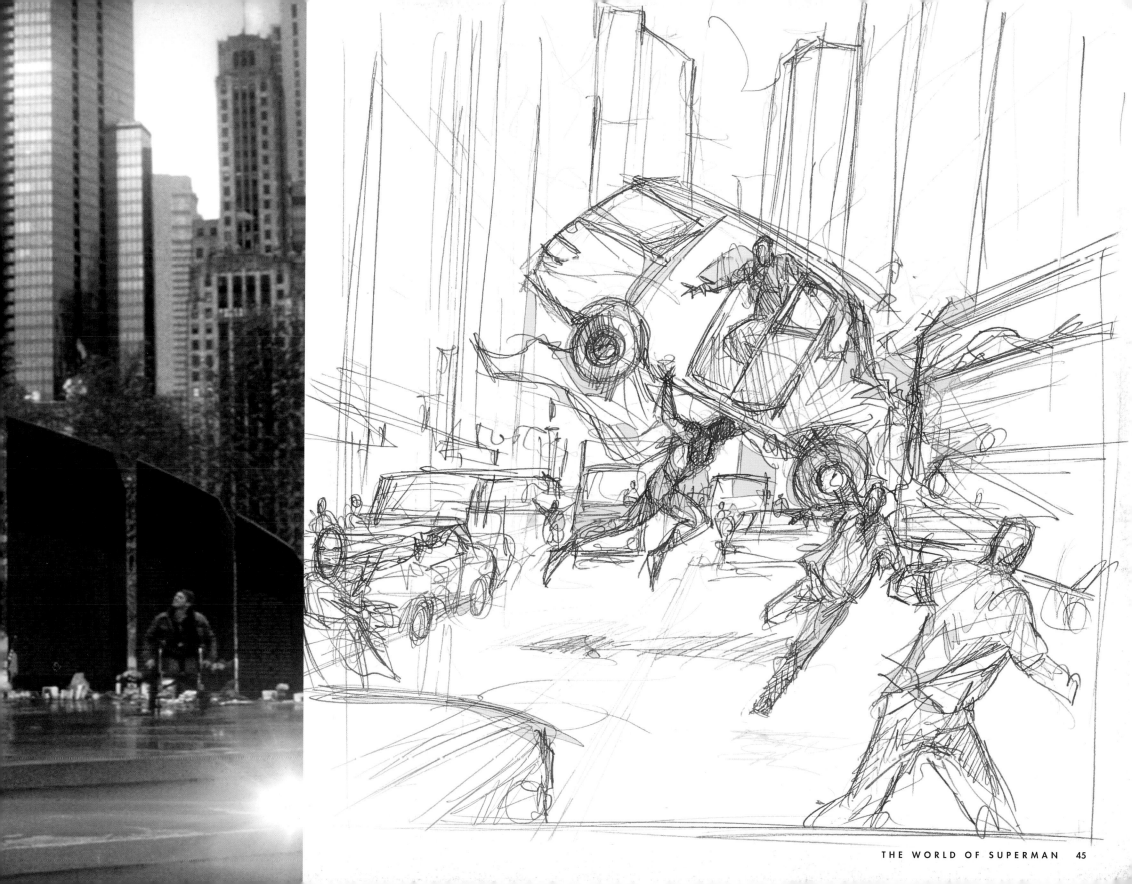

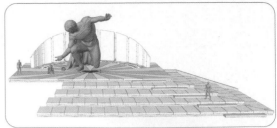

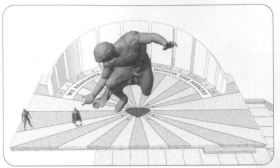

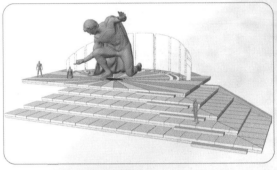

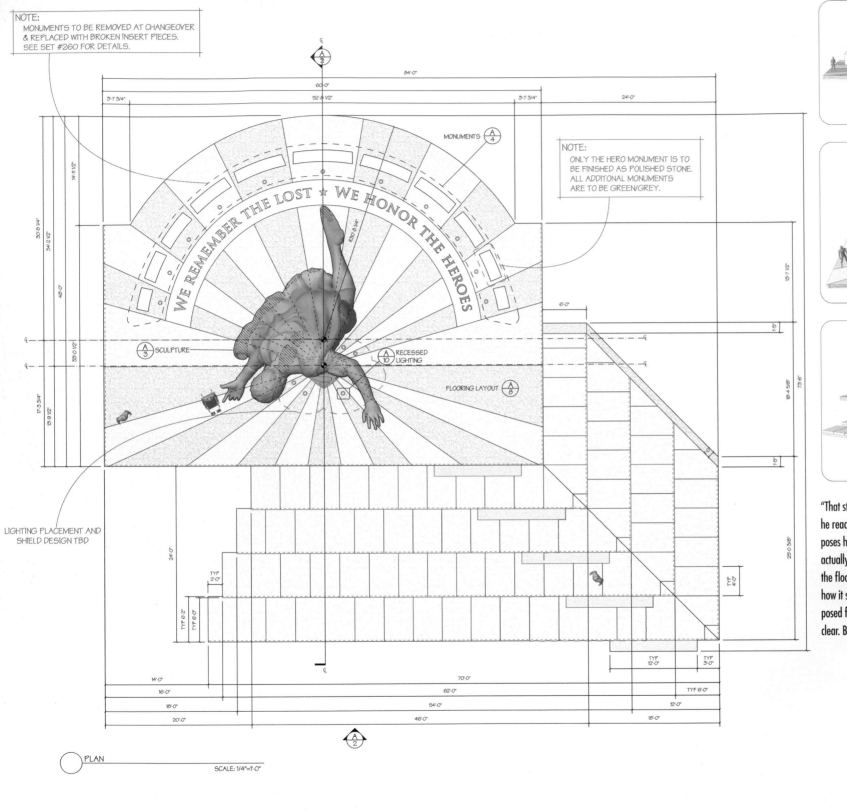

NOTE:
MONUMENTS TO BE REMOVED AT CHANGEOVER
& REPLACED WITH BROKEN INSERT PIECES.
SEE SET #260 FOR DETAILS.

MONUMENTS A/4

NOTE:
ONLY THE HERO MONUMENT IS TO
BE FINISHED AS POLISHED STONE.
ALL ADDITONAL MONUMENTS
ARE TO BE GREEN/GREY.

WE REMEMBER THE LOST ★ WE HONOR THE HEROES

A/3 SCULPTURE

A/10 RECESSED LIGHTING

FLOORING LAYOUT A/8

LIGHTING PLACEMENT AND
SHIELD DESIGN TBD

84'-0"
60'-0"
52'-8 1/2"
3'-7 3/4"
3'-7 3/4"
24'-0"

6'-0"

14'-0"
16'-0"
62'-0"
18'-0"
54'-0"
20'-0"
46'-0"
70'-0"
12'-0"
18'-0"

TYP 6'-0"
TYP 2'-0"
TYP 6'-0"
TYP 4'-0"
TYP 12'-0"
TYP 3'-0"
TYP 6'-0"

24'-0"

PLAN

SCALE: 1/4"=1'-0"

A/2

"That statue shows humility, just the way
he reaches out to people, the way he
poses himself," says Tatopoulos. "Zack
actually posed for us for this. He went on
the floor one day and said, 'Hey, this is
how it should be,' and until he actually
posed for it, I just was not completely
clear. But I got it in the end."

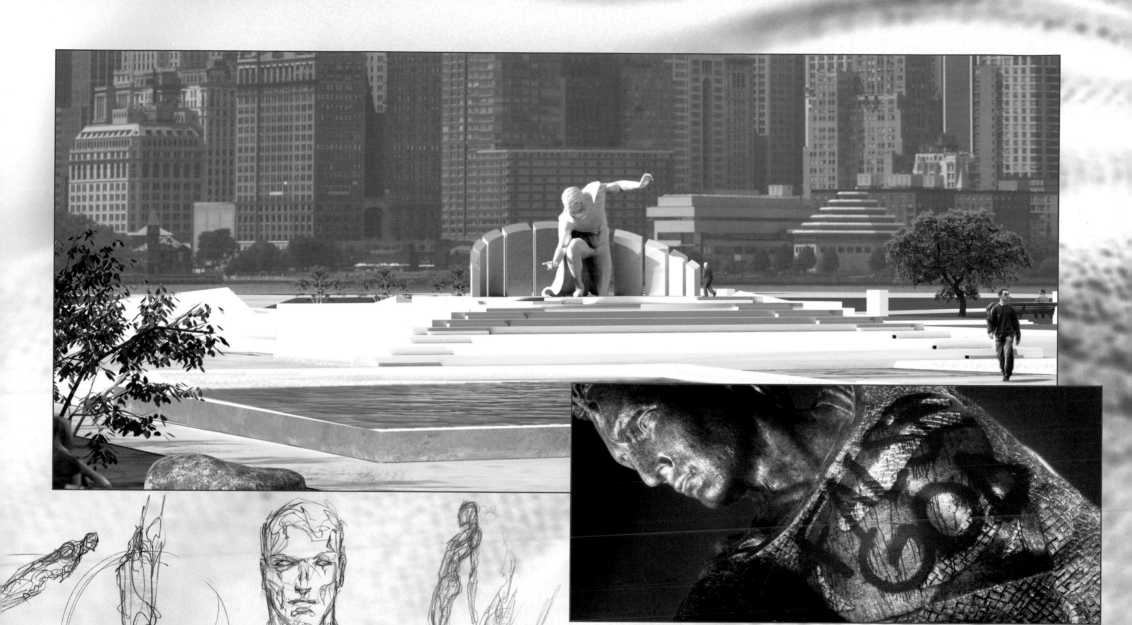

HEROES PARK

Nowhere was the tragic rebirth of Metropolis more graphically illustrated than in the addition of Heroes Park: a memorial plaza for those who died in the Black Zero Event, constructed within the gargantuan scar gouged out of the middle of the city by the Kryptonian world engine. This was an environment created almost entirely in CGI. "The whole language for that is very bold and almost bleak. It's not fun. We tried not to be fancy," explains Tatopoulos. "The park is taking the whole footprint of where the fight has happened. We get the lines of the streets that used to be there—you only see this on the aerial shots—so somehow there's a respect of the pattern of what that city used to be."

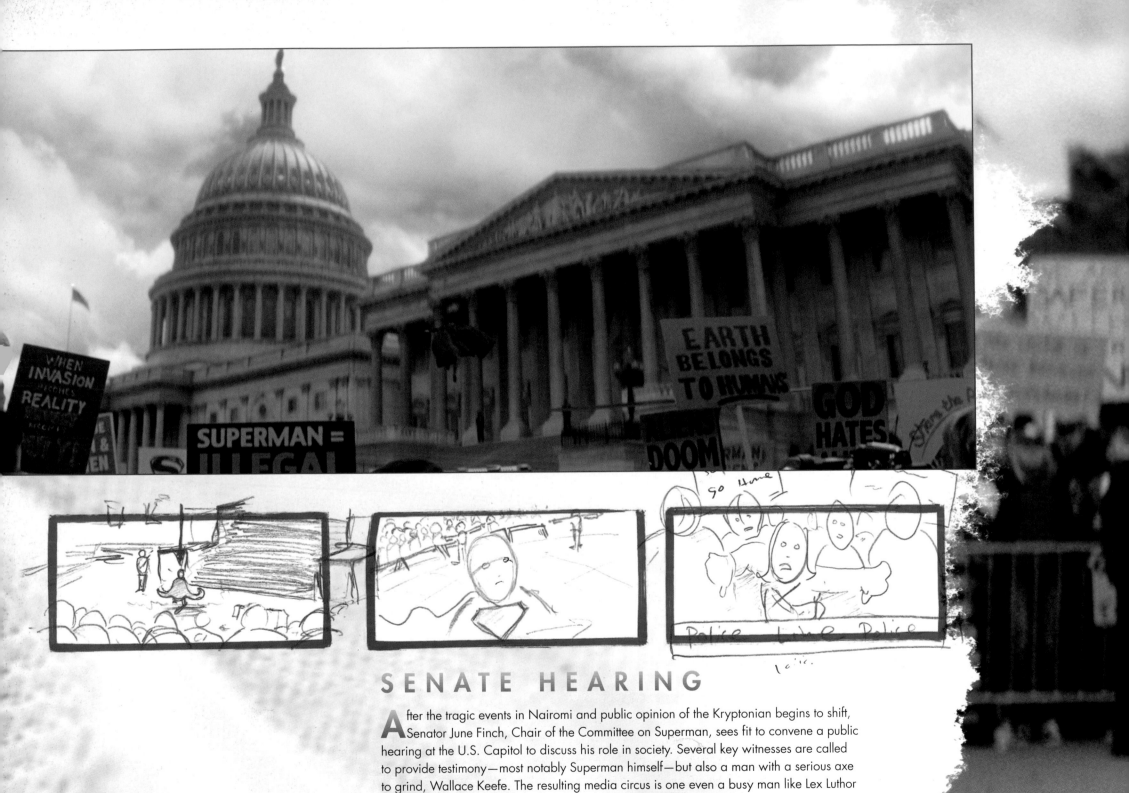

SENATE HEARING

After the tragic events in Nairomi and public opinion of the Kryptonian begins to shift, Senator June Finch, Chair of the Committee on Superman, sees fit to convene a public hearing at the U.S. Capitol to discuss his role in society. Several key witnesses are called to provide testimony—most notably Superman himself—but also a man with a serious axe to grind, Wallace Keefe. The resulting media circus is one even a busy man like Lex Luthor wouldn't dream of missing.

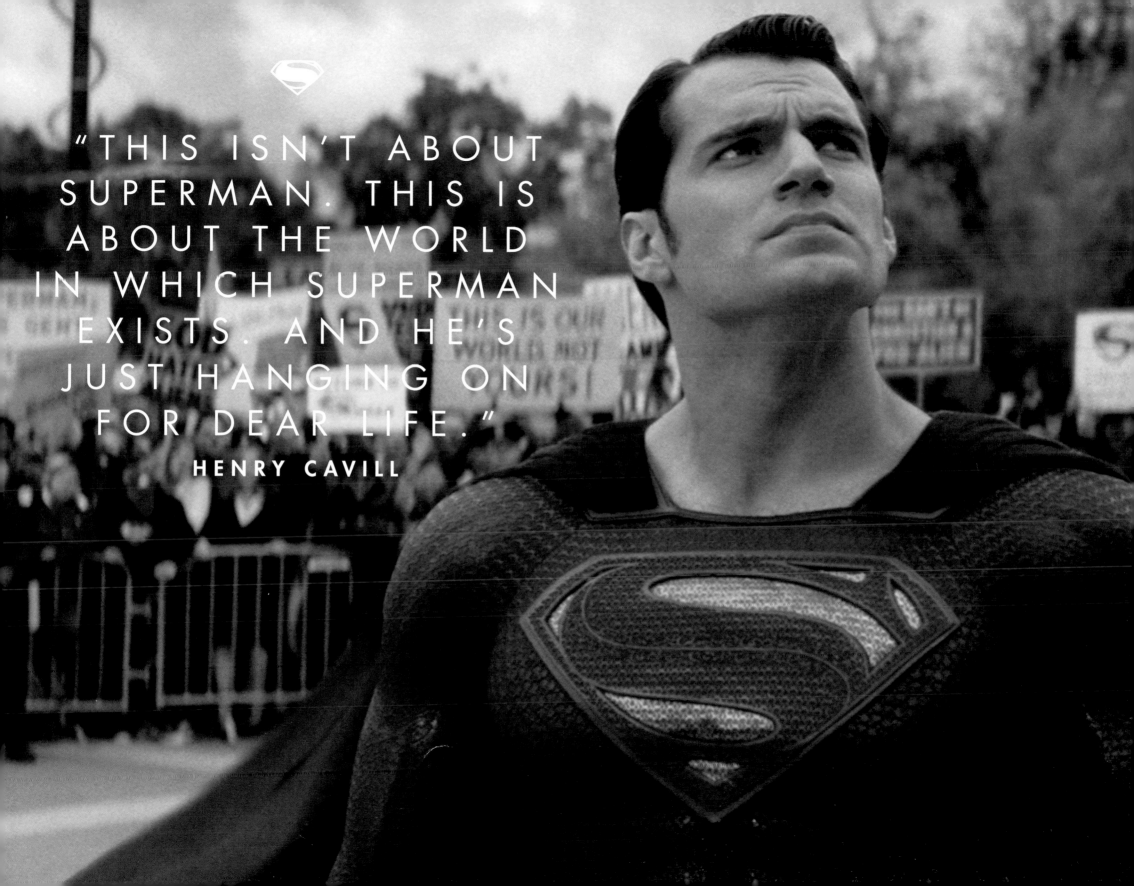

"THIS ISN'T ABOUT SUPERMAN. THIS IS ABOUT THE WORLD IN WHICH SUPERMAN EXISTS. AND HE'S JUST HANGING ON FOR DEAR LIFE."

HENRY CAVILL

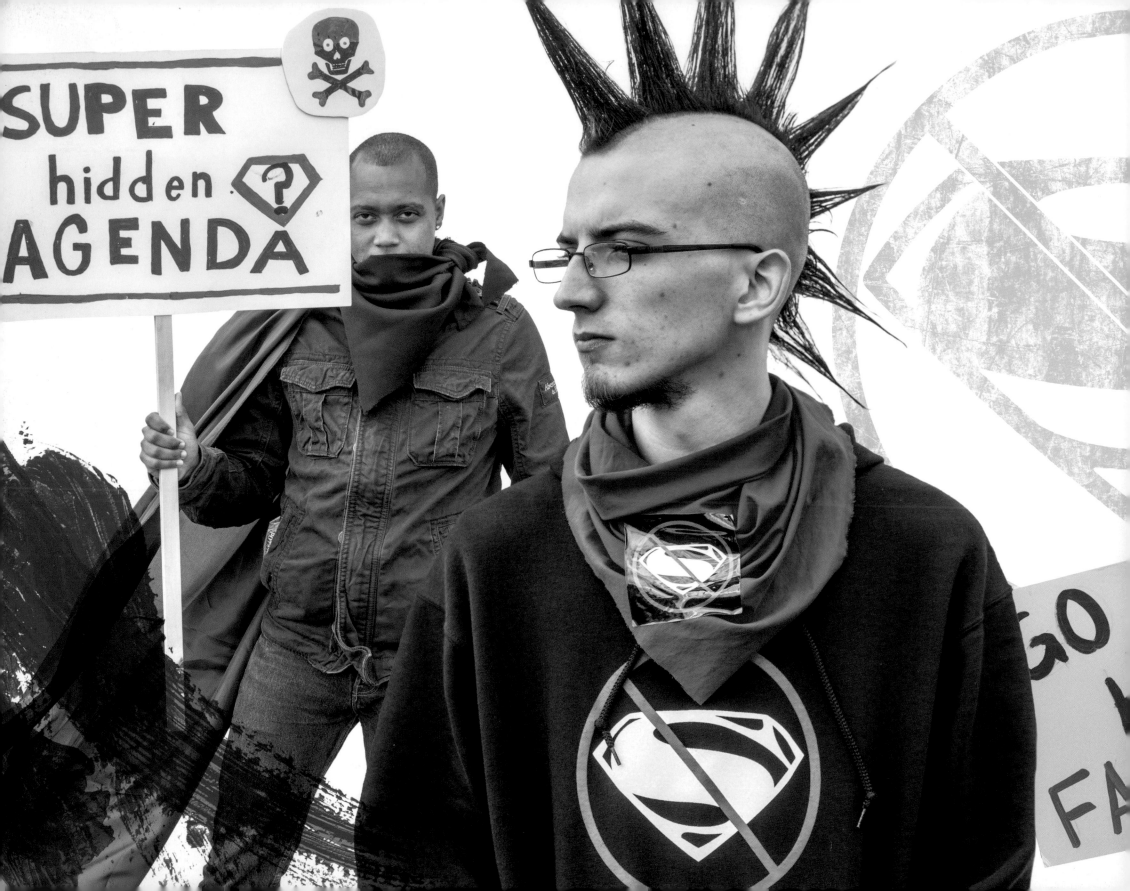

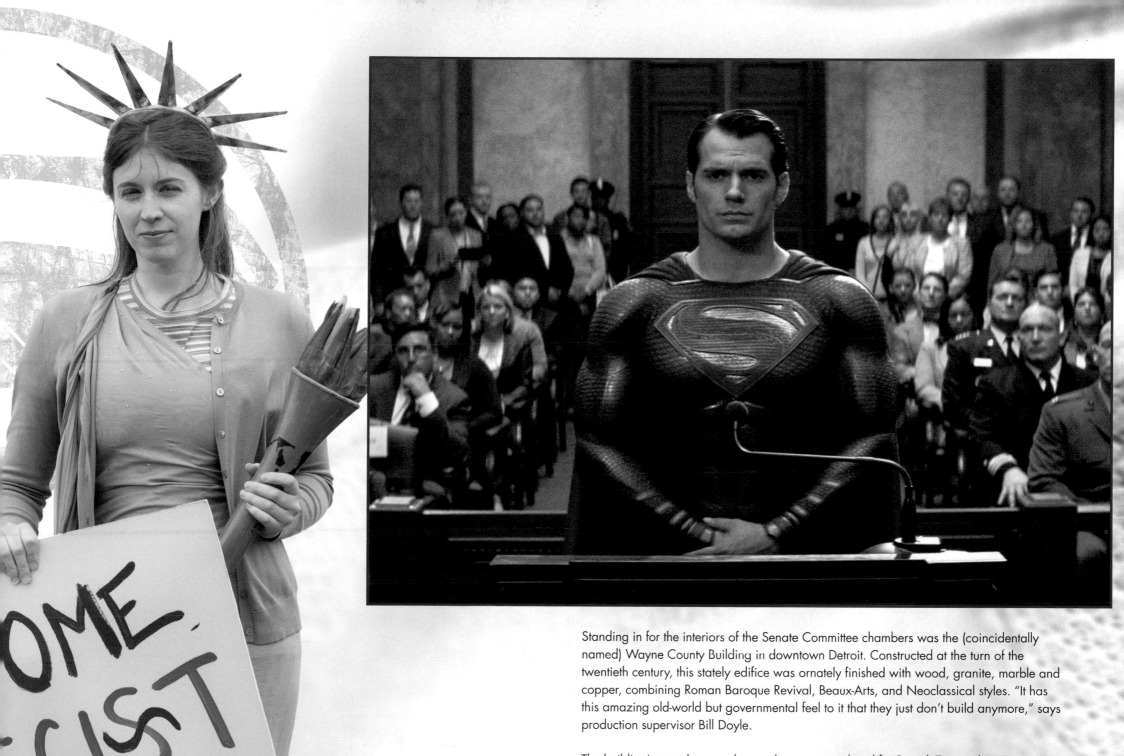

Protesters from all walks of life now dog Superman's steps whenever he makes a public appearance.

Standing in for the interiors of the Senate Committee chambers was the (coincidentally named) Wayne County Building in downtown Detroit. Constructed at the turn of the twentieth century, this stately edifice was ornately finished with wood, granite, marble and copper, combining Roman Baroque Revival, Beaux-Arts, and Neoclassical styles. "It has this amazing old-world but governmental feel to it that they just don't build anymore," says production supervisor Bill Doyle.

The building's grandness and versatility was a godsend for Patrick Tatopoulos: "It was a big, beautiful building that gave us a lot of the interiors... It was a great resource for us, because it was such a large space and gave us so many different looks, and we only had to concentrate on what we had to add to it."

THE DAILY PLANET

The newsroom of Metropolis' biggest newspaper, like the city itself, has undergone a few changes due to damage. "The windows are slightly different, a lot of things are different, but the basic layout at the office is the same," explains production designer Patrick Tatopoulos. "Zack went all the way to say, 'Well, maybe they moved to another floor.'" Other additions viewers will note is the scaffolding outside the window and the construction workers downstairs fixing the street, all pointing to The Daily Planet as a microcosm of the city under repair.

The set dressing of the cubicles was important for establishing individual characters, but even more crucial for storytelling was careful placement of the desks and even TV news monitors. Tatopoulos explains, "The way Zack has set up the desks was really so those two (Lois and Clark) can actually interact across the room... Those screens are super important—that's how they see some of the events happening and moving... So, the whole layout is actually really thought out."

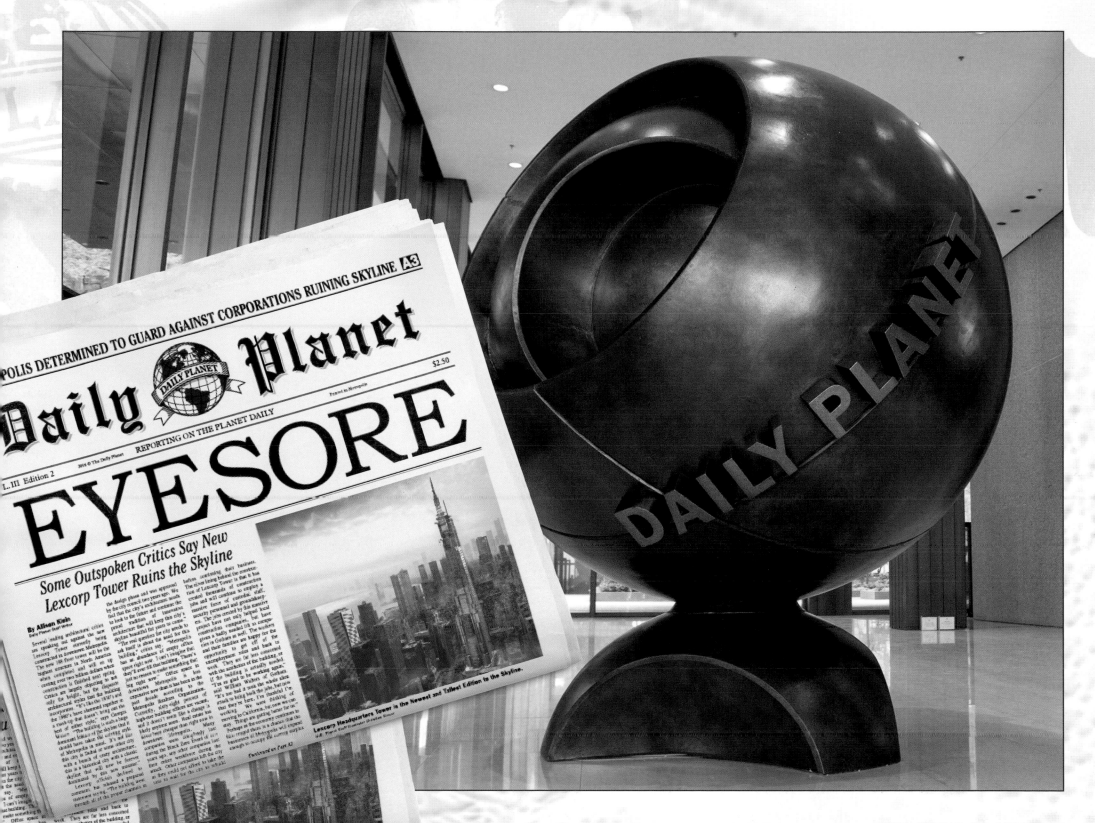

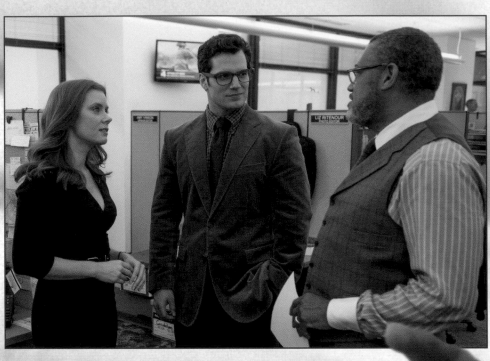

PERRY WHITE

"PRINT JOURNALISM'S ON A **RESPIRATOR**. ANY DAY NOW, SOME BLOGGER IN PAJAMAS WILL TRIP OVER THE CORD AND PULL THE PLUG."

If there is a Greek chorus in Metropolis, it is Perry White, the editor who rides herd over his stable of reporters as he holds The Daily Planet together. "Perry white is kind of us. He is the barometer when public opinion sways against Superman," says Deborah Snyder.

At the same time, he is a definite father figure to both Lois and Clark; although he seems cranky, he's willing to back them up when the time comes. "When Lois is in need and she needs something from him and tells him that it's a personal thing—it's not just work—he gives her exactly what she needs," says Snyder.

His interactions with Clark, however, while still in a parental mold, usually involve a less gentle hand. "Chris Terrio has done such a great job of continuing what we've established with Perry White, but just turning him up a notch," says co-producer Curt Kanemoto. "It's really, really fun to see how he takes these gentle and not so gentle stabs at Clark in the film."

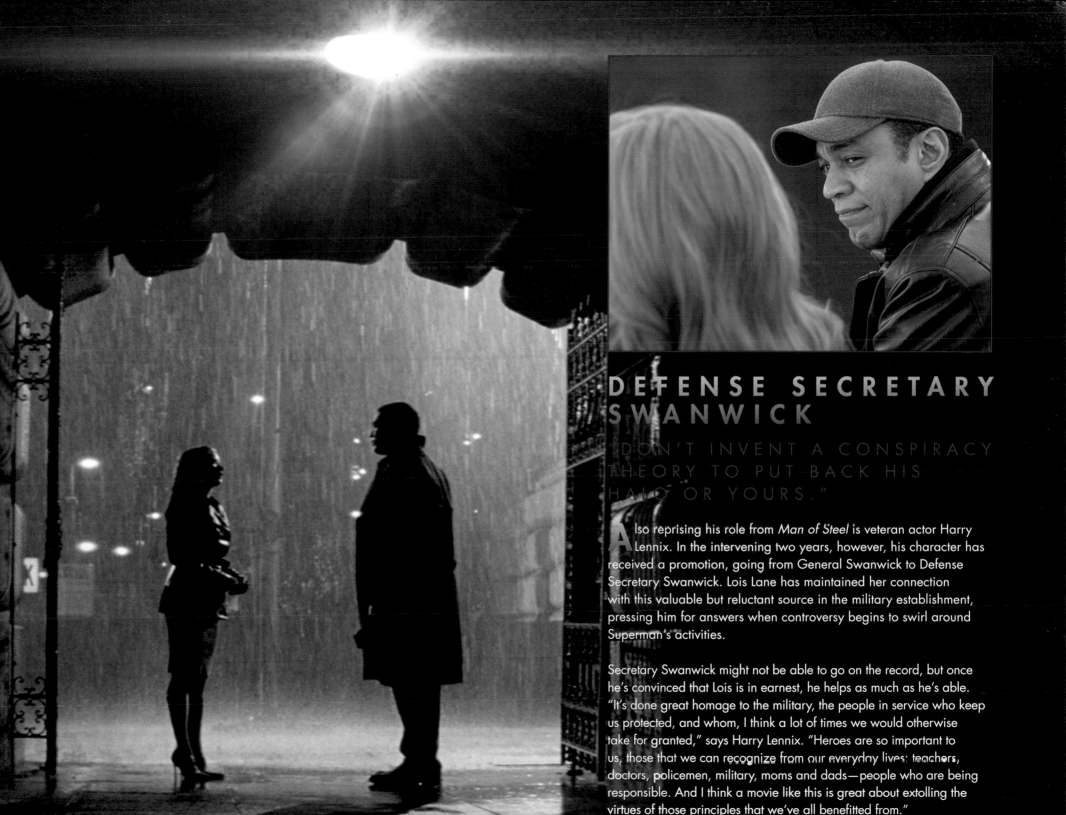

DEFENSE SECRETARY SWANWICK

"DON'T INVENT A CONSPIRACY THEORY TO PUT BACK HIS HALO OR YOURS."

Also reprising his role from *Man of Steel* is veteran actor Harry Lennix. In the intervening two years, however, his character has received a promotion, going from General Swanwick to Defense Secretary Swanwick. Lois Lane has maintained her connection with this valuable but reluctant source in the military establishment, pressing him for answers when controversy begins to swirl around Superman's activities.

Secretary Swanwick might not be able to go on the record, but once he's convinced that Lois is in earnest, he helps as much as he's able. "It's done great homage to the military, the people in service who keep us protected, and whom, I think a lot of times we would otherwise take for granted," says Harry Lennix. "Heroes are so important to us, those that we can recognize from our everyday lives: teachers, doctors, policemen, military, moms and dads—people who are being responsible. And I think a movie like this is great about extolling the virtues of those principles that we've all benefitted from."

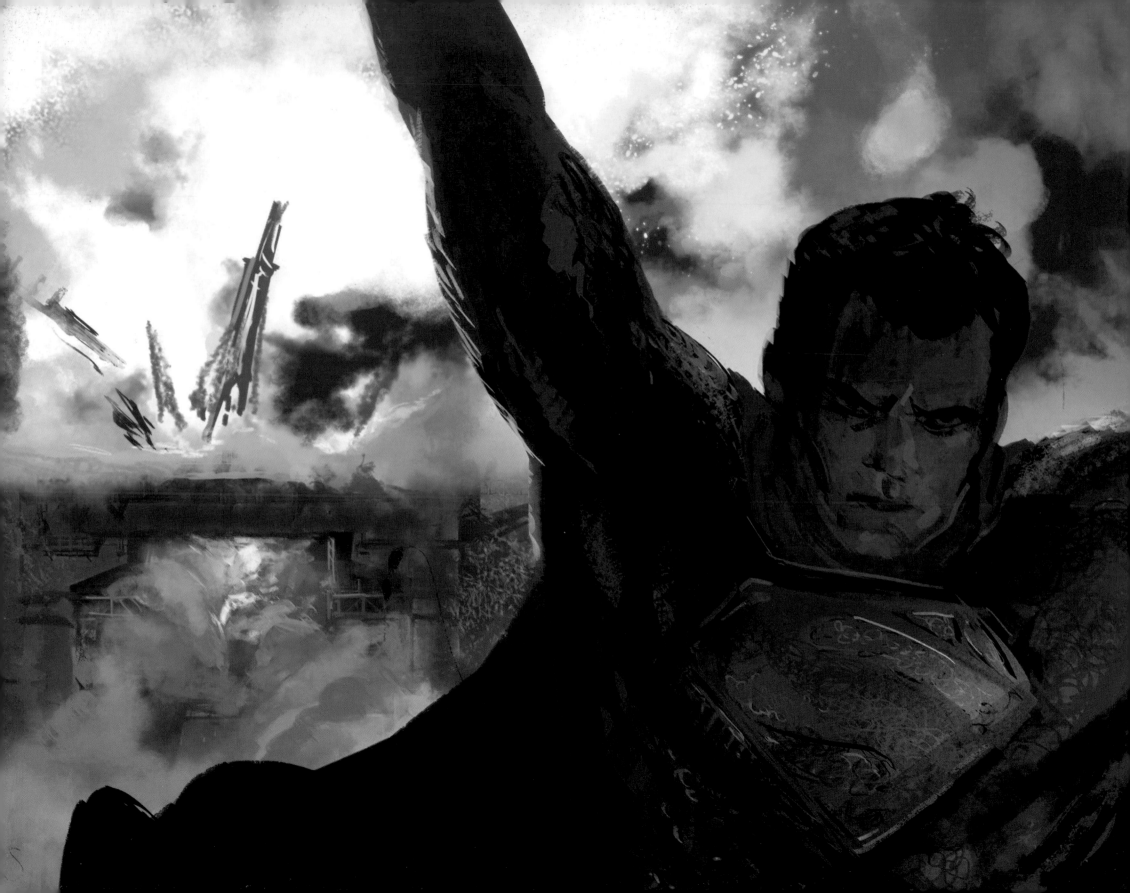

"WE'RE SEEING WHAT IT MEANS TO BE SUPERMAN, WHAT IT MEANS TO HAVE THESE POWERS. WHEN DO YOU INTERVENE? WHEN DO YOU NOT INTERVENE? EVEN WHEN SUPERMAN MEANS TO DO GOOD, THERE ARE CONSEQUENCES HE DIDN'T EXPECT."

DEBORAH SNYDER

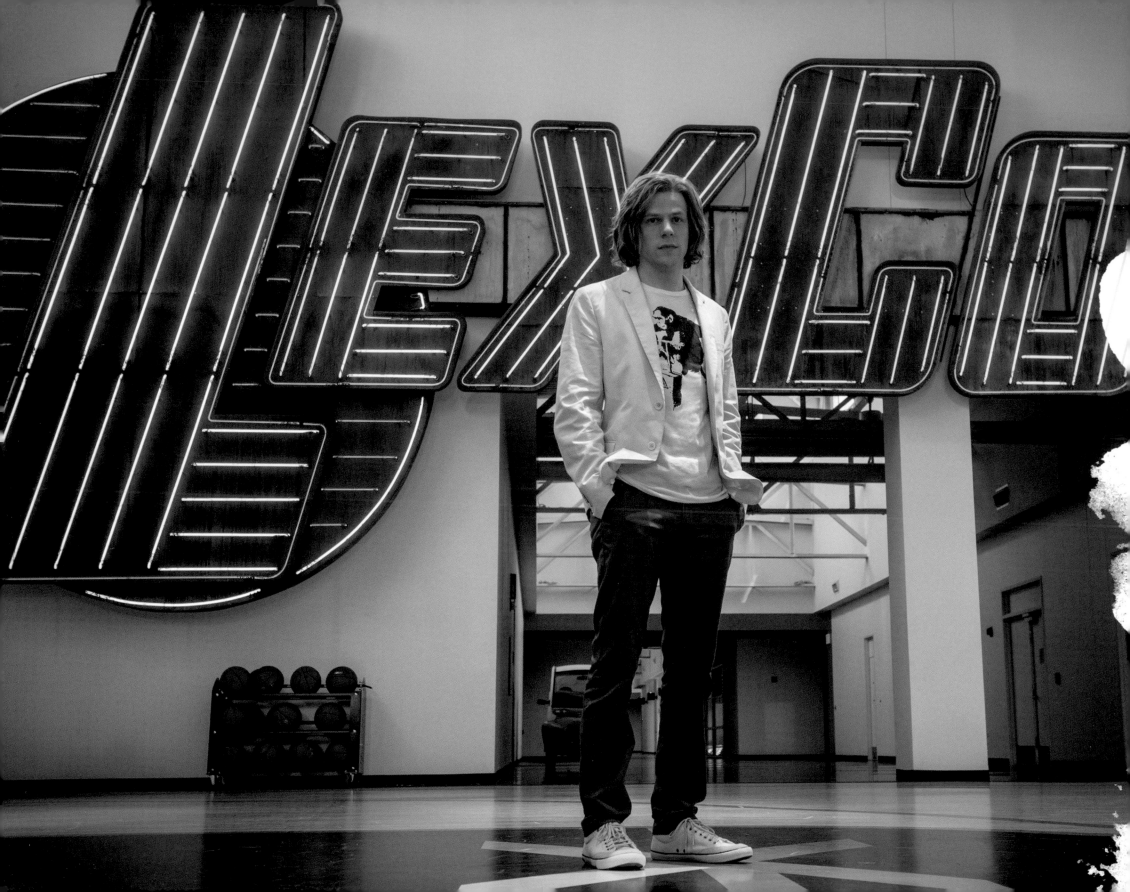

LEX LUTHOR

"YOU DON'T HAVE TO USE A SILVER BULLET—BUT IF YOU FORGE ONE . . . WE DON'T HAVE TO DEPEND ON THE KINDNESS OF THE MONSTERS."

OUTSIDE RETURNS
PAINTED

4"

8"

2"

1 1/2"

INSIDE
PAINTED

CABINET
PAINTED

4"

8"

2"

1 1/2"

CABINET FACE
PAINTED

RACEWAY
COLOR PAINTED

TO MATCH
WALL

1 1/2"

1 1/2"

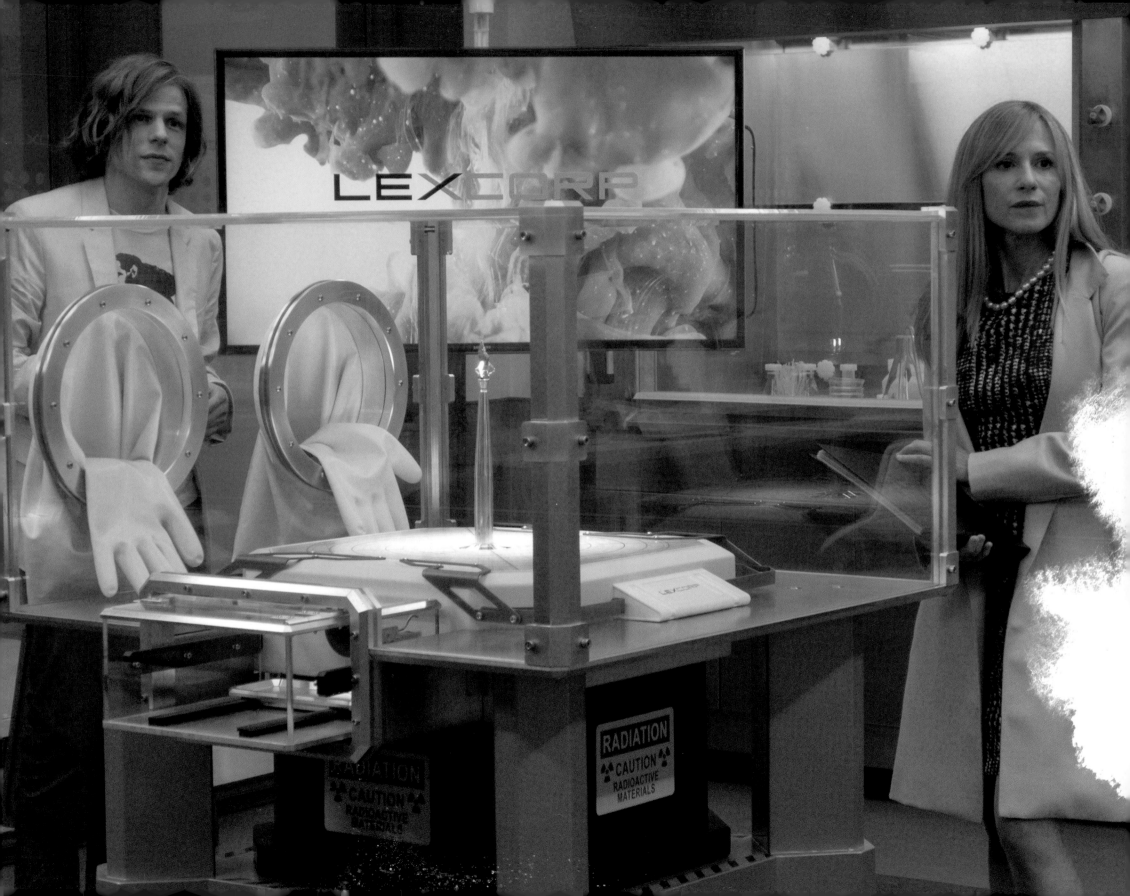

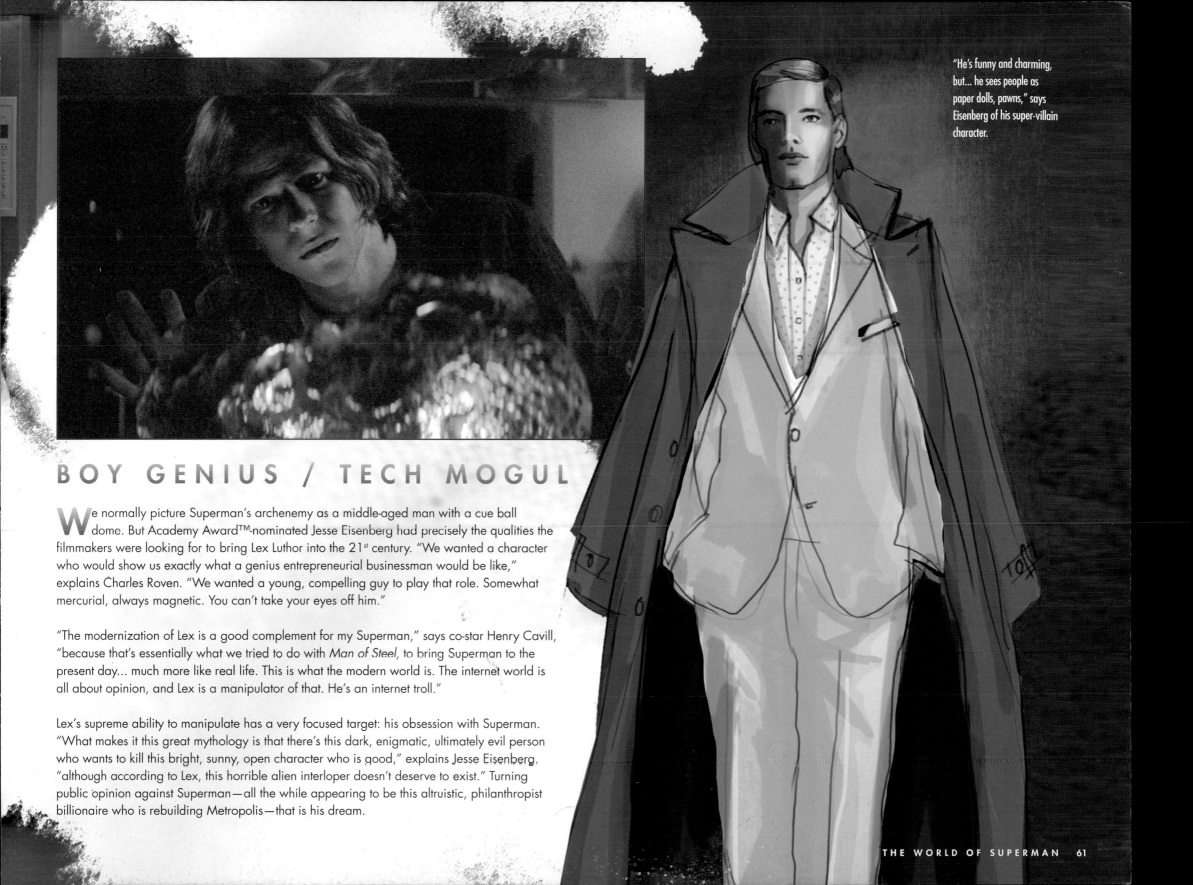

"He's funny and charming, but... he sees people as paper dolls, pawns," says Eisenberg of his super-villain character.

BOY GENIUS / TECH MOGUL

We normally picture Superman's archenemy as a middle-aged man with a cue ball dome. But Academy Award™-nominated Jesse Eisenberg had precisely the qualities the filmmakers were looking for to bring Lex Luthor into the 21st century. "We wanted a character who would show us exactly what a genius entrepreneurial businessman would be like," explains Charles Roven. "We wanted a young, compelling guy to play that role. Somewhat mercurial, always magnetic. You can't take your eyes off him."

"The modernization of Lex is a good complement for my Superman," says co-star Henry Cavill, "because that's essentially what we tried to do with *Man of Steel*, to bring Superman to the present day... much more like real life. This is what the modern world is. The internet world is all about opinion, and Lex is a manipulator of that. He's an internet troll."

Lex's supreme ability to manipulate has a very focused target: his obsession with Superman. "What makes it this great mythology is that there's this dark, enigmatic, ultimately evil person who wants to kill this bright, sunny, open character who is good," explains Jesse Eisenberg, "although according to Lex, this horrible alien interloper doesn't deserve to exist." Turning public opinion against Superman—all the while appearing to be this altruistic, philanthropist billionaire who is rebuilding Metropolis—that is his dream.

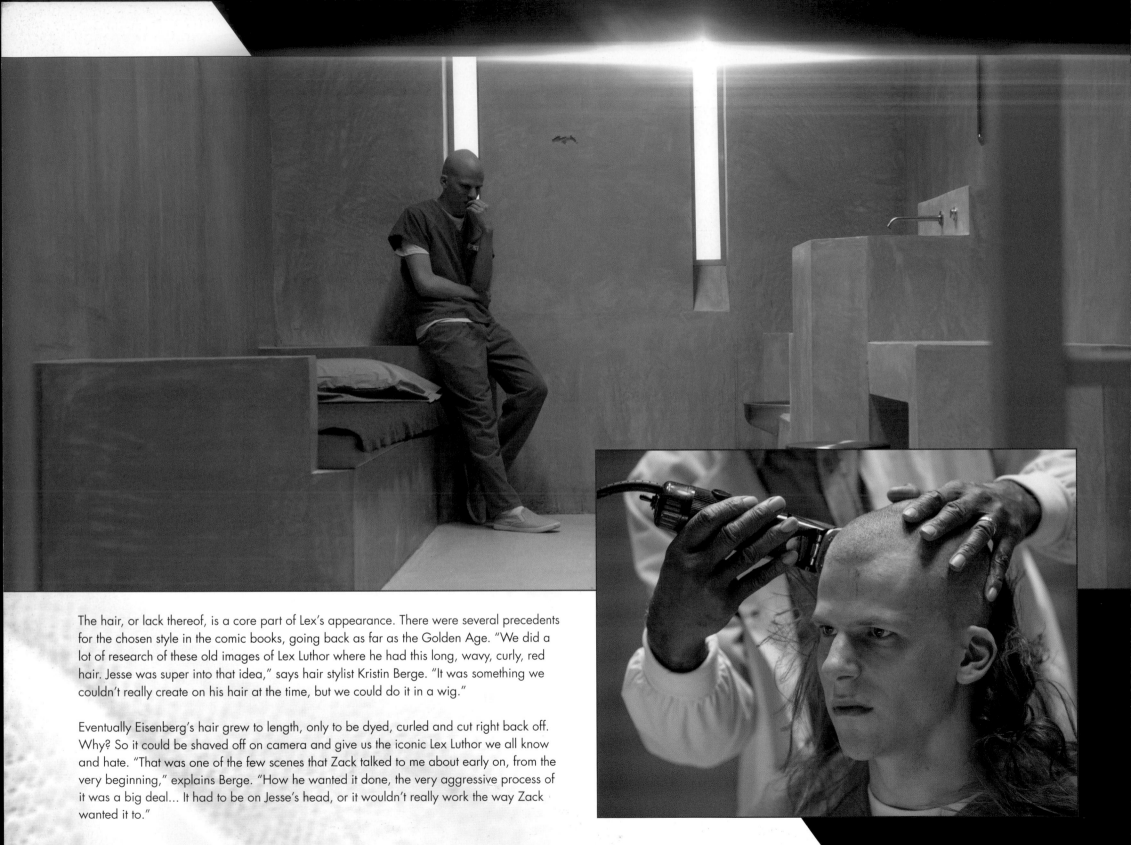

The hair, or lack thereof, is a core part of Lex's appearance. There were several precedents for the chosen style in the comic books, going back as far as the Golden Age. "We did a lot of research of these old images of Lex Luthor where he had this long, wavy, curly, red hair. Jesse was super into that idea," says hair stylist Kristin Berge. "It was something we couldn't really create on his hair at the time, but we could do it in a wig."

Eventually Eisenberg's hair grew to length, only to be dyed, curled and cut right back off. Why? So it could be shaved off on camera and give us the iconic Lex Luthor we all know and hate. "That was one of the few scenes that Zack talked to me about early on, from the very beginning," explains Berge. "How he wanted it done, the very aggressive process of it was a big deal... It had to be on Jesse's head, or it wouldn't really work the way Zack wanted it to."

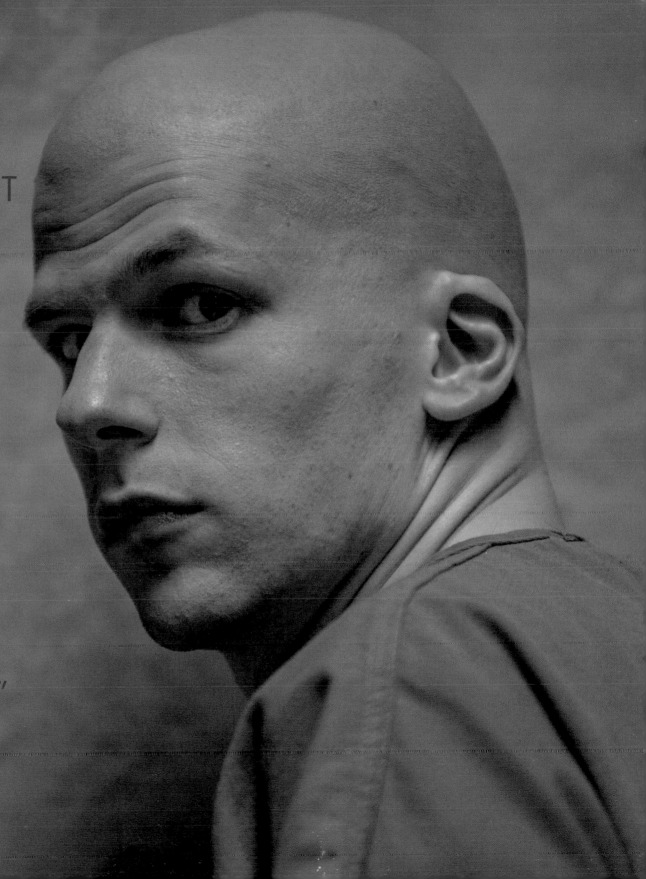

"LEX THINKS THAT
SUPERMAN IS
AN EXISTENTIAL
PARADOX:
HE CANNOT
BE ALL GOOD,
BECAUSE HE'S
SO POWERFUL,
AND ALSO HE
CANNOT BE ALL
POWERFUL IF
HE'S ALL GOOD."

JESSE EISENBERG

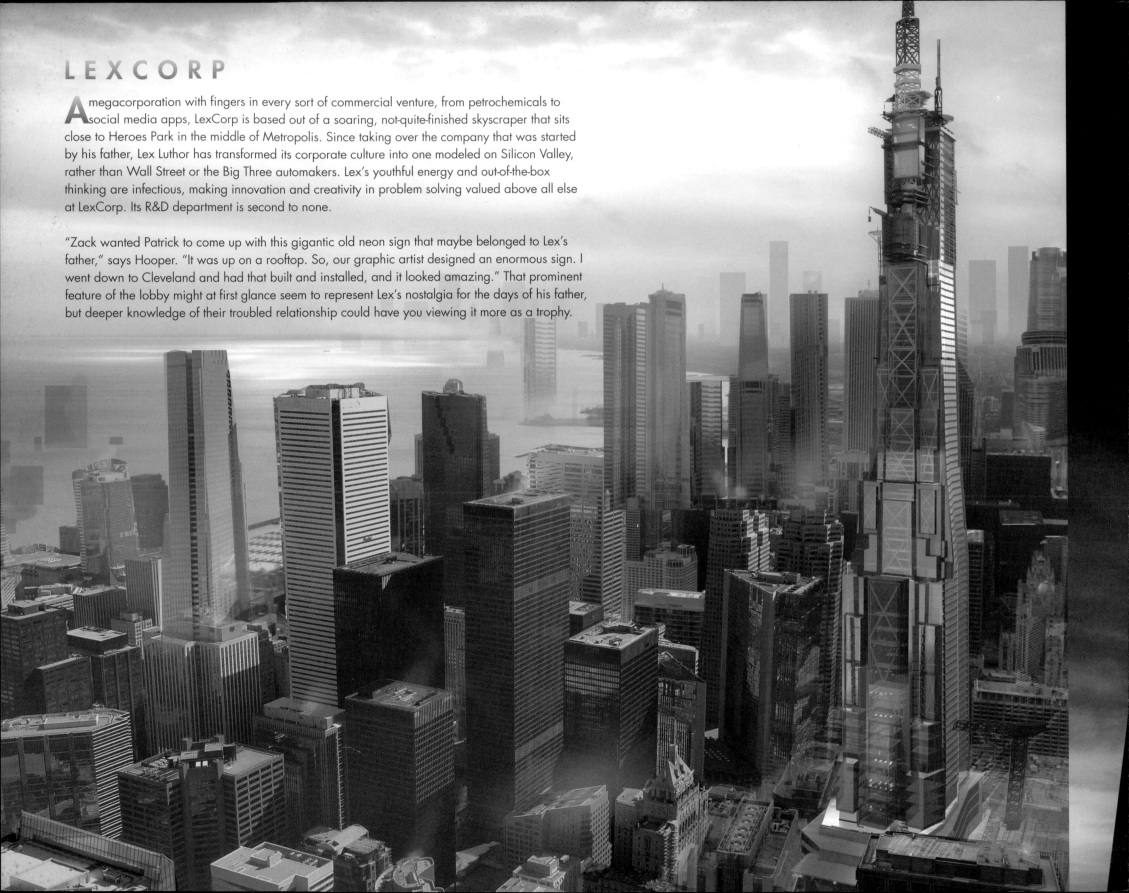

LEXCORP

A megacorporation with fingers in every sort of commercial venture, from petrochemicals to social media apps, LexCorp is based out of a soaring, not-quite-finished skyscraper that sits close to Heroes Park in the middle of Metropolis. Since taking over the company that was started by his father, Lex Luthor has transformed its corporate culture into one modeled on Silicon Valley, rather than Wall Street or the Big Three automakers. Lex's youthful energy and out-of-the-box thinking are infectious, making innovation and creativity in problem solving valued above all else at LexCorp. Its R&D department is second to none.

"Zack wanted Patrick to come up with this gigantic old neon sign that maybe belonged to Lex's father," says Hooper. "It was up on a rooftop. So, our graphic artist designed an enormous sign. I went down to Cleveland and had that built and installed, and it looked amazing." That prominent feature of the lobby might at first glance seem to represent Lex's nostalgia for the days of his father, but deeper knowledge of their troubled relationship could have you viewing it more as a trophy.

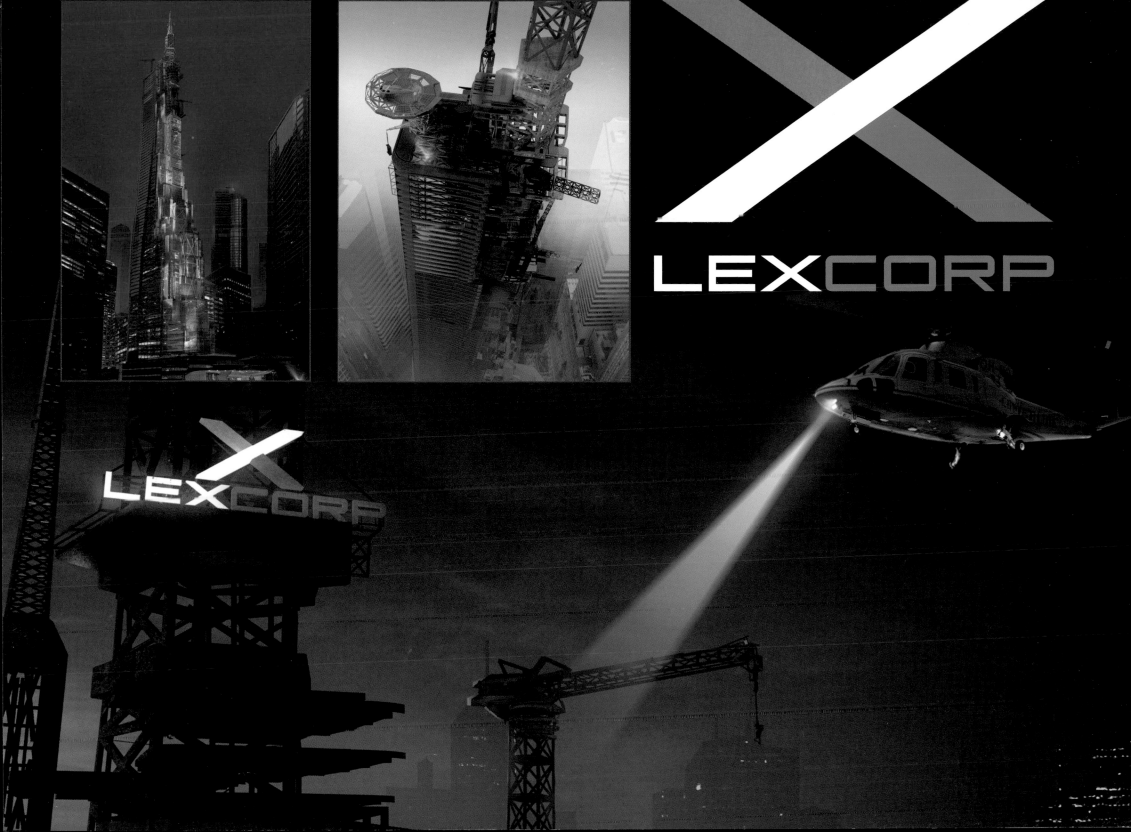

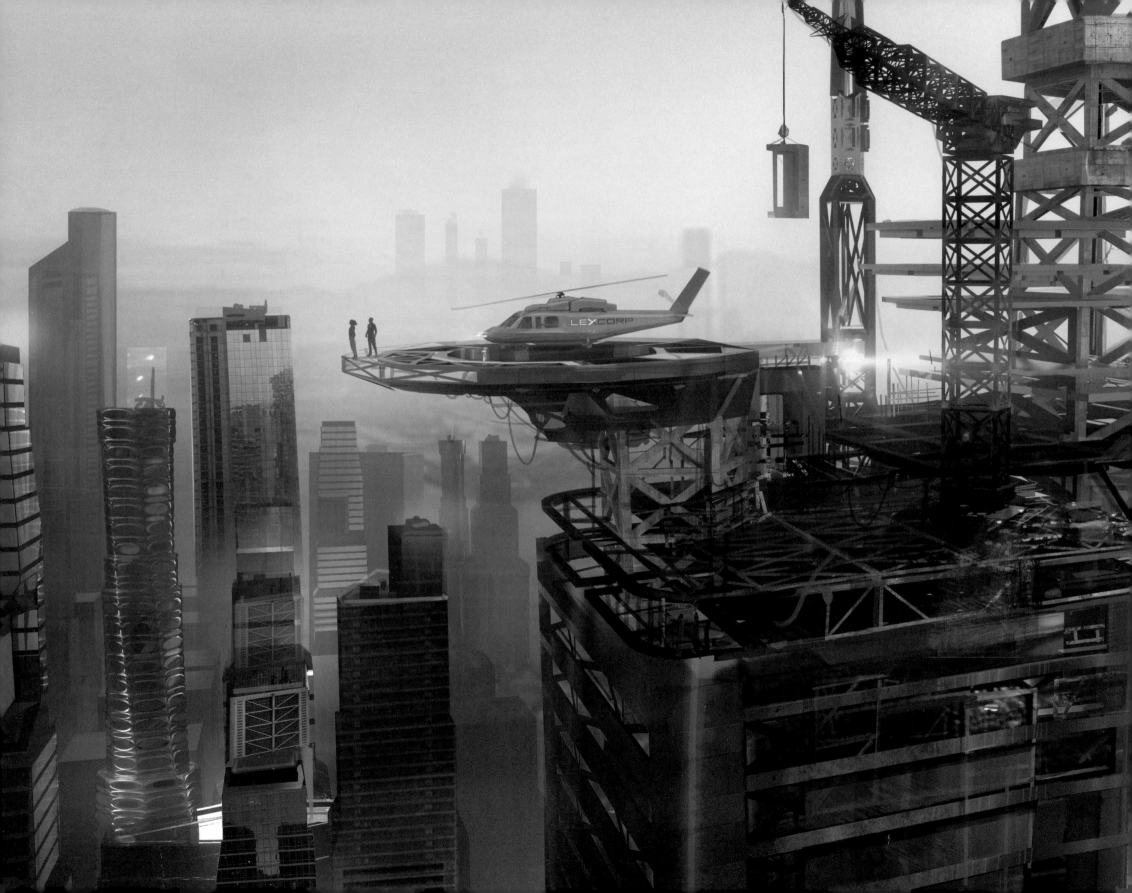

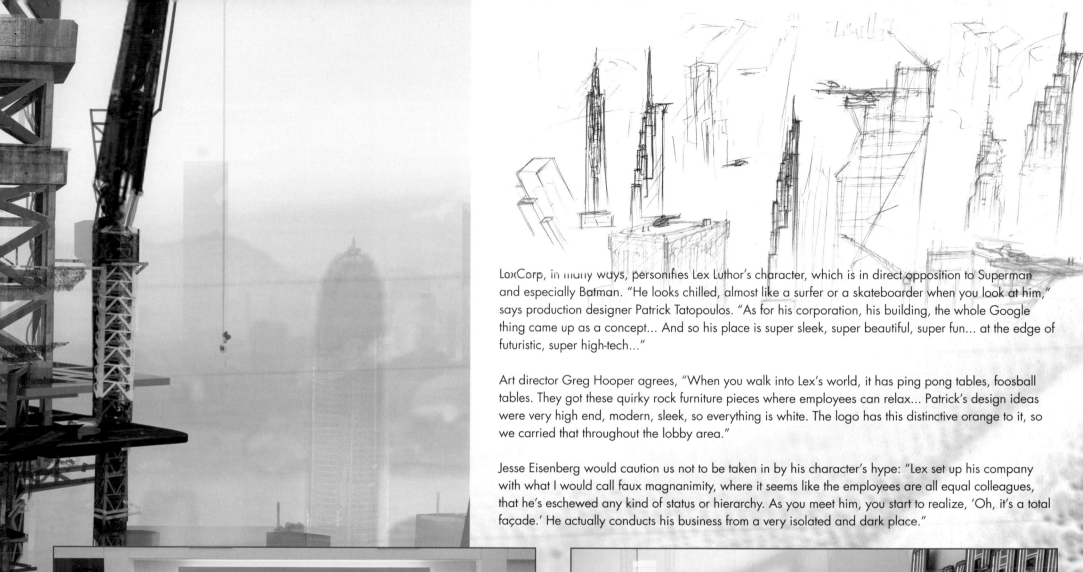

LexCorp, in many ways, personifies Lex Luthor's character, which is in direct opposition to Superman and especially Batman. "He looks chilled, almost like a surfer or a skateboarder when you look at him," says production designer Patrick Tatopoulos. "As for his corporation, his building, the whole Google thing came up as a concept... And so his place is super sleek, super beautiful, super fun... at the edge of futuristic, super high-tech..."

Art director Greg Hooper agrees, "When you walk into Lex's world, it has ping pong tables, foosball tables. They got these quirky rock furniture pieces where employees can relax... Patrick's design ideas were very high end, modern, sleek, so everything is white. The logo has this distinctive orange to it, so we carried that throughout the lobby area."

Jesse Eisenberg would caution us not to be taken in by his character's hype: "Lex set up his company with what I would call faux magnanimity, where it seems like the employees are all equal colleagues, that he's eschewed any kind of status or hierarchy. As you meet him, you start to realize, 'Oh, it's a total façade.' He actually conducts his business from a very isolated and dark place."

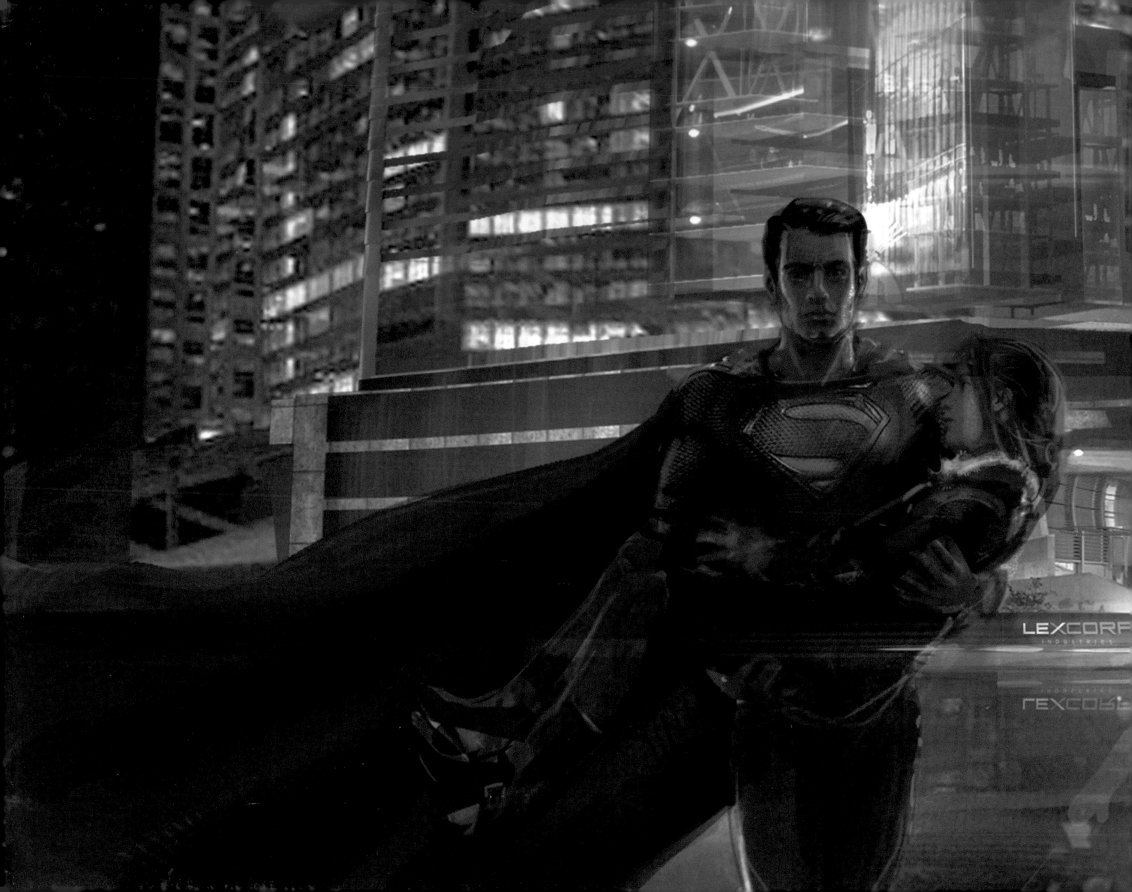

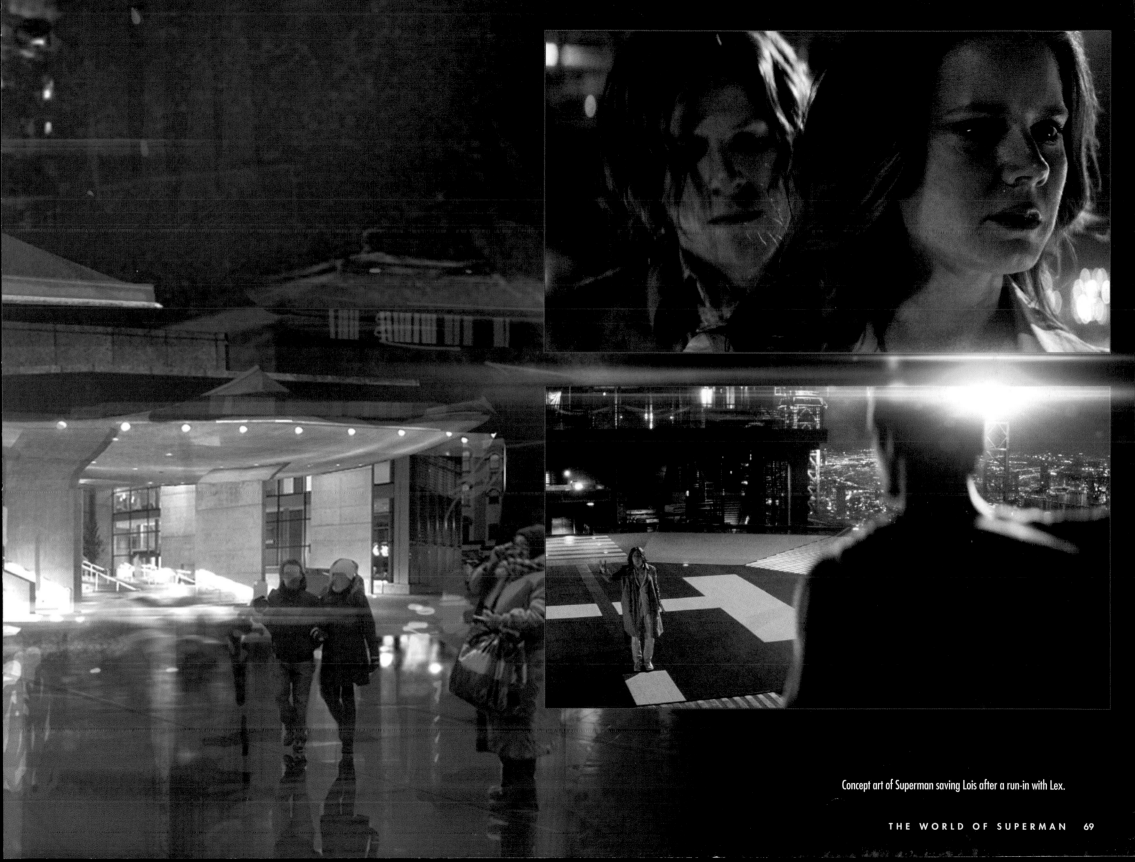

Concept art of Superman saving Lois after a run-in with Lex.

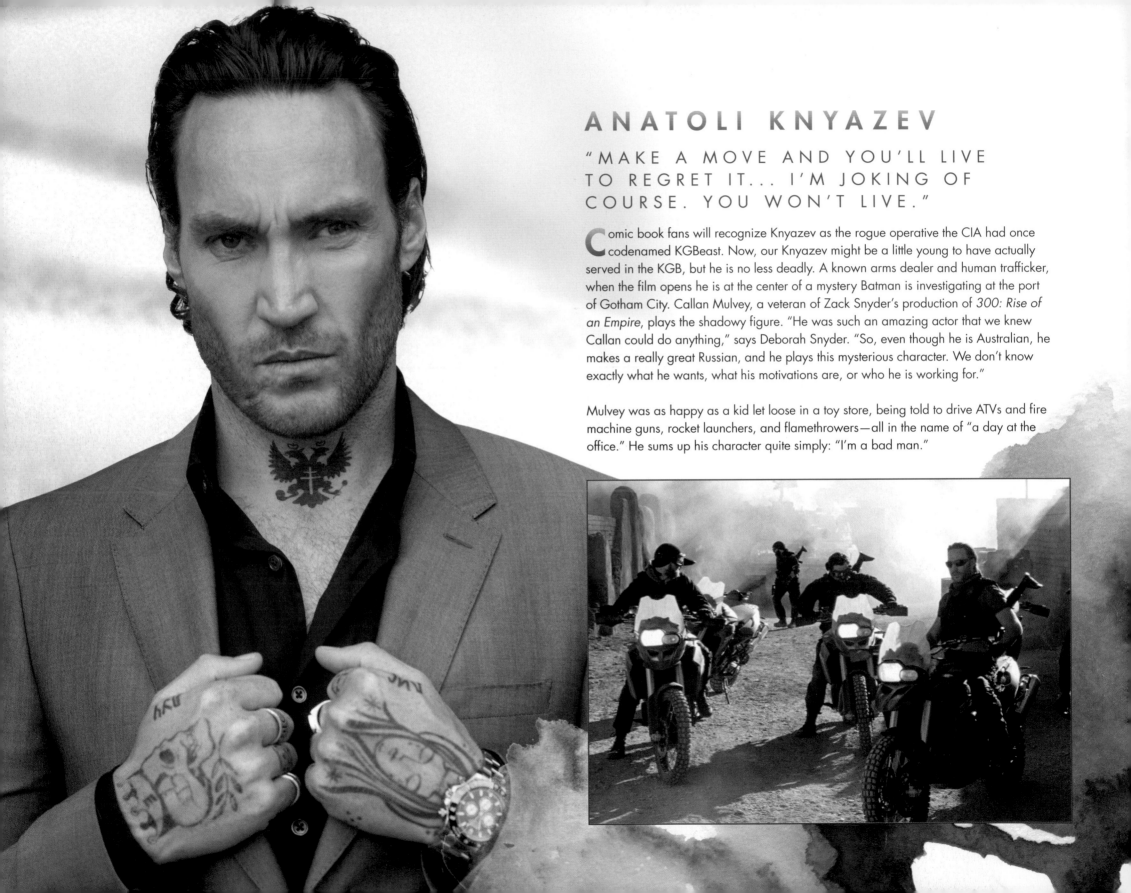

ANATOLI KNYAZEV

"MAKE A MOVE AND YOU'LL LIVE TO REGRET IT... I'M JOKING OF COURSE. YOU WON'T LIVE."

Comic book fans will recognize Knyazev as the rogue operative the CIA had once codenamed KGBeast. Now, our Knyazev might be a little young to have actually served in the KGB, but he is no less deadly. A known arms dealer and human trafficker, when the film opens he is at the center of a mystery Batman is investigating at the port of Gotham City. Callan Mulvey, a veteran of Zack Snyder's production of *300: Rise of an Empire*, plays the shadowy figure. "He was such an amazing actor that we knew Callan could do anything," says Deborah Snyder. "So, even though he is Australian, he makes a really great Russian, and he plays this mysterious character. We don't know exactly what he wants, what his motivations are, or who he is working for."

Mulvey was as happy as a kid let loose in a toy store, being told to drive ATVs and fire machine guns, rocket launchers, and flamethrowers—all in the name of "a day at the office." He sums up his character quite simply: "I'm a bad man."

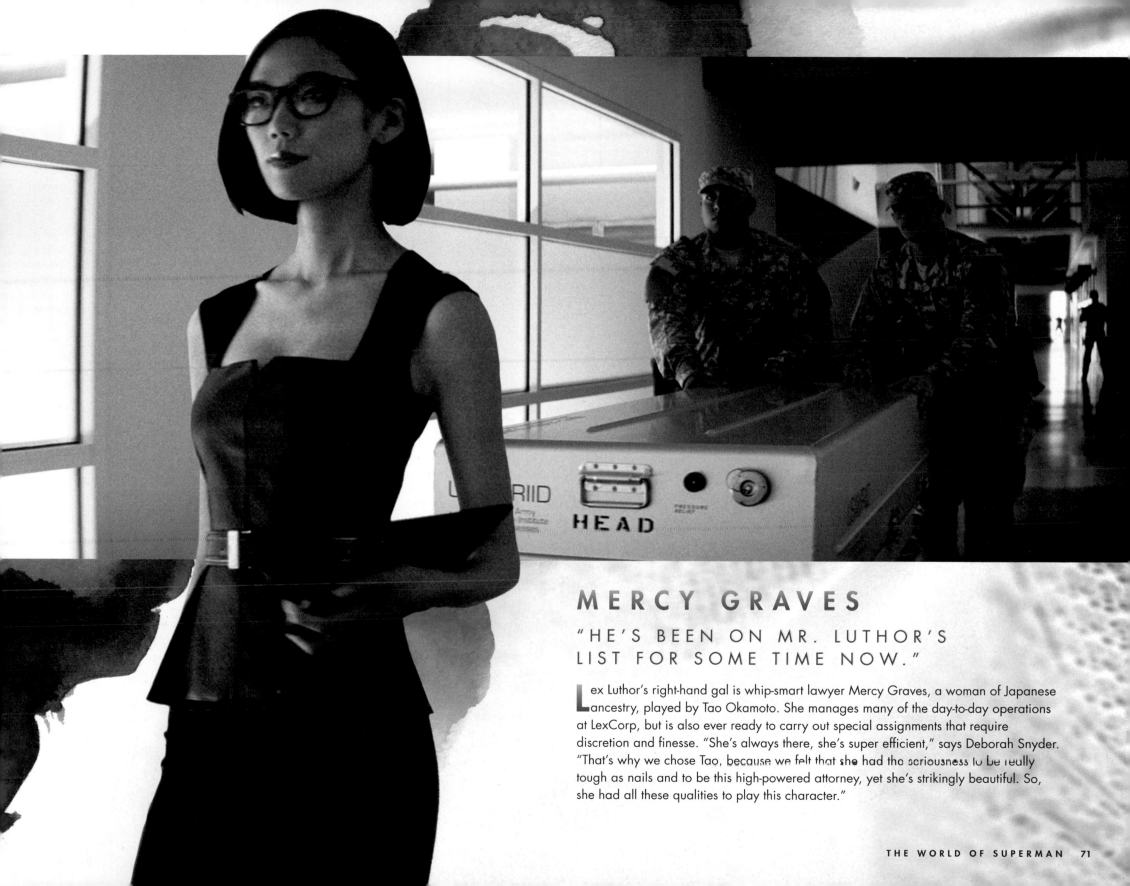

MERCY GRAVES

"HE'S BEEN ON MR. LUTHOR'S LIST FOR SOME TIME NOW."

Lex Luthor's right-hand gal is whip-smart lawyer Mercy Graves, a woman of Japanese ancestry, played by Tao Okamoto. She manages many of the day-to-day operations at LexCorp, but is also ever ready to carry out special assignments that require discretion and finesse. "She's always there, she's super efficient," says Deborah Snyder. "That's why we chose Tao, because we felt that she had the seriousness to be really tough as nails and to be this high-powered attorney, yet she's strikingly beautiful. So, she had all these qualities to play this character."

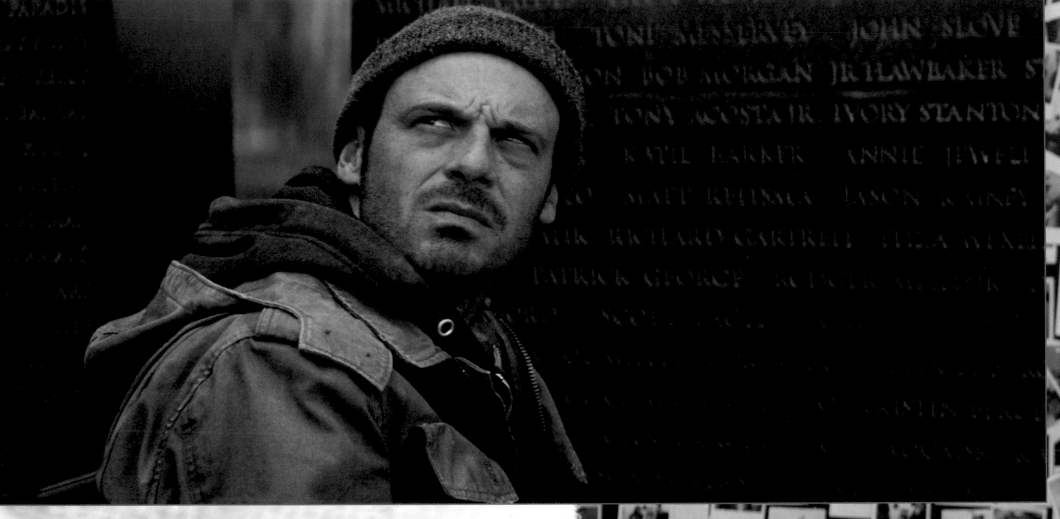

WALLACE KEEFE

"I WORKED FOR BRUCE WAYNE! I WAS A **PERSON**!"

While he was security guard at Wayne Financial in Metropolis, Wallace Keefe became a double amputee after being gravely injured during the Black Zero Event. The incident left him a broken man with little to live for, except for one thing. "He's built up all this hatred and aggression towards Superman," says actor Scoot McNairy. "He's got newspaper clippings all over his wall... He just wants to take [Superman] down, because he's lost his legs and he's lost his family and he's lost his job, and his life sucks. He blames Superman for it." It's a fixation that eventually leads to Keefe testifying at a fateful hearing before a committee of the U.S. Senate.

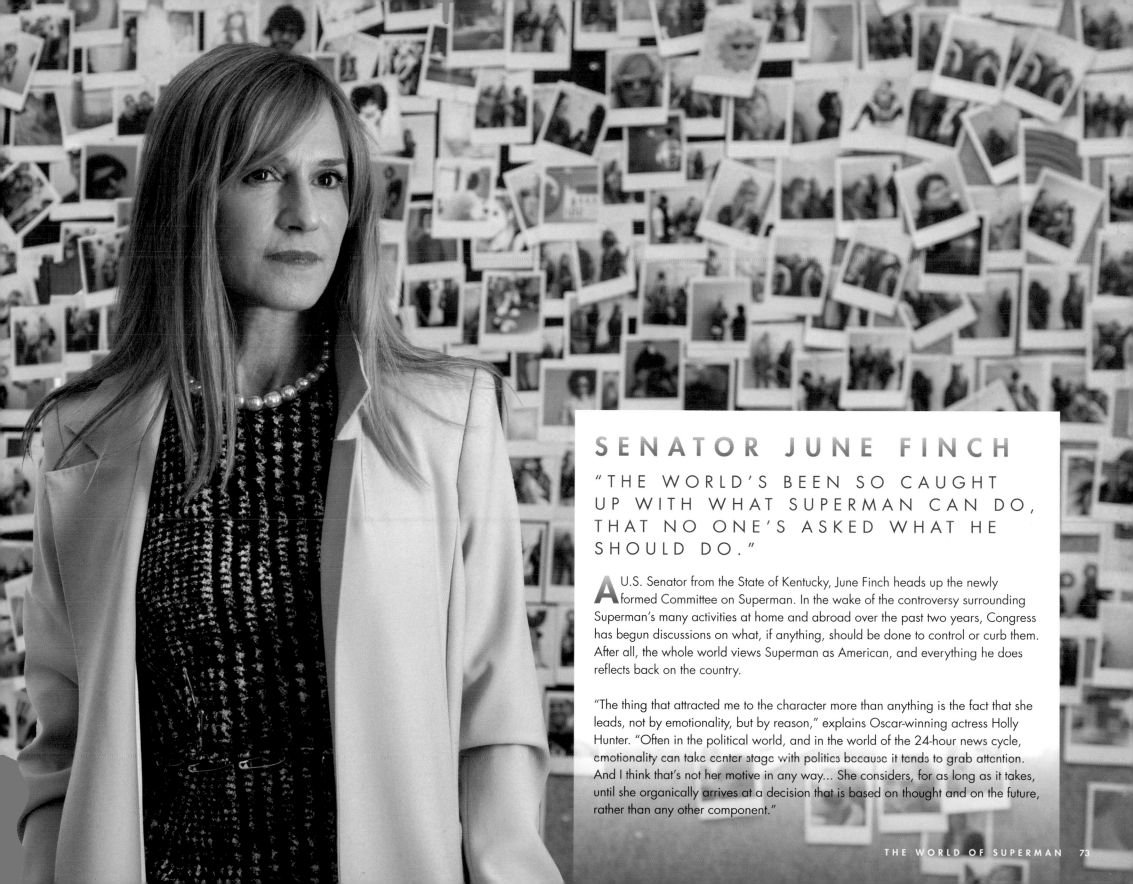

SENATOR JUNE FINCH

"THE WORLD'S BEEN SO CAUGHT UP WITH WHAT SUPERMAN CAN DO, THAT NO ONE'S ASKED WHAT HE SHOULD DO."

A U.S. Senator from the State of Kentucky, June Finch heads up the newly formed Committee on Superman. In the wake of the controversy surrounding Superman's many activities at home and abroad over the past two years, Congress has begun discussions on what, if anything, should be done to control or curb them. After all, the whole world views Superman as American, and everything he does reflects back on the country.

"The thing that attracted me to the character more than anything is the fact that she leads, not by emotionality, but by reason," explains Oscar-winning actress Holly Hunter. "Often in the political world, and in the world of the 24-hour news cycle, emotionality can take center stage with politics because it tends to grab attention. And I think that's not her motive in any way... She considers, for as long as it takes, until she organically arrives at a decision that is based on thought and on the future, rather than any other component."

THE SCOUT SHIP AND CONTAINMENT CENTER

"WHAT I LOVE ABOUT WORKING WITH ZACK IS HIS IMAGINATION IS LIMITLESS. HE REALLY THINKS BIG. HE SEES THE ENTIRE SCOPE OF THE FILM AND HE'S NOT AFRAID TO GO AFTER IT."

AMY ADAMS

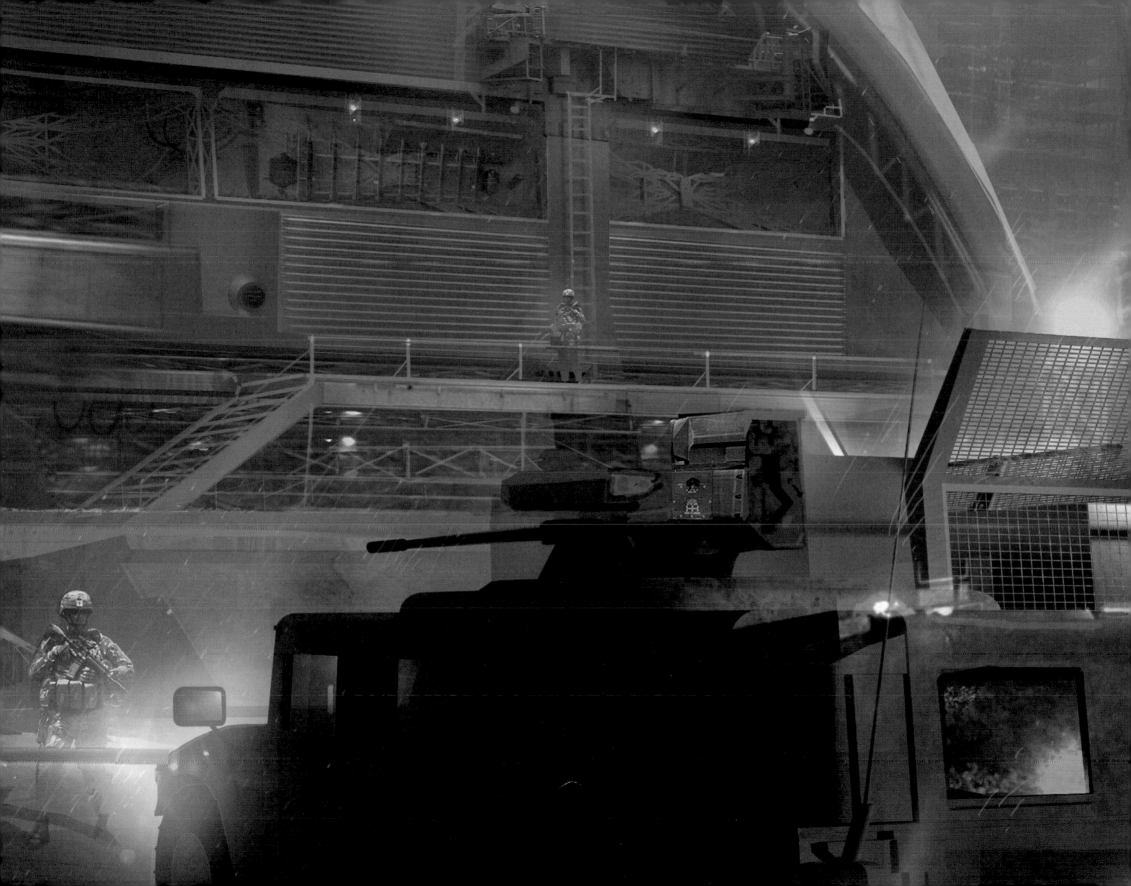

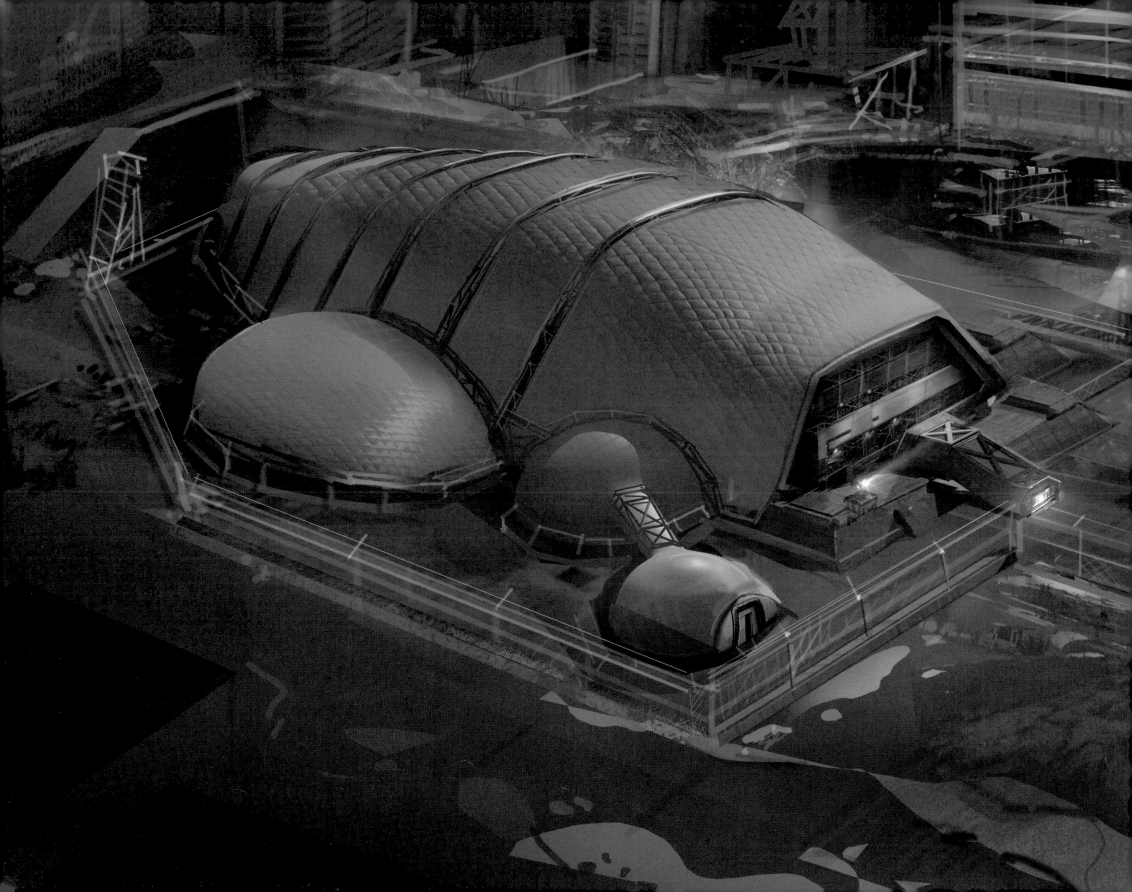

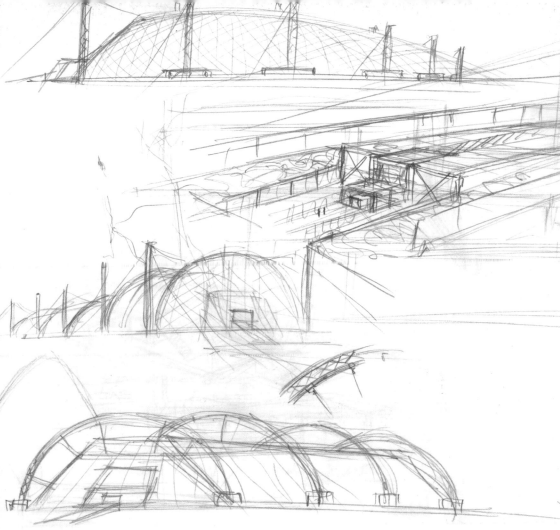

Crashed into downtown Metropolis during the fight between Superman and General Zod, the Kryptonian scout ship had previously rested beneath the Arctic ice for millennia before Kal-El and the avatar of his father, Jor-El, resurrected it (as seen in *Man of Steel*). It now sits at the edge of Heroes' Park in a secure containment facility run by the U.S. military. The ship represents a vast, untapped cache of priceless alien technology that many would love to get their hands on to exploit.

Obviously, the layout of the ship and the unique Kryptonian aesthetic had been established in *Man of Steel*, yet production designer Patrick Tatopoulos found a logical way to put his own stamp on the sets. "Whenever you make a new film that's a sequel, it's always nice to be able to change things a little and make them your own," he says. "Luckily, in the last film it crashes and is damaged on the inside. I thought it would be great if there was some liquid, a fuel of sorts, that as the craft crashed would burn the surface. So, I was able to create a burned look on the corridors—of course, we built them from scratch as none of the original sets were left."

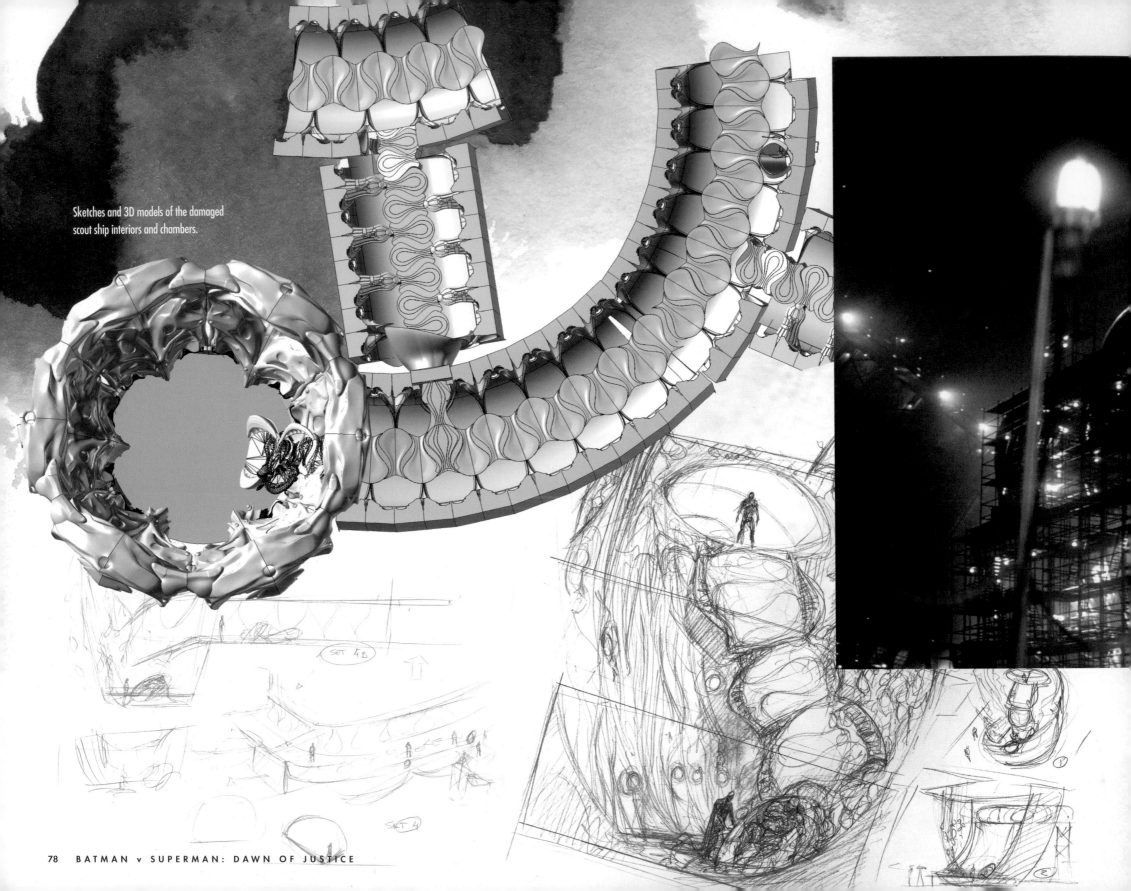

Sketches and 3D models of the damaged scout ship interiors and chambers.

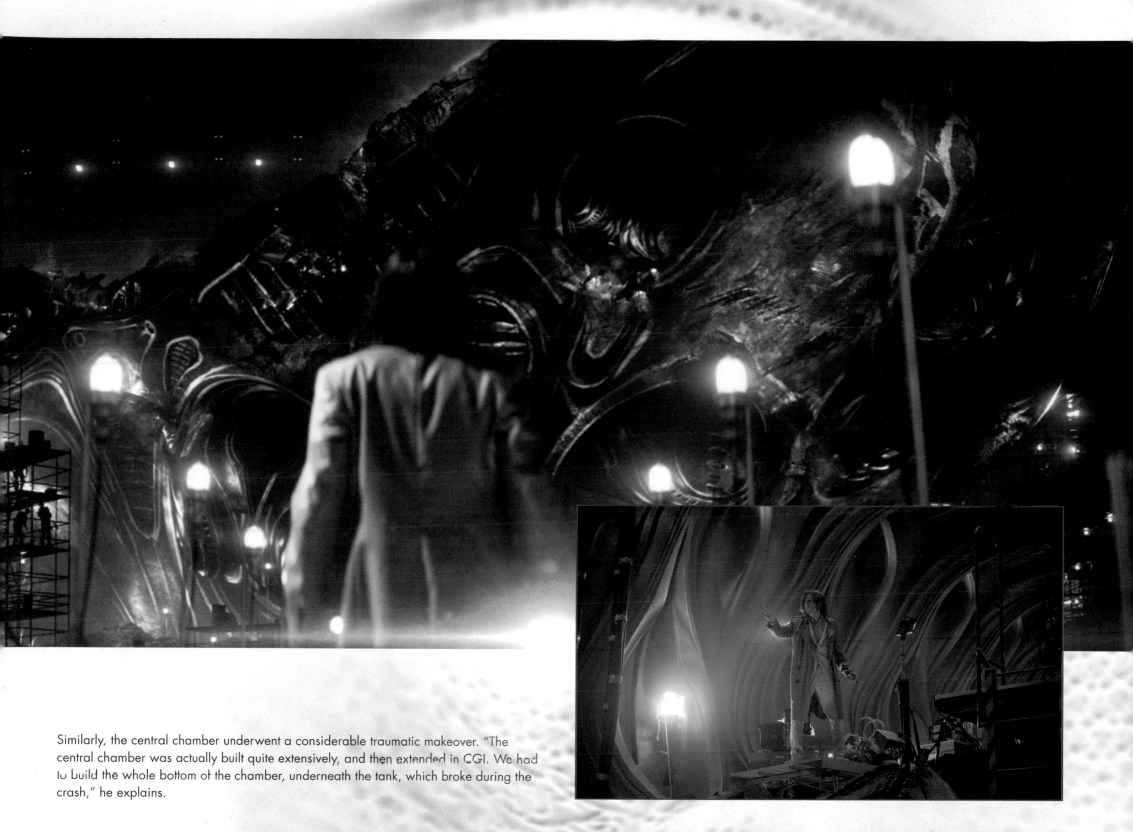

Similarly, the central chamber underwent a considerable traumatic makeover. "The central chamber was actually built quite extensively, and then extended in CGI. We had to build the whole bottom of the chamber, underneath the tank, which broke during the crash," he explains.

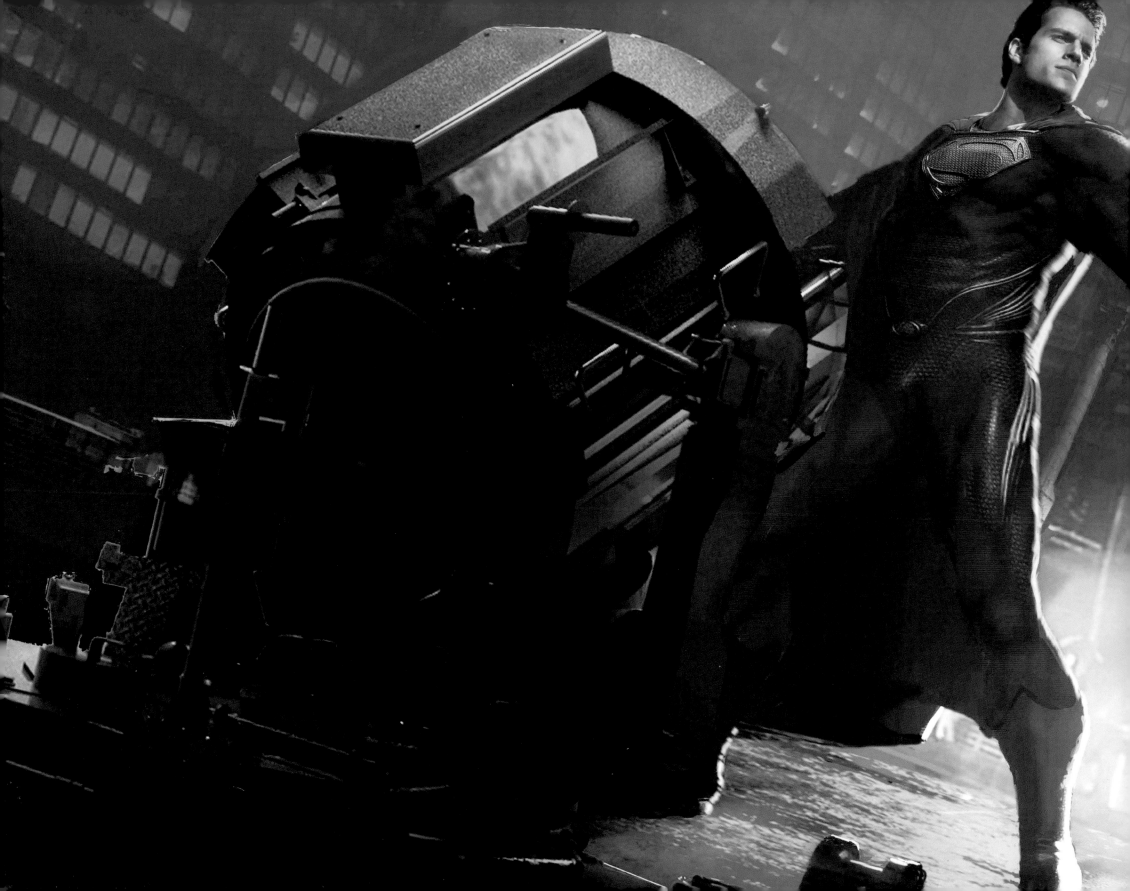

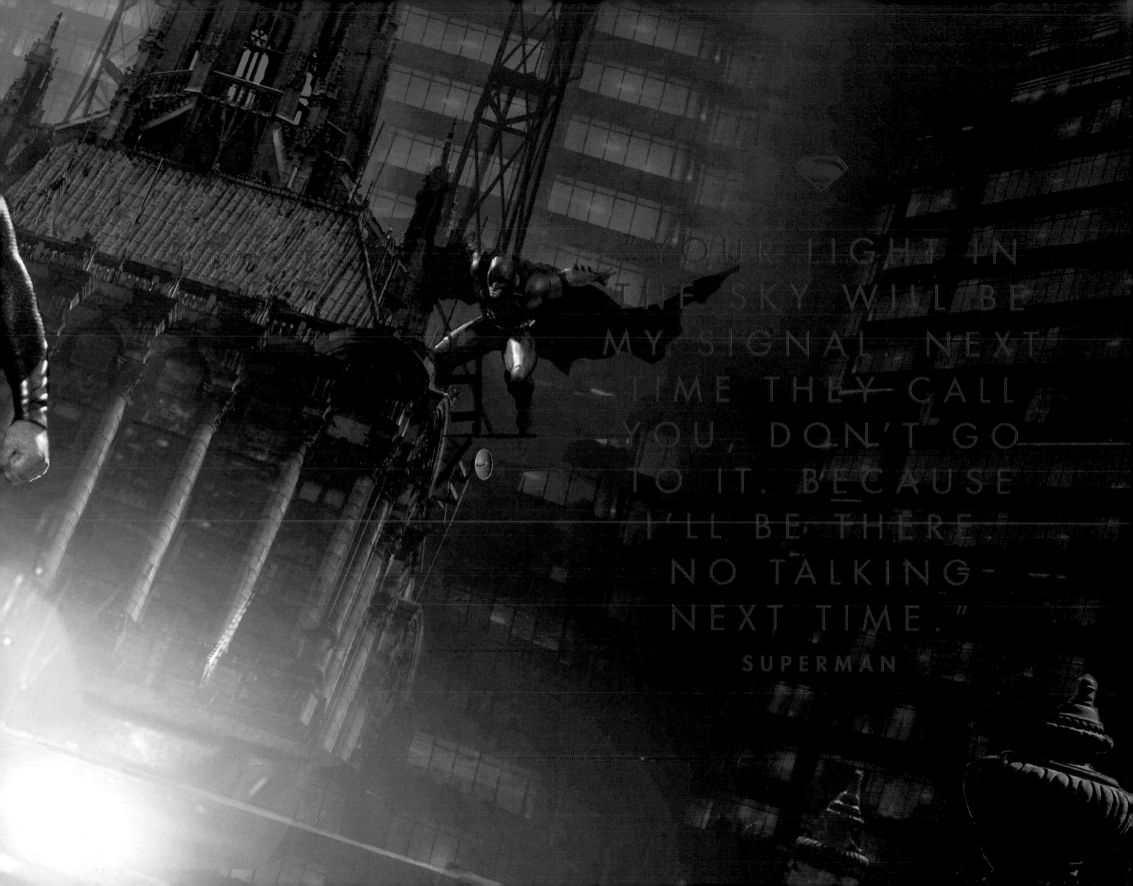

"YOUR LIGHT IN THE SKY WILL BE MY SIGNAL. NEXT TIME THEY CALL YOU, DON'T GO TO IT. BECAUSE I'LL BE THERE. NO TALKING NEXT TIME."

SUPERMAN

THE WORLD OF
BATMAN

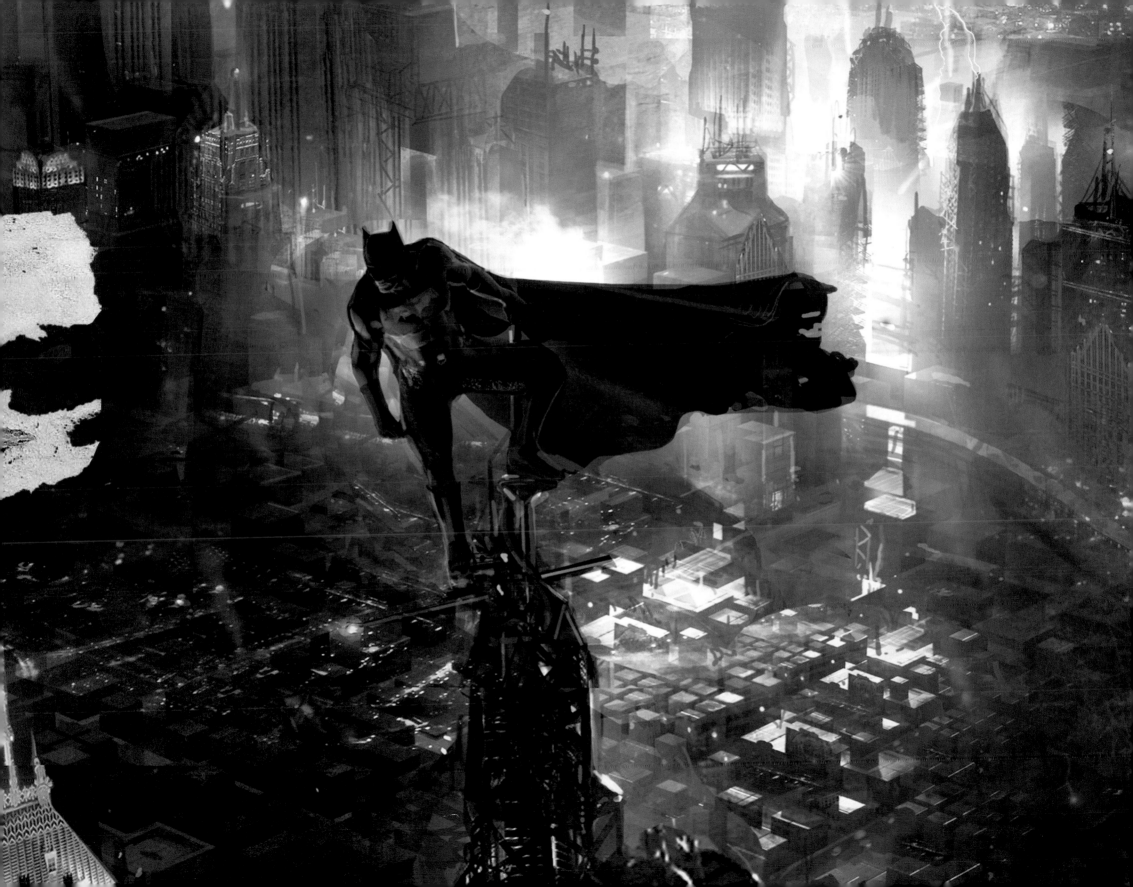

BATMAN

"IF THERE'S A ONE-PERCENT CHANCE HE COULD BECOME AN ENEMY, WE HAVE TO TREAT IT AS A CERTAINTY."

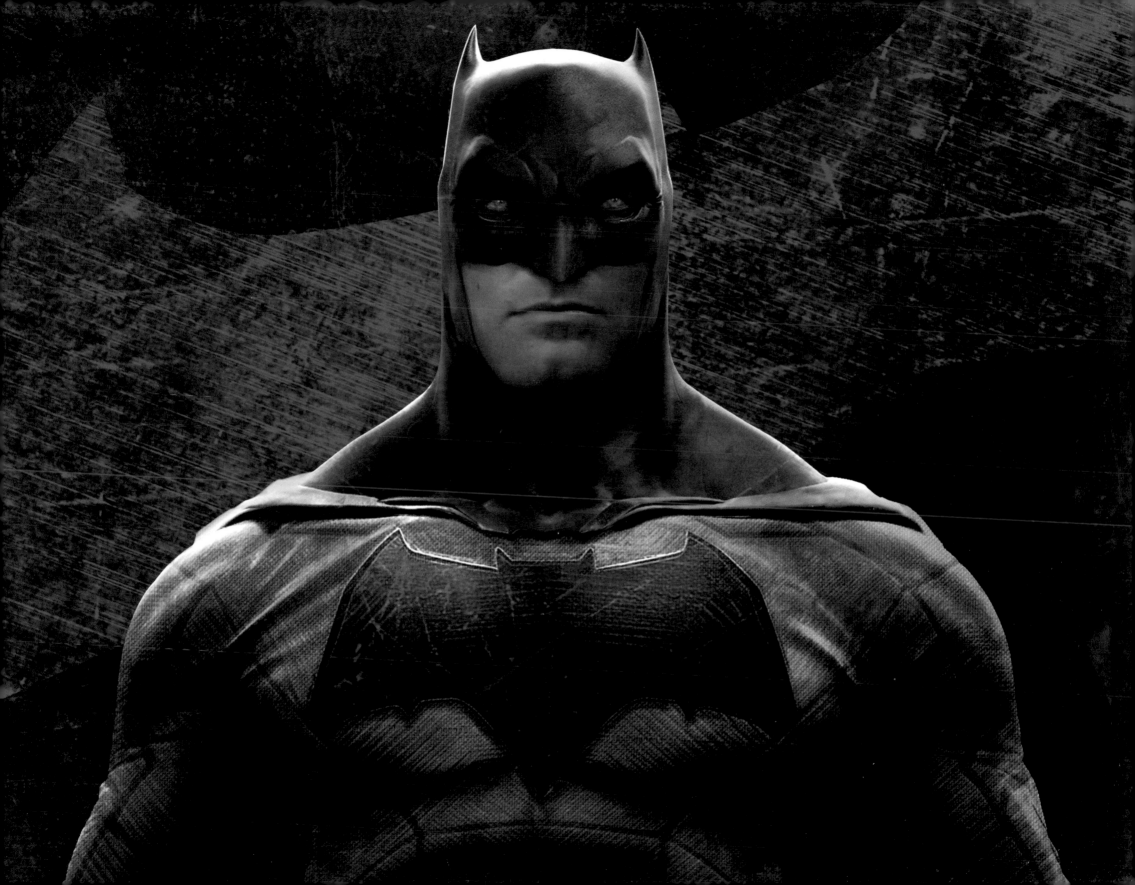

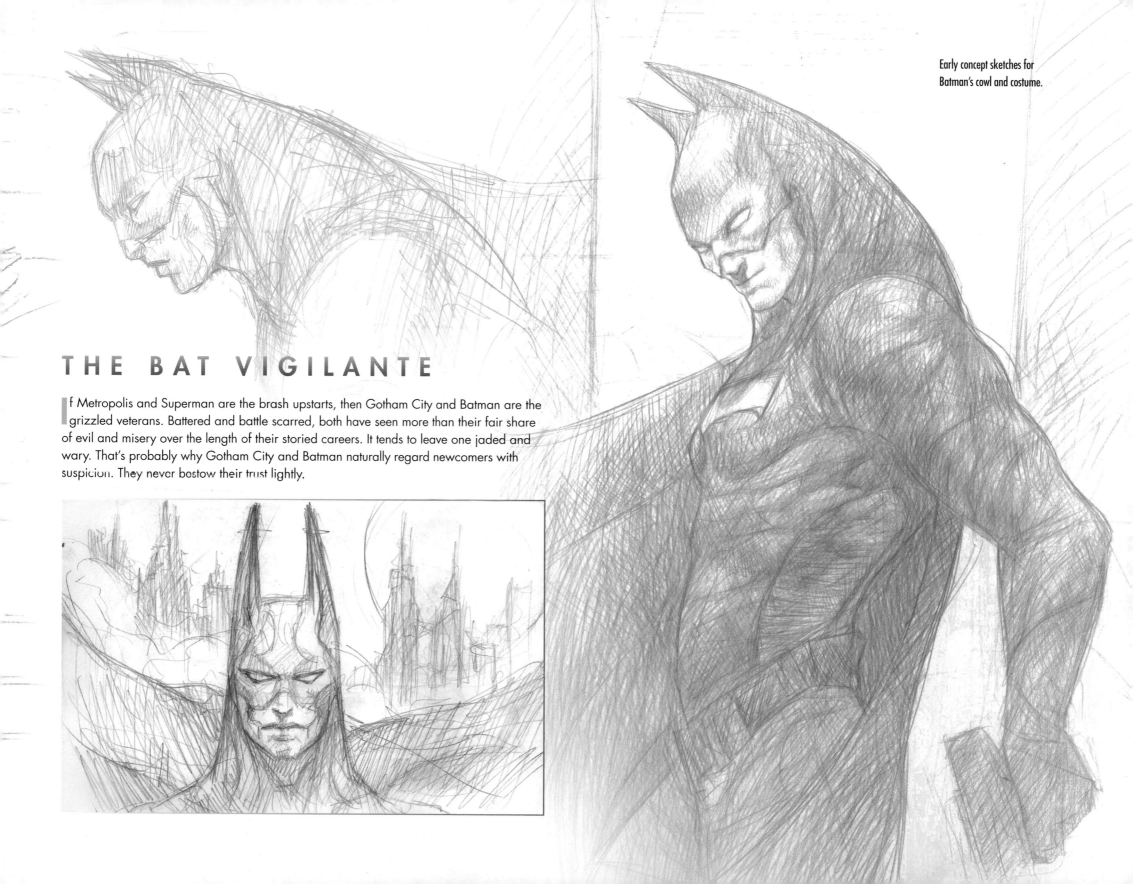

THE BAT VIGILANTE

If Metropolis and Superman are the brash upstarts, then Gotham City and Batman are the grizzled veterans. Battered and battle scarred, both have seen more than their fair share of evil and misery over the length of their storied careers. It tends to leave one jaded and wary. That's probably why Gotham City and Batman naturally regard newcomers with suspicion. They never bestow their trust lightly.

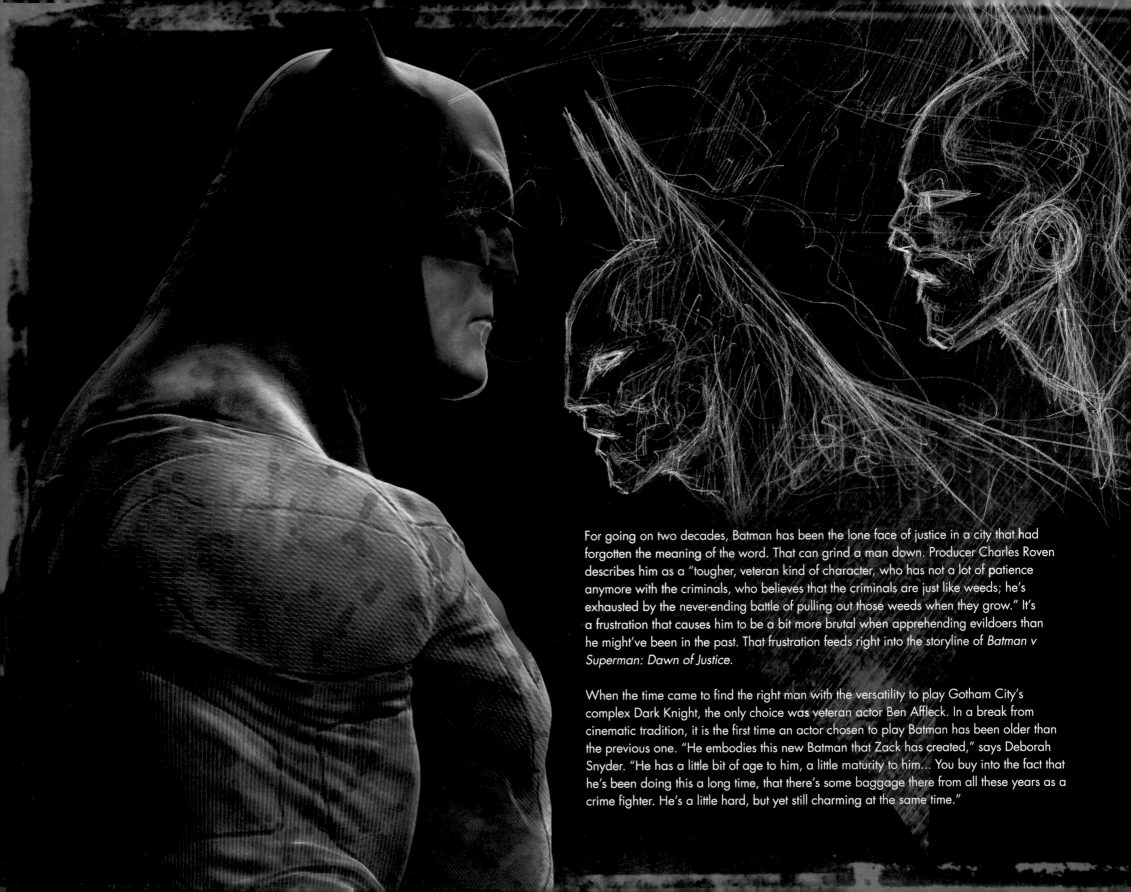

For going on two decades, Batman has been the lone face of justice in a city that had forgotten the meaning of the word. That can grind a man down. Producer Charles Roven describes him as a "tougher, veteran kind of character, who has not a lot of patience anymore with the criminals, who believes that the criminals are just like weeds; he's exhausted by the never-ending battle of pulling out those weeds when they grow." It's a frustration that causes him to be a bit more brutal when apprehending evildoers than he might've been in the past. That frustration feeds right into the storyline of *Batman v Superman: Dawn of Justice*.

When the time came to find the right man with the versatility to play Gotham City's complex Dark Knight, the only choice was veteran actor Ben Affleck. In a break from cinematic tradition, it is the first time an actor chosen to play Batman has been older than the previous one. "He embodies this new Batman that Zack has created," says Deborah Snyder. "He has a little bit of age to him, a little maturity to him... You buy into the fact that he's been doing this a long time, that there's some baggage there from all these years as a crime fighter. He's a little hard, but yet still charming at the same time."

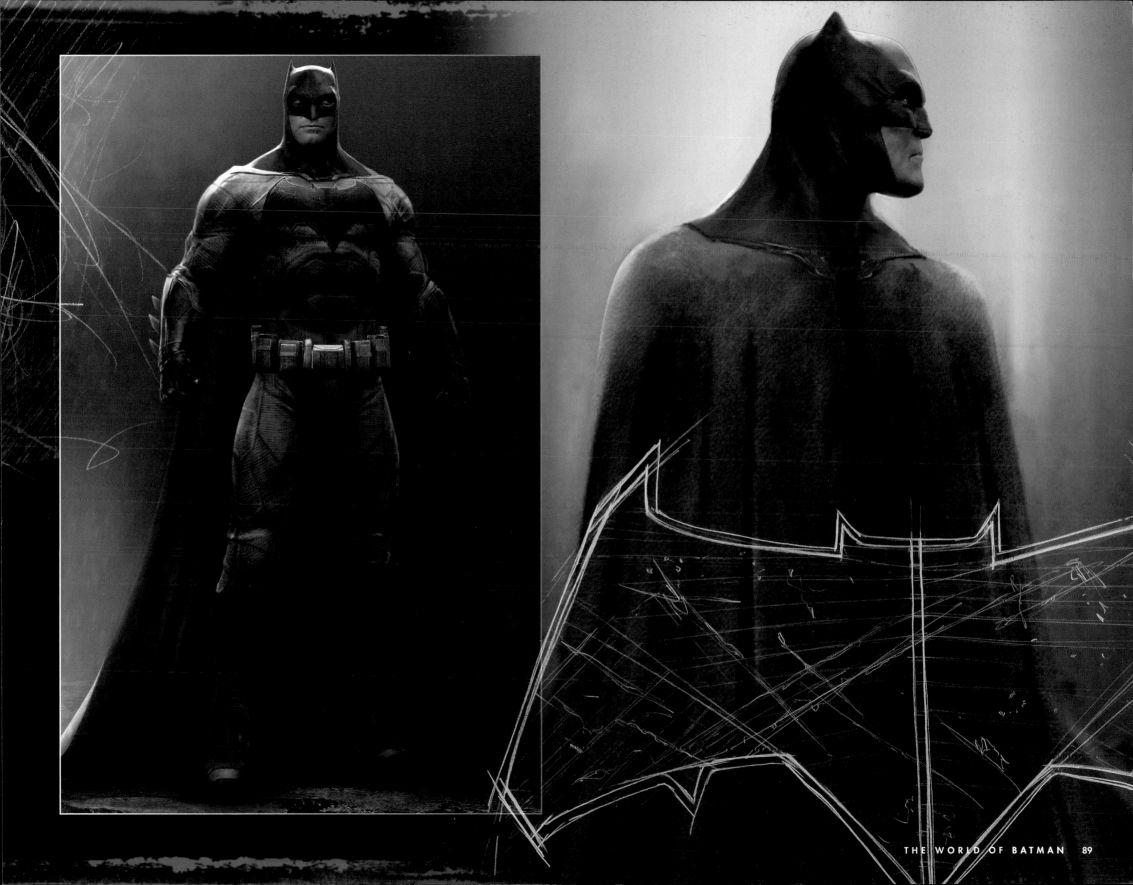

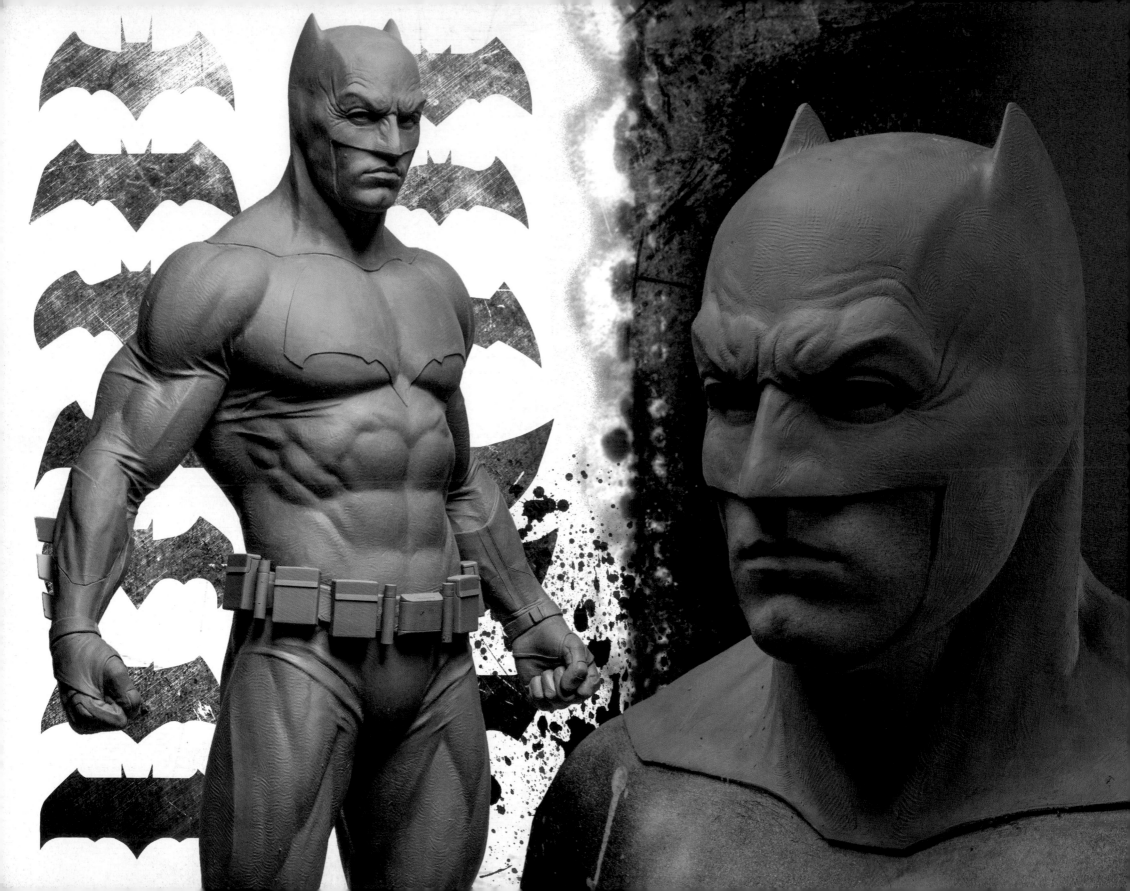

A new Batman needs a new Batsuit, but in this case, the inspiration for it went back to designs even older than its earliest modern portrayal on film in *Batman* (1989). As costume designer Michael Wilkinson explains it: "Zack really wanted to pay homage to the way the Batsuit's been drawn in the graphic novels and comic books over the last 75 years of his history... that his power wasn't through the armor and the technical details of the suit, but just the brute strength of the man inside the suit... You get a sense of the actor and the performance within the suit, rather than the suit wearing Ben."

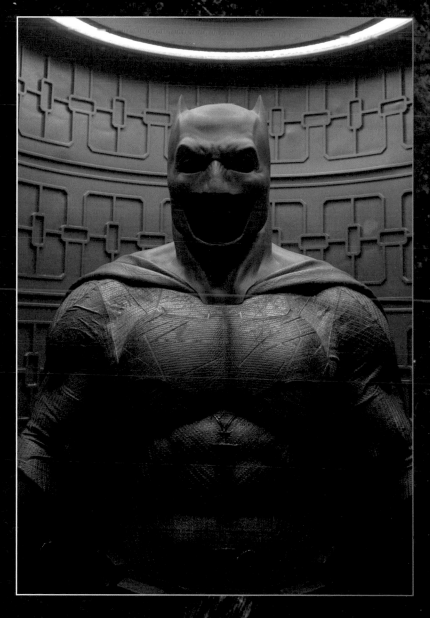

"JUSTICE IS VENGEANCE WITHOUT THE PASSION, WHEREAS VENGEANCE IS ALL PASSION."

JERMEMY IRONS

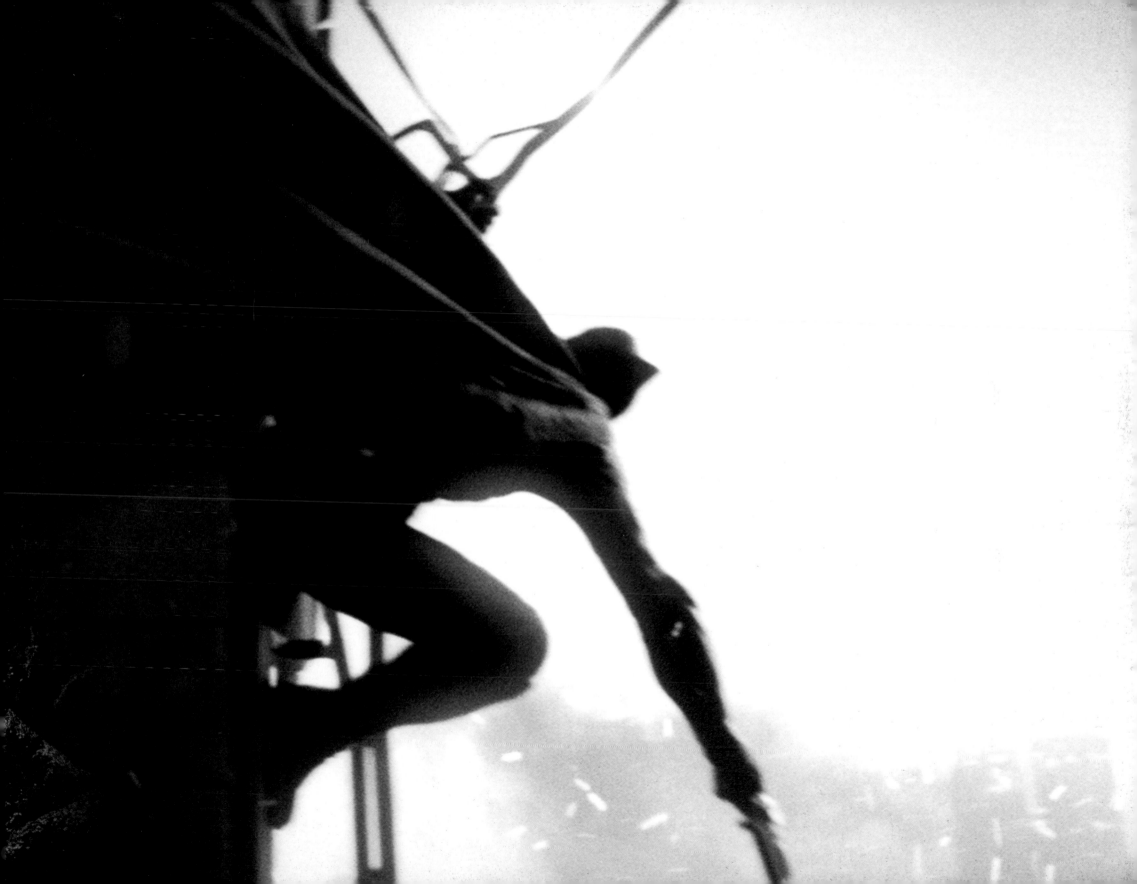

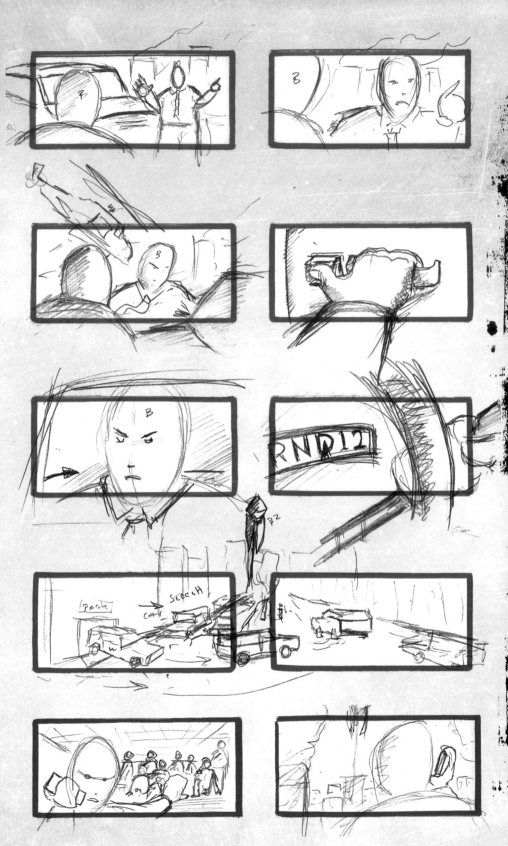

THE BLACK ZERO EVENT

Bruce Wayne has been fighting costumed psychopaths in Gotham City as Batman for nearly his entire adult life, but the alien attack on Metropolis two years ago was more insane and destructive than anything those criminals ever dreamed up. And it would forever change his worldview. "He looks up in the sky and sees Superman, and it's the moment, the inception of his rage toward Superman—that emotional, almost irrational sense of desperate anger and hatred," explains Ben Affleck.

Coming on top of a lengthy career spent obsessively waging a war on crime—a war that seems more and more futile to him—that day forces Bruce to focus his ire and considerable resources on Superman and the risk that he represents to Earth. "I could say it was the straw that broke—it wasn't a straw, really, it was a big hammer that broke the camel's back in terms of his emotional resilience," says Charles Roven. "And even though he's trying to do the right thing, he's doing it in very, very dark ways."

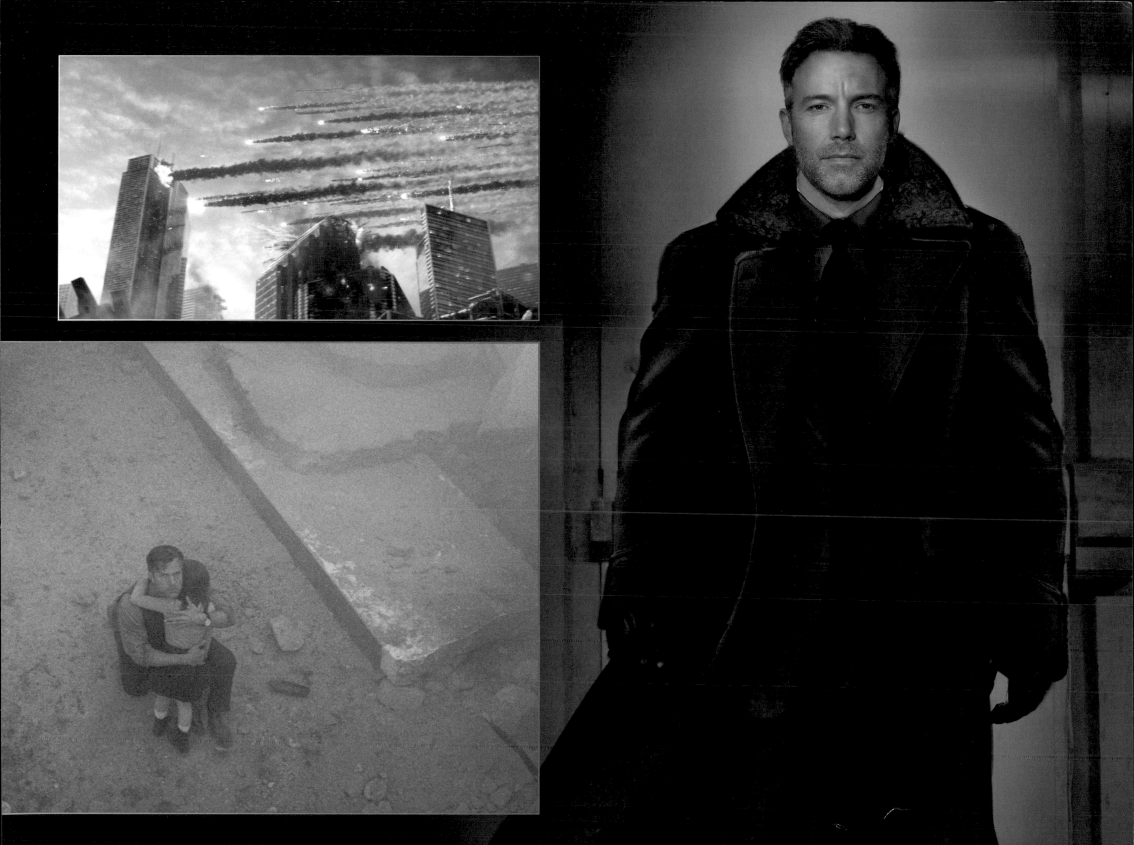

"WHAT HAPPENED TO THE PEOPLE
THAT WERE IN HIS BUILDING...
THAT LEAVES A SCAR."

BEN AFFLECK

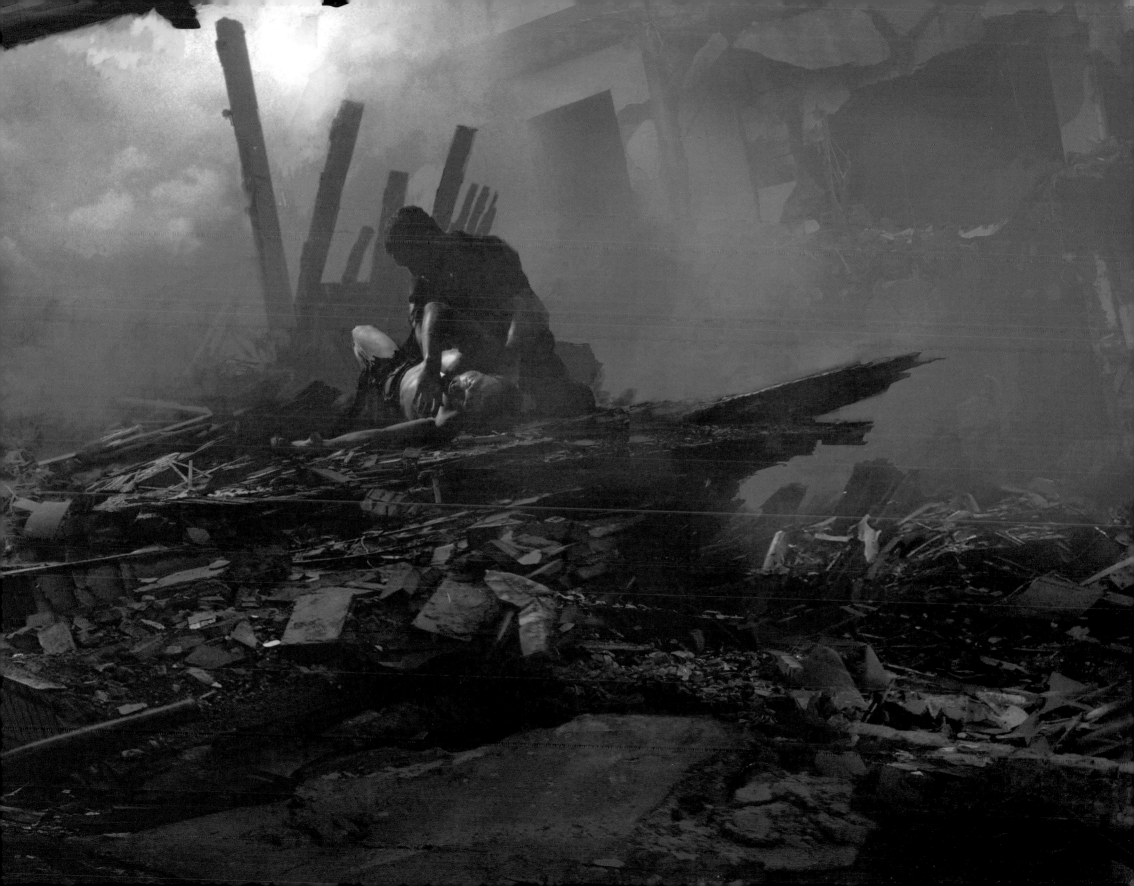

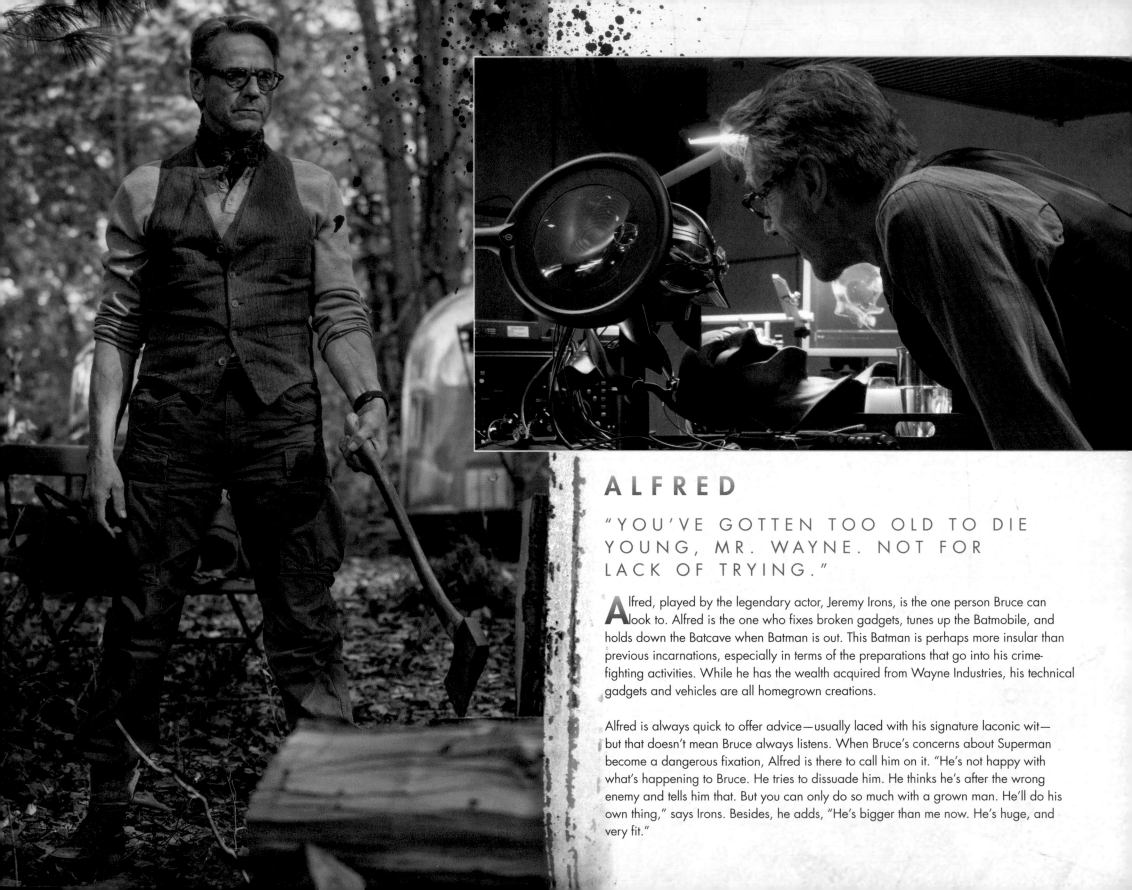

ALFRED

"YOU'VE GOTTEN TOO OLD TO DIE YOUNG, MR. WAYNE. NOT FOR LACK OF TRYING."

Alfred, played by the legendary actor, Jeremy Irons, is the one person Bruce can look to. Alfred is the one who fixes broken gadgets, tunes up the Batmobile, and holds down the Batcave when Batman is out. This Batman is perhaps more insular than previous incarnations, especially in terms of the preparations that go into his crime-fighting activities. While he has the wealth acquired from Wayne Industries, his technical gadgets and vehicles are all homegrown creations.

Alfred is always quick to offer advice—usually laced with his signature laconic wit—but that doesn't mean Bruce always listens. When Bruce's concerns about Superman become a dangerous fixation, Alfred is there to call him on it. "He's not happy with what's happening to Bruce. He tries to dissuade him. He thinks he's after the wrong enemy and tells him that. But you can only do so much with a grown man. He'll do his own thing," says Irons. Besides, he adds, "He's bigger than me now. He's huge, and very fit."

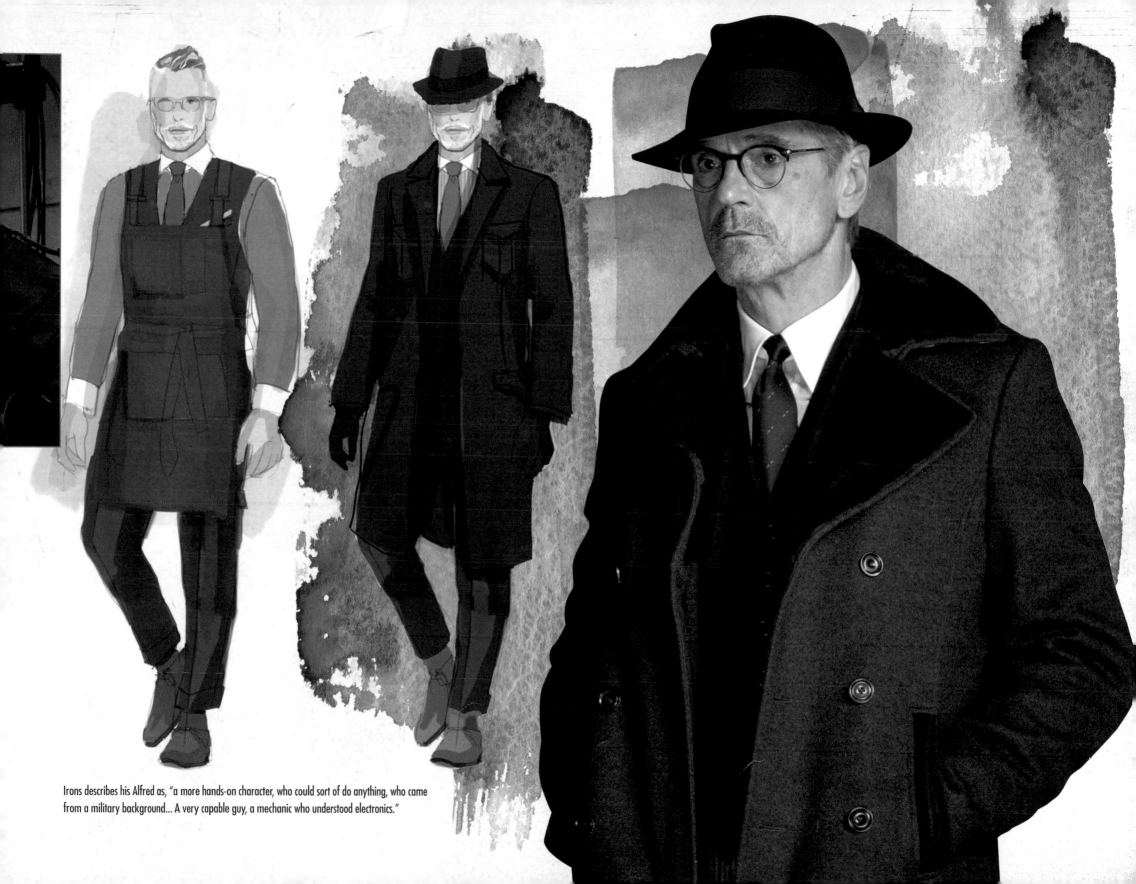

Irons describes his Alfred as, "a more hands-on character, who could sort of do anything, who came from a military background... A very capable guy, a mechanic who understood electronics."

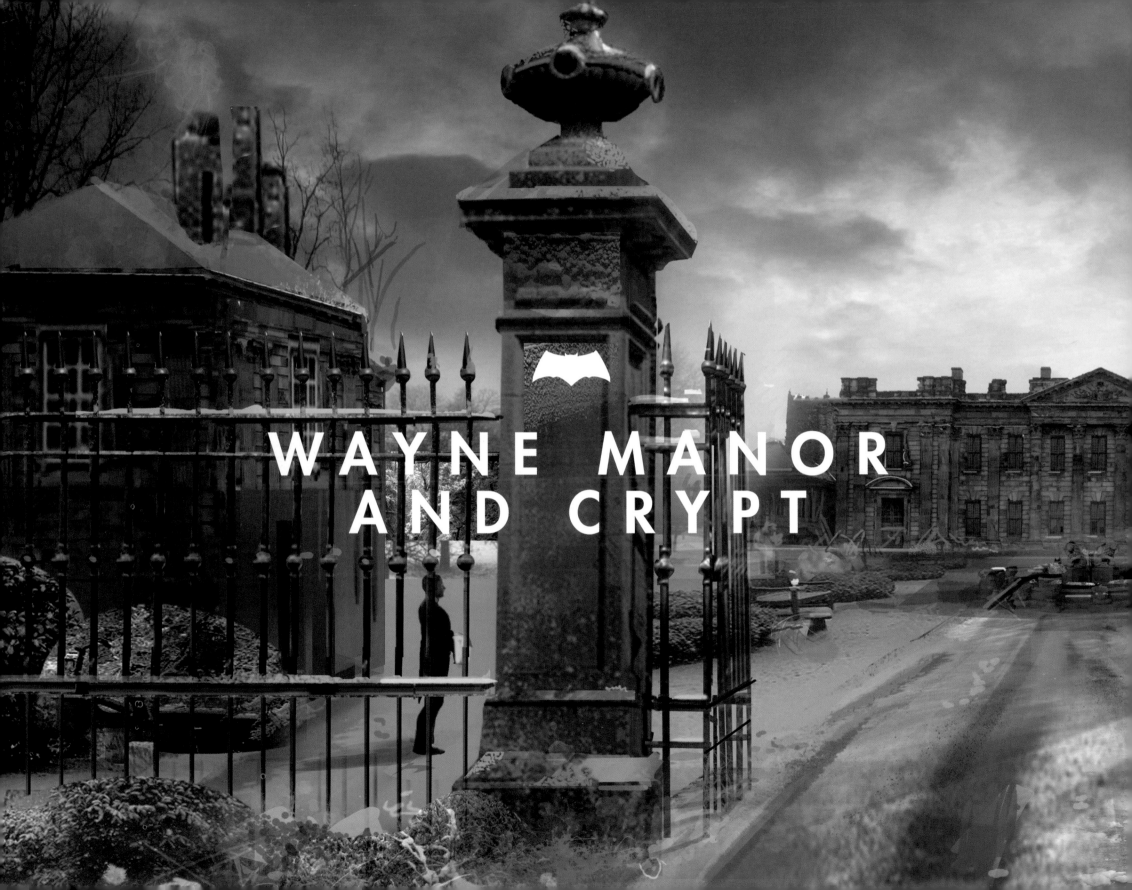

WAYNE MANOR
AND CRYPT

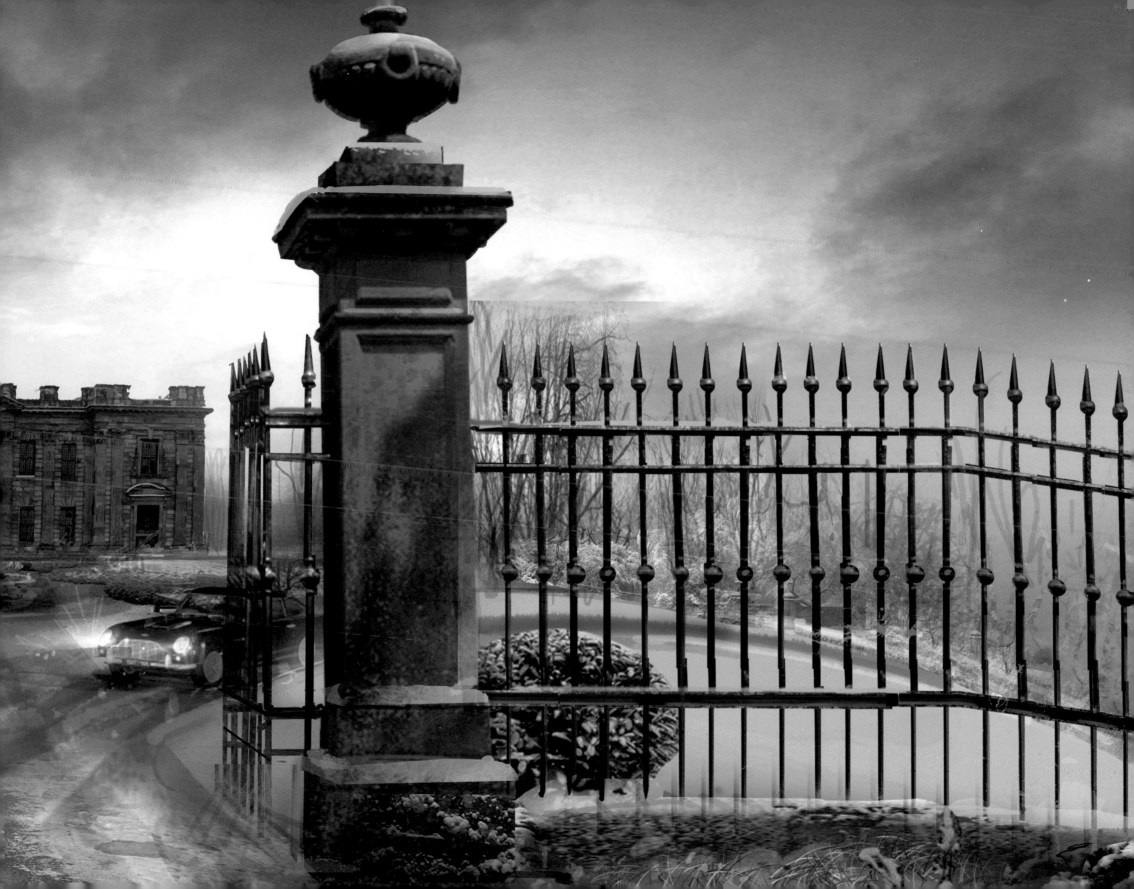

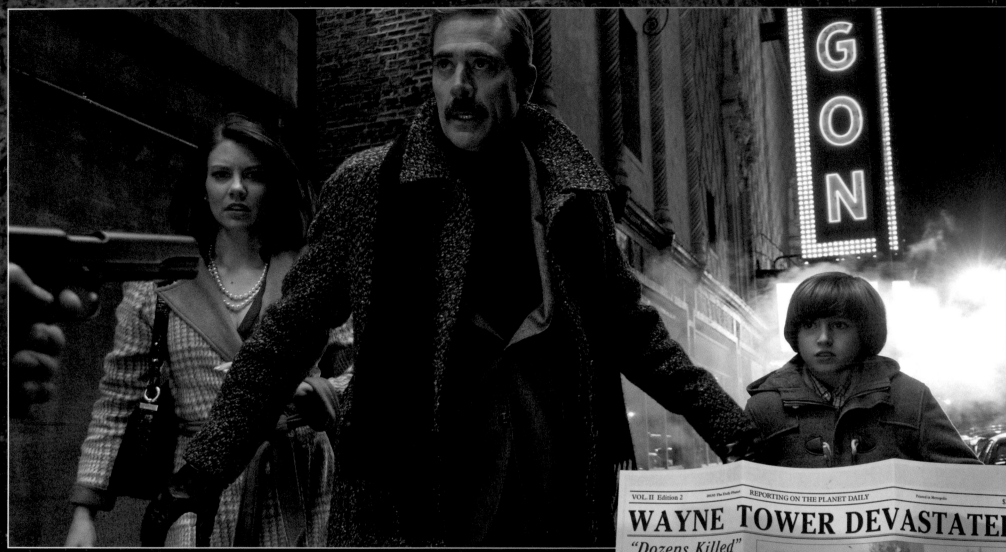

THE WAYNE LEGACY

Sitting abandoned on a hill, Wayne Manor is an ever-present reminder of Bruce Wayne's family legacy, even if he doesn't live there anymore. At this point in his life, he has opted for a smaller, less ostentatious lake house elsewhere on the family property. Heavily damaged during a fire many years ago, the mansion is a shell of its former glory and has since become overgrown with weeds.

It would be wrong to assume, however, that Bruce has completely turned his back on his former life. On the contrary, it is significant that he's never had the mansion torn down despite it being a burnt-out shell. It may hold painful memories of a youth turned tragic, but still he can't bring himself to shake the ghosts that cling to him so strongly.

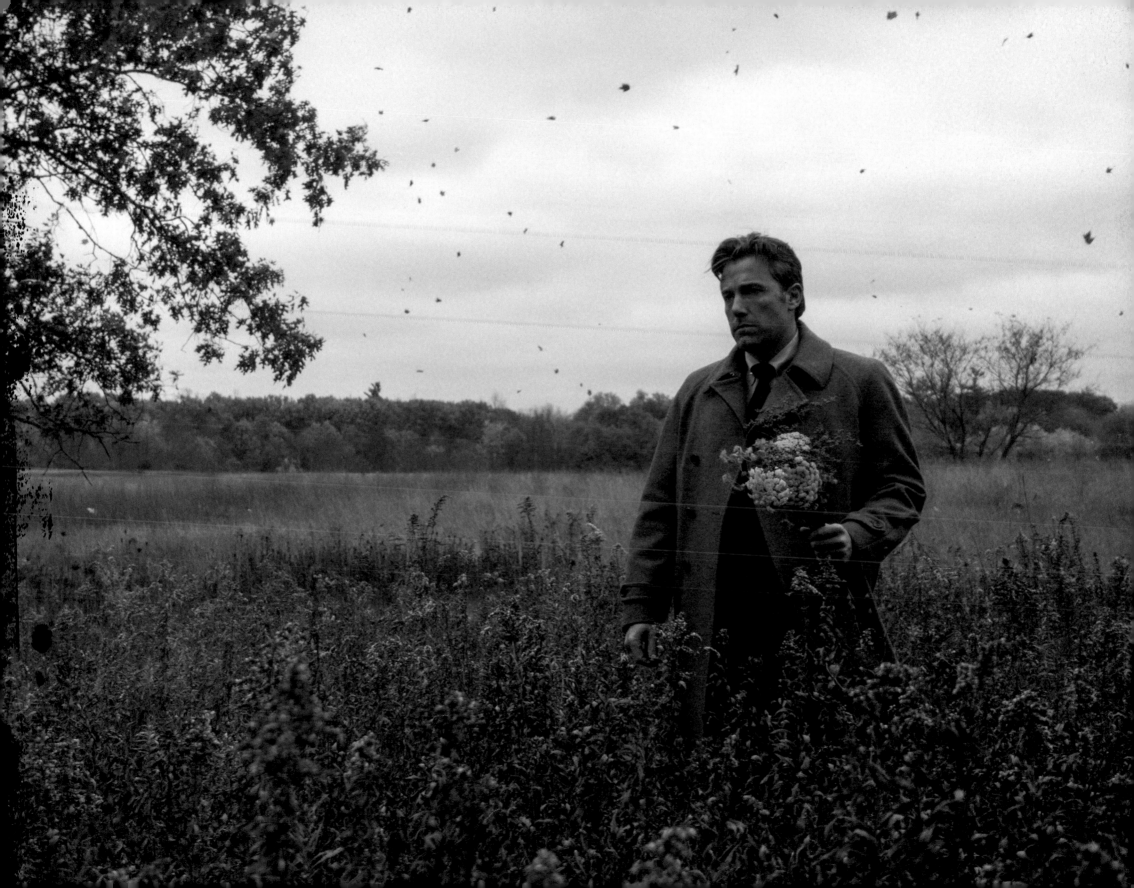

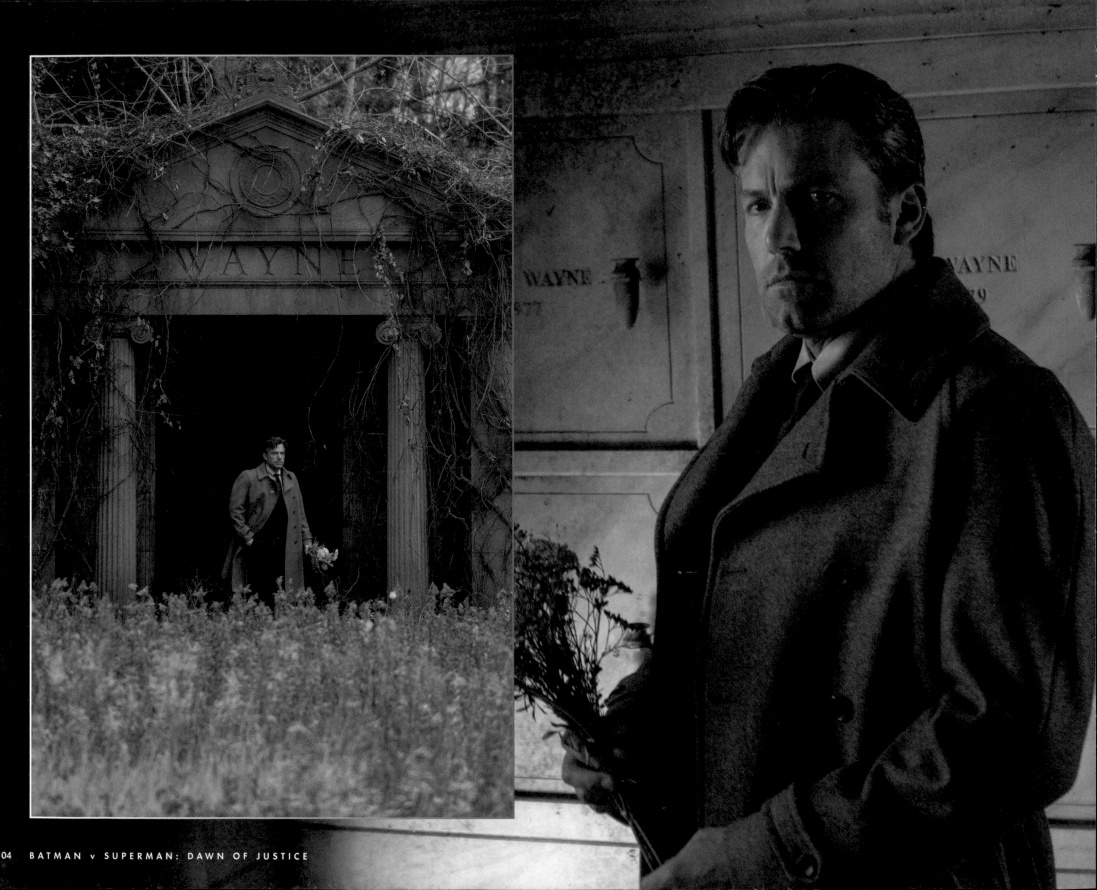

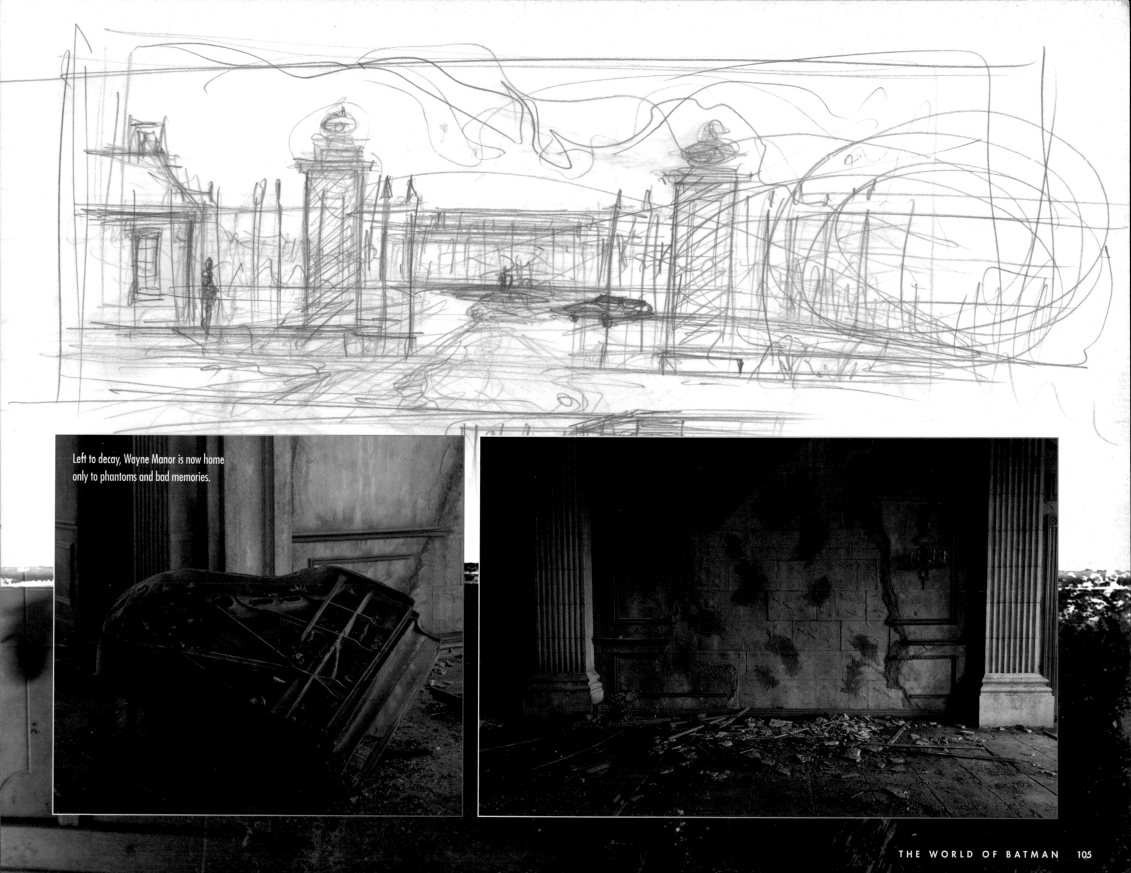

Left to decay, Wayne Manor is now home only to phantoms and bad memories.

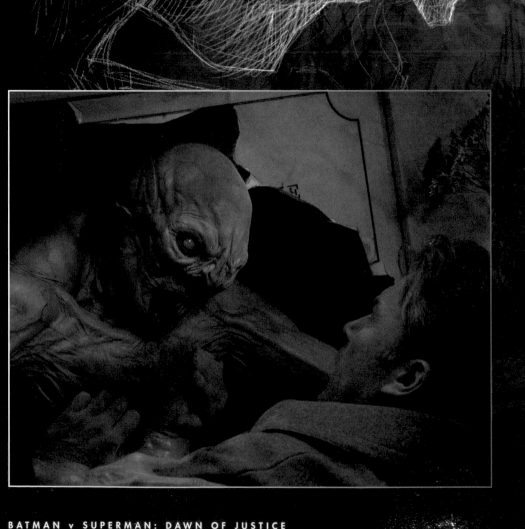

The nearby family crypt containing the remains of his parents, Thomas and Martha, is also in a similar state of neglect. It is a reminder of the night they were murdered, when the three of them went into the city to take in a movie. The loss of his parents at such an early age was the impetus for his crime-fighting career, but that event still has the power to invade his sleep with nightmarish visions, all these years later.

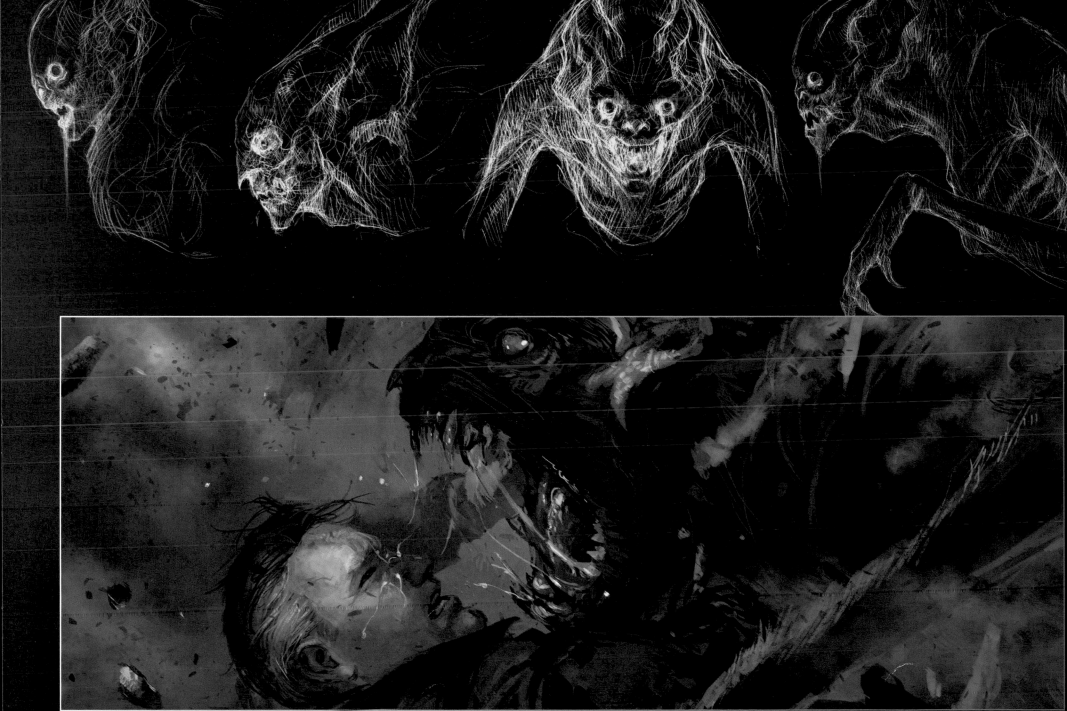

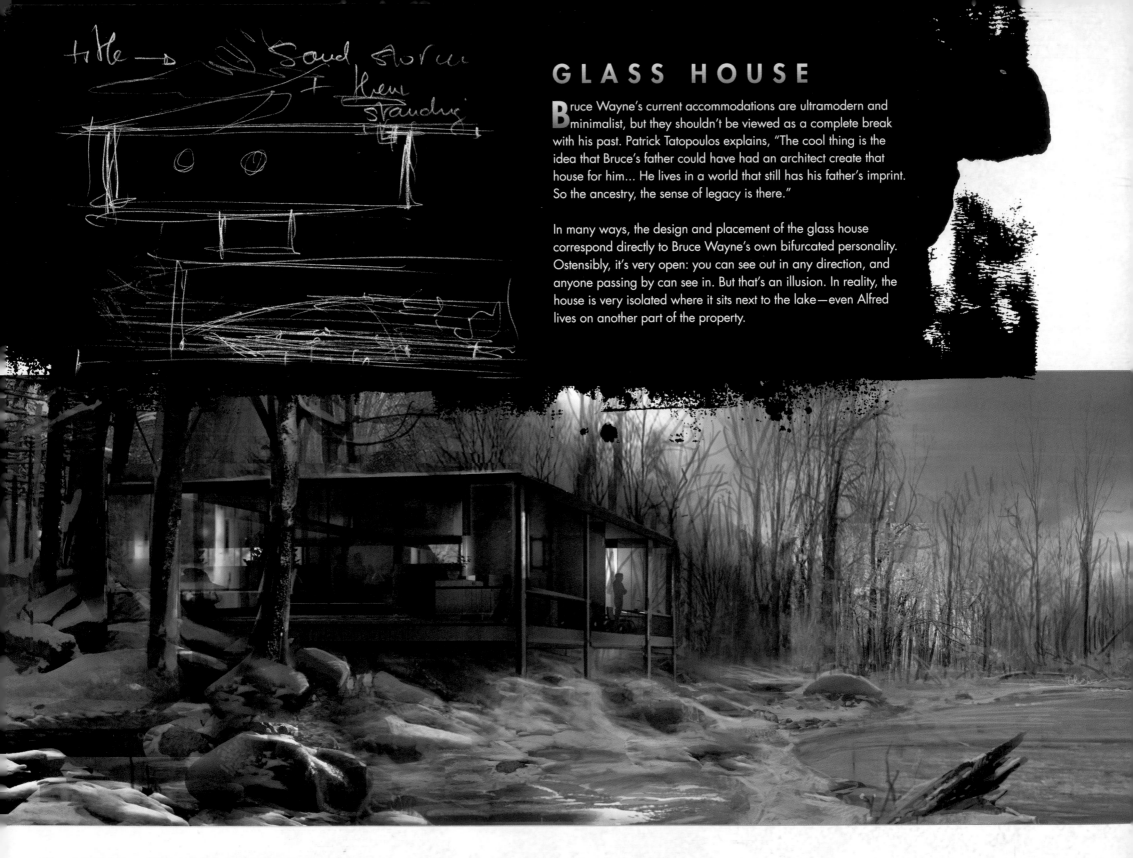

GLASS HOUSE

Bruce Wayne's current accommodations are ultramodern and minimalist, but they shouldn't be viewed as a complete break with his past. Patrick Tatopoulos explains, "The cool thing is the idea that Bruce's father could have had an architect create that house for him... He lives in a world that still has his father's imprint. So the ancestry, the sense of legacy is there."

In many ways, the design and placement of the glass house correspond directly to Bruce Wayne's own bifurcated personality. Ostensibly, it's very open: you can see out in any direction, and anyone passing by can see in. But that's an illusion. In reality, the house is very isolated where it sits next to the lake—even Alfred lives on another part of the property.

SUSPENDED IN CAVE
BAT LIKE

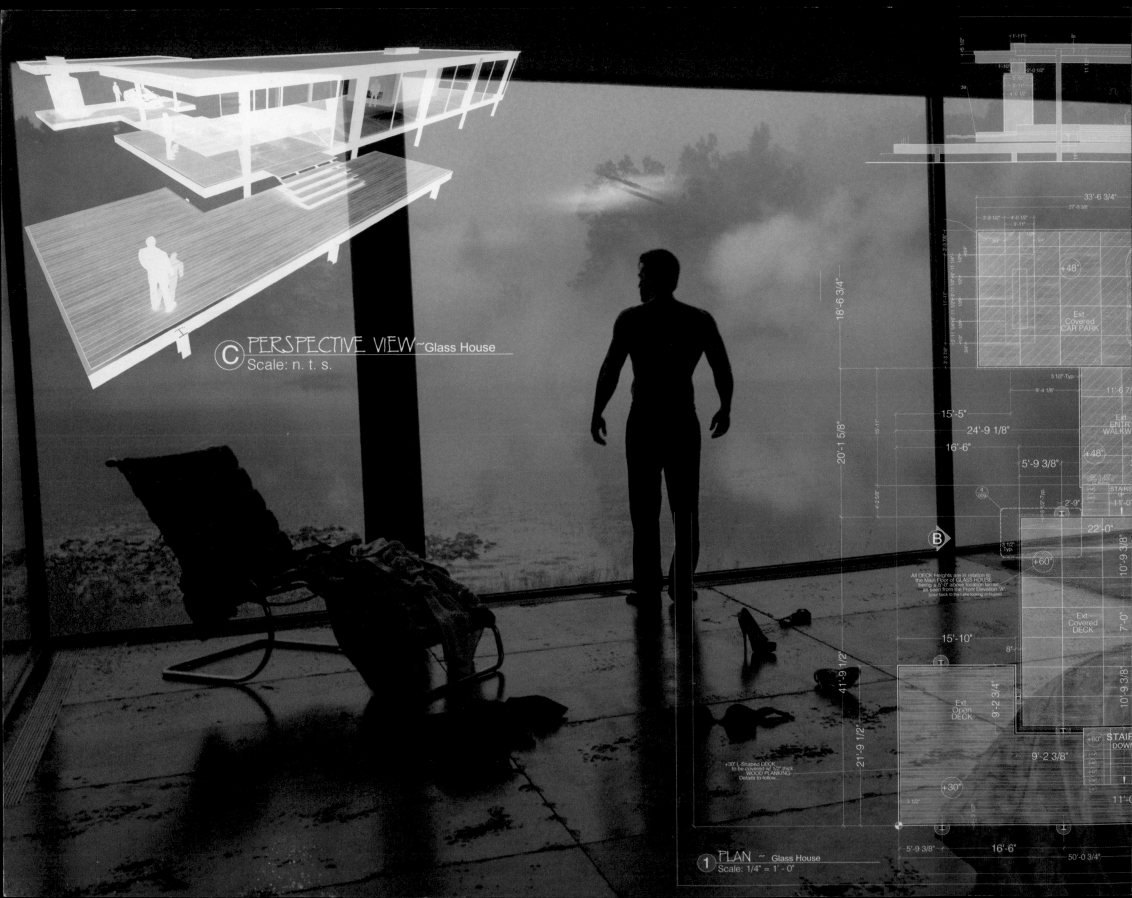

PERSPECTIVE VIEW~Glass House
Scale: n. t. s.

PLAN ~ Glass House
Scale: 1/4" = 1' - 0"

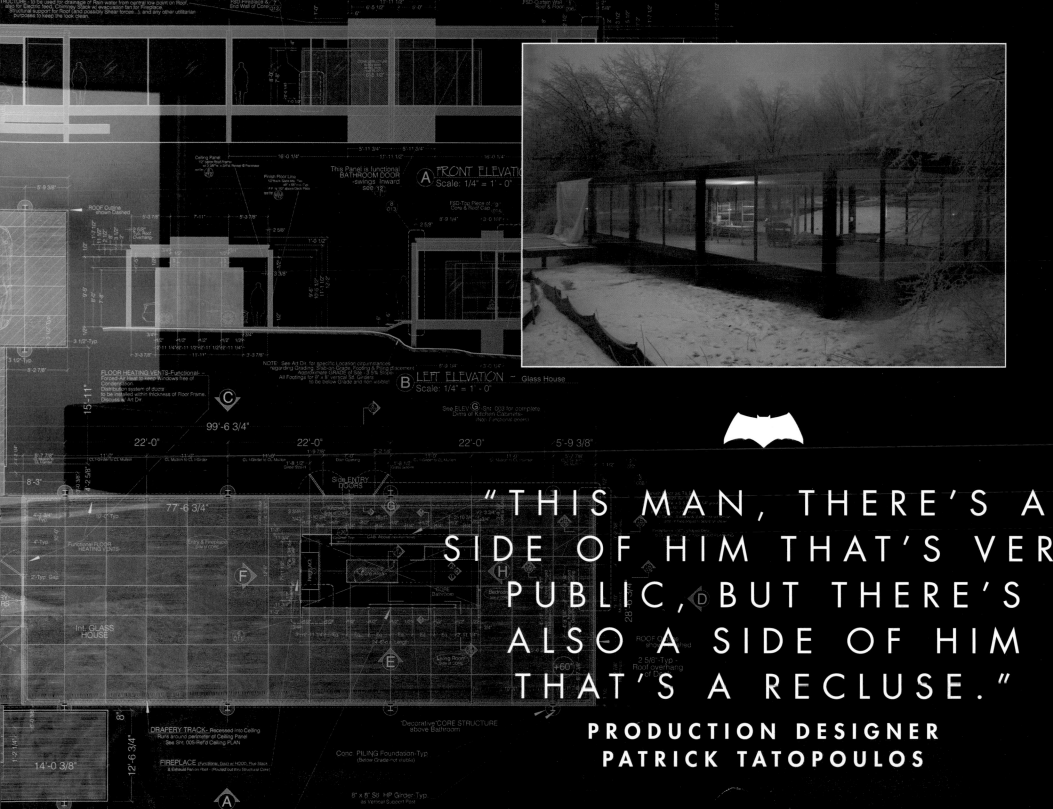

"THIS MAN, THERE'S A SIDE OF HIM THAT'S VER PUBLIC, BUT THERE'S ALSO A SIDE OF HIM THAT'S A RECLUSE."

PRODUCTION DESIGNER PATRICK TATOPOULOS

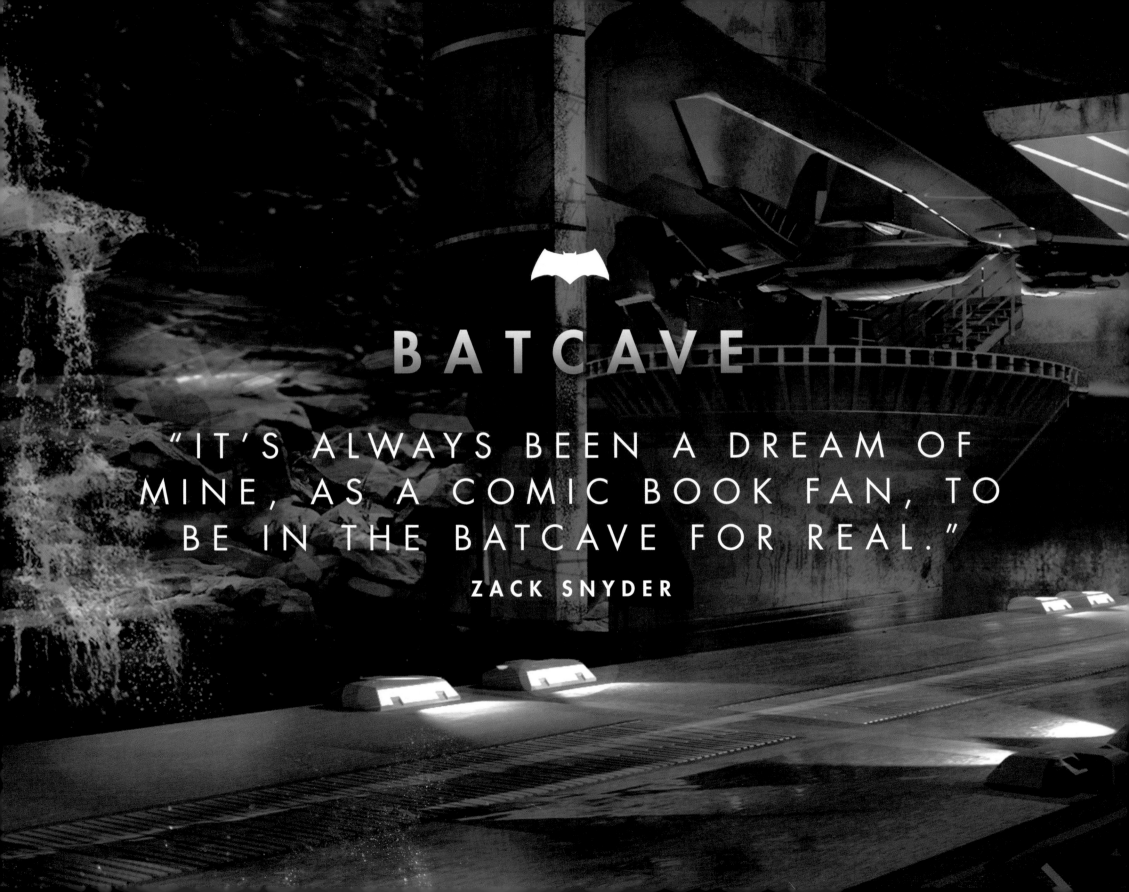

BATCAVE

"IT'S ALWAYS BEEN A DREAM OF MINE, AS A COMIC BOOK FAN, TO BE IN THE BATCAVE FOR REAL."

ZACK SNYDER

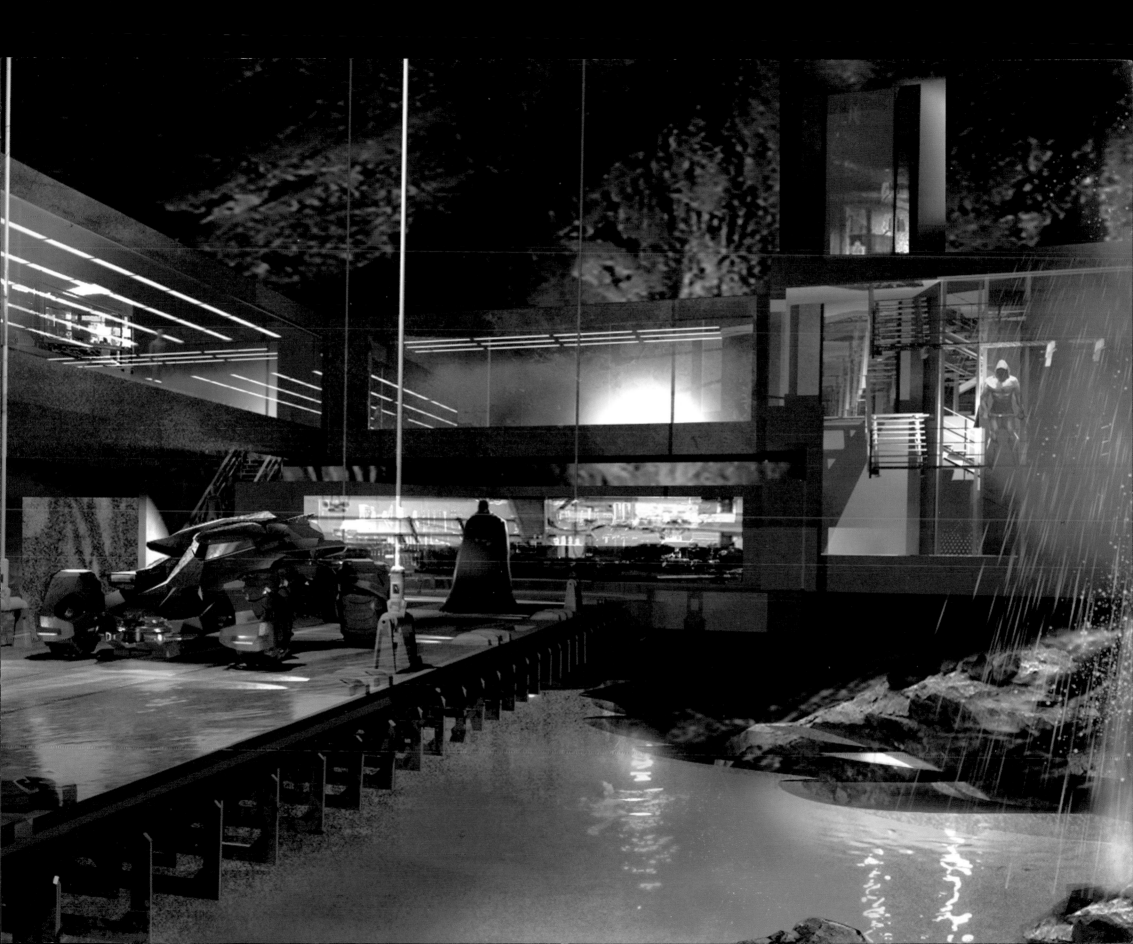

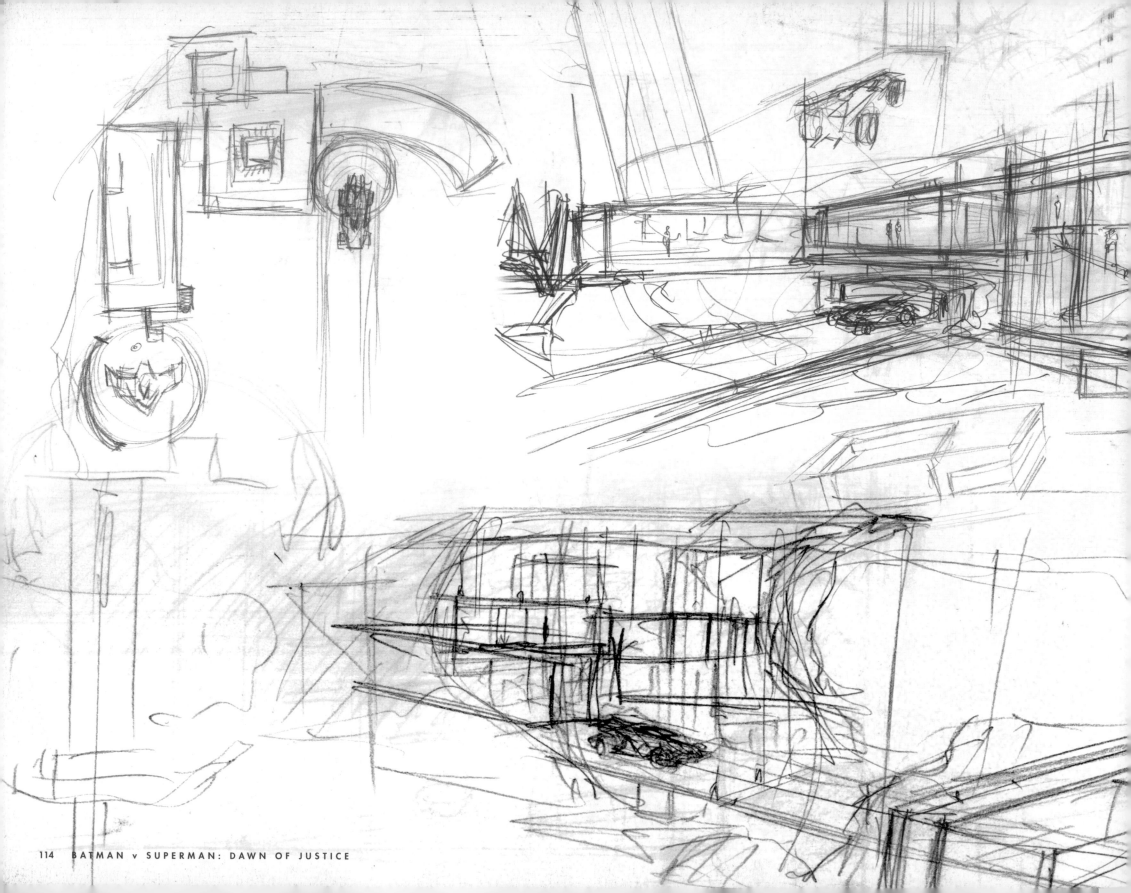

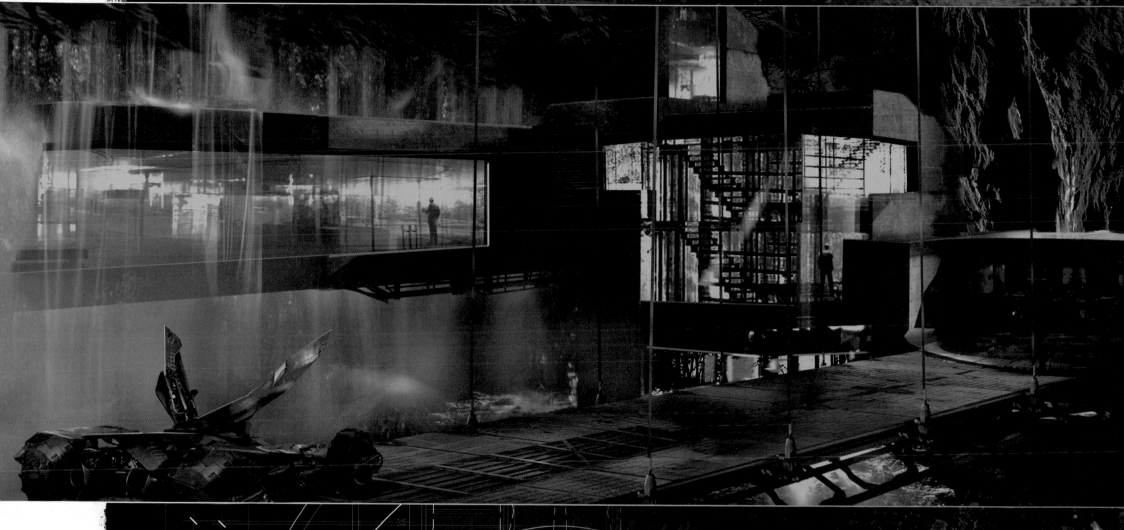

20'-0" DIA MINIMUM TURNTABLE NEEDED

13'-7" WHEEL BASE

13'-4" DIAMETER

What is immediately striking about this Batcave is how claustrophobic it feels. "Most of the caves in the Batman movies are usually gigantic and beautiful opera houses… very open," says Patrick Tatopoulos. But for this story, the cave needed to connect with Batman's current state of mind. "It needed to feel like it's not comfortable," he explains. "The place is pretty oppressive, and nature is in control in some ways. You want to feel like the ceiling could be cracking… Elements of different plates that seem to be shifting and going down, so you feel like, 'Wow, there's tons of rocks on top of me.'"

Approximately 85 pieces of ½"-thick tempered glass, each 5' x 10' and weighing in at 320 lbs. apiece, were needed to build out the Batcave.

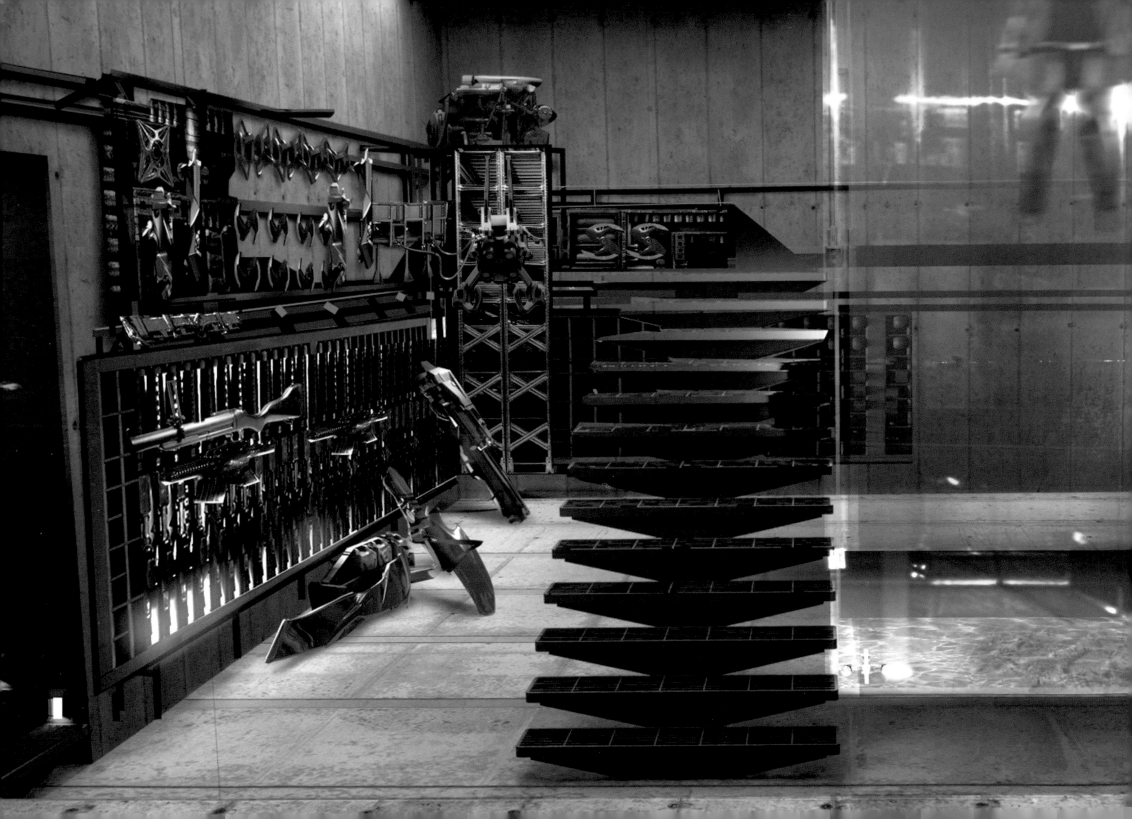

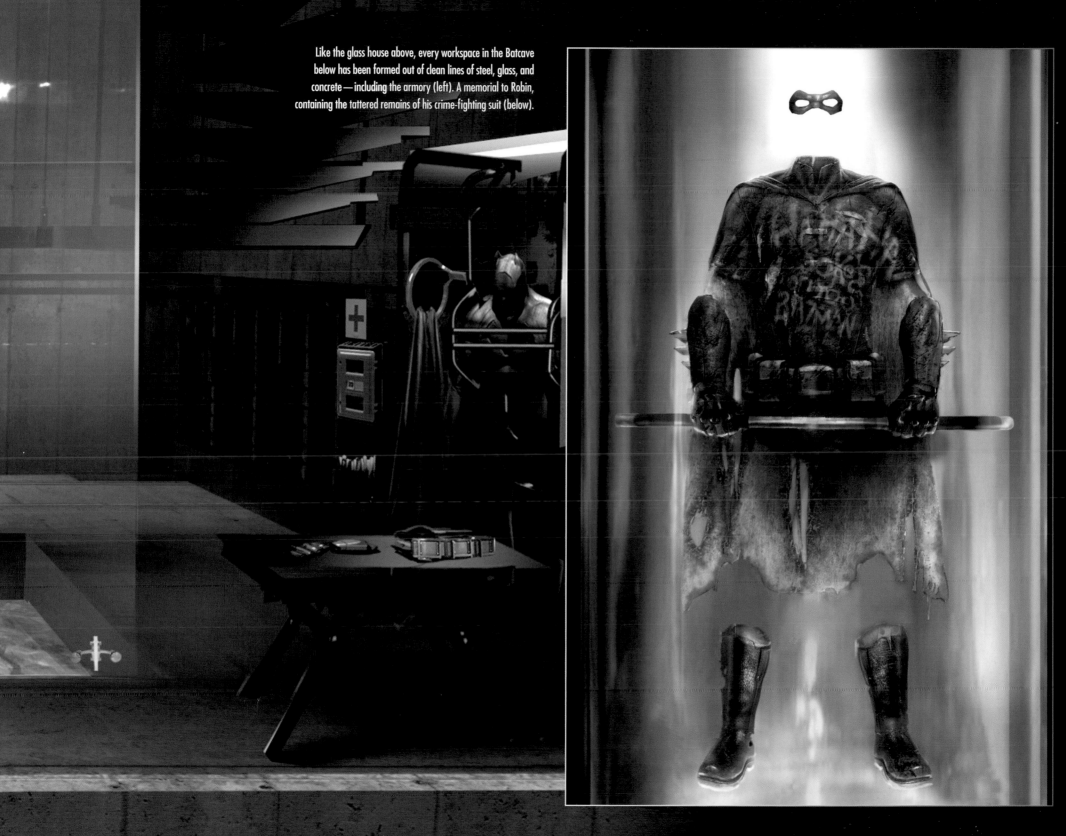

Like the glass house above, every workspace in the Batcave below has been formed out of clean lines of steel, glass, and concrete—including the armory (left). A memorial to Robin, containing the tattered remains of his crime-fighting suit (below).

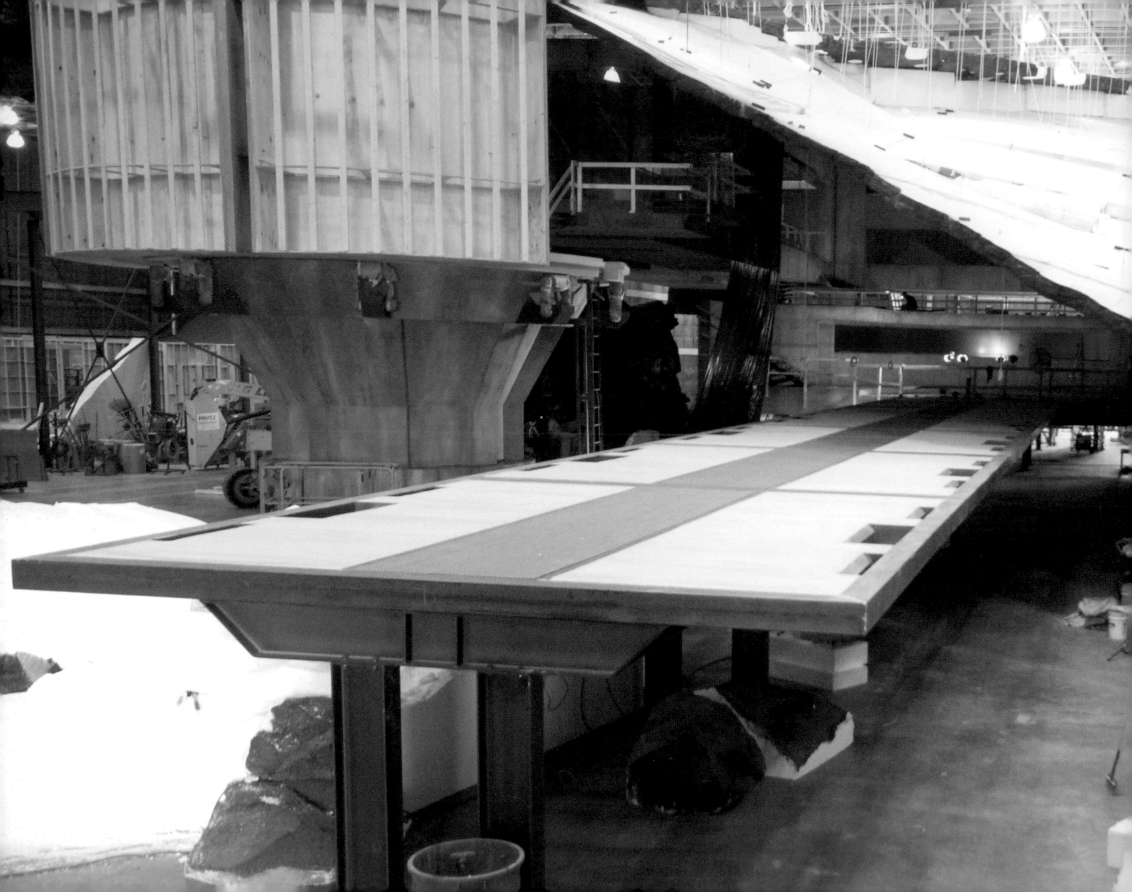

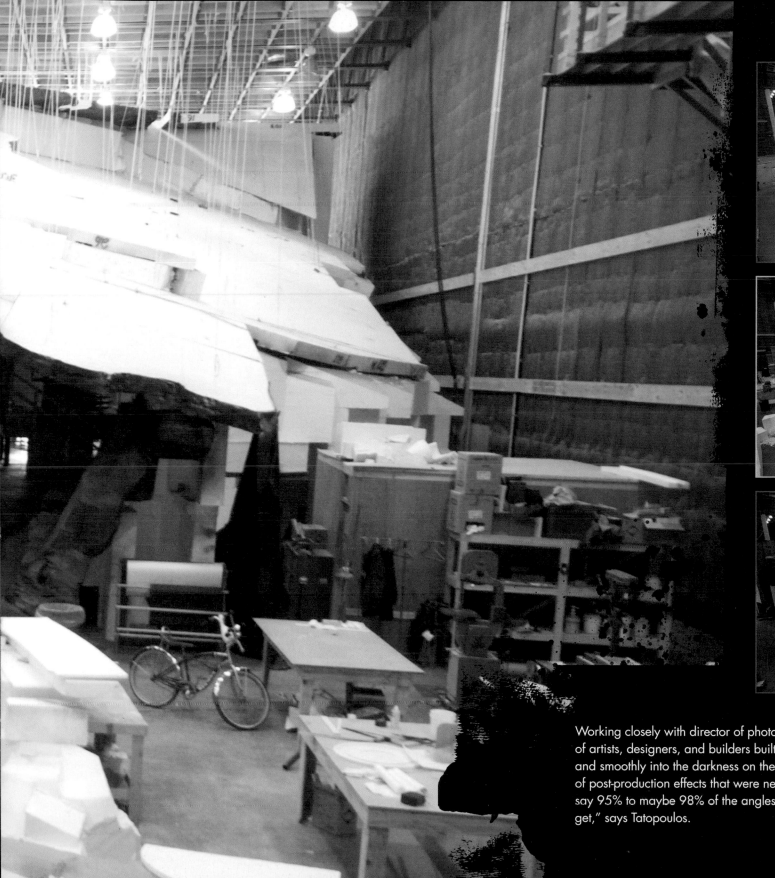

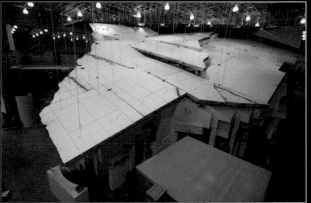

Working closely with director of photography Larry Fong, Tatopoulos and his talented crew of artists, designers, and builders built a practical set where clever lighting dove quickly and smoothly into the darkness on the edges of the cave. This greatly reduced the amount of post-production effects that were needed to extend the set in the audience's mind. "I'd say 95% to maybe 98% of the angles don't require CGI. What you're seeing is what you get," says Tatopoulos.

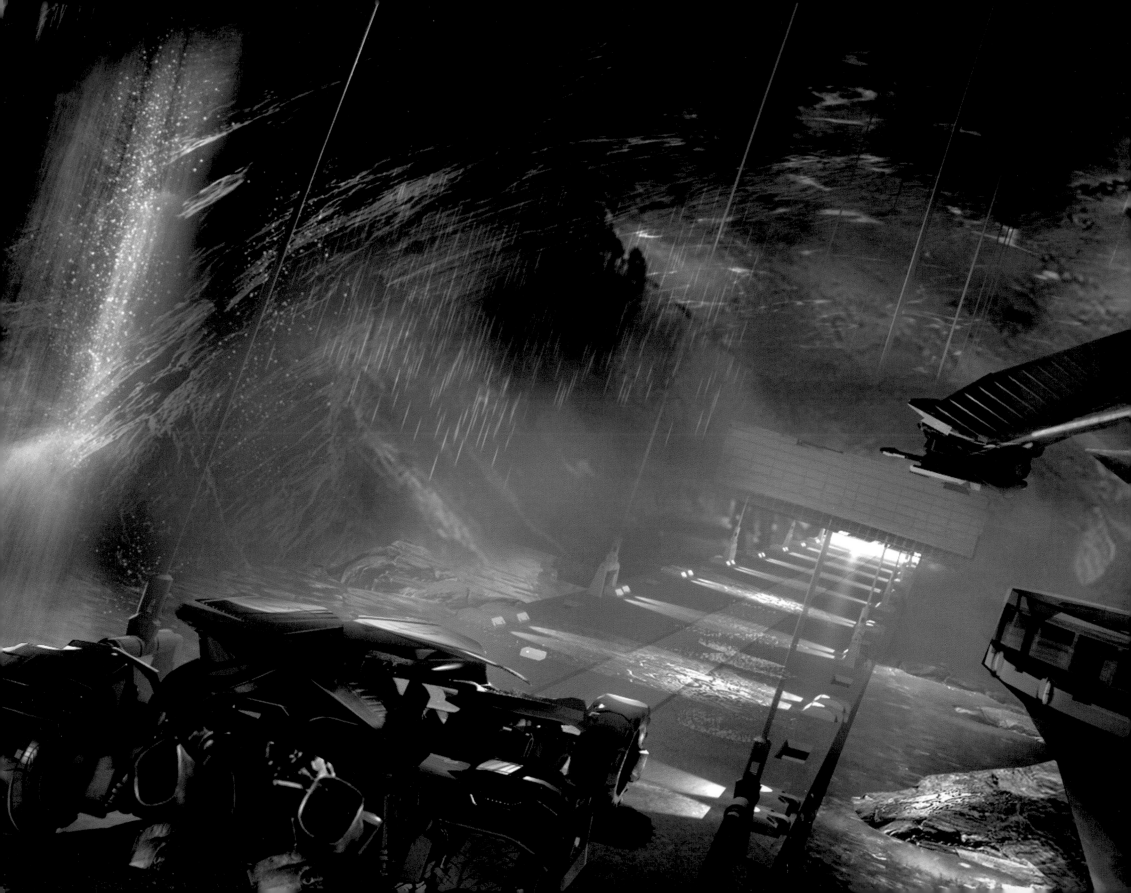

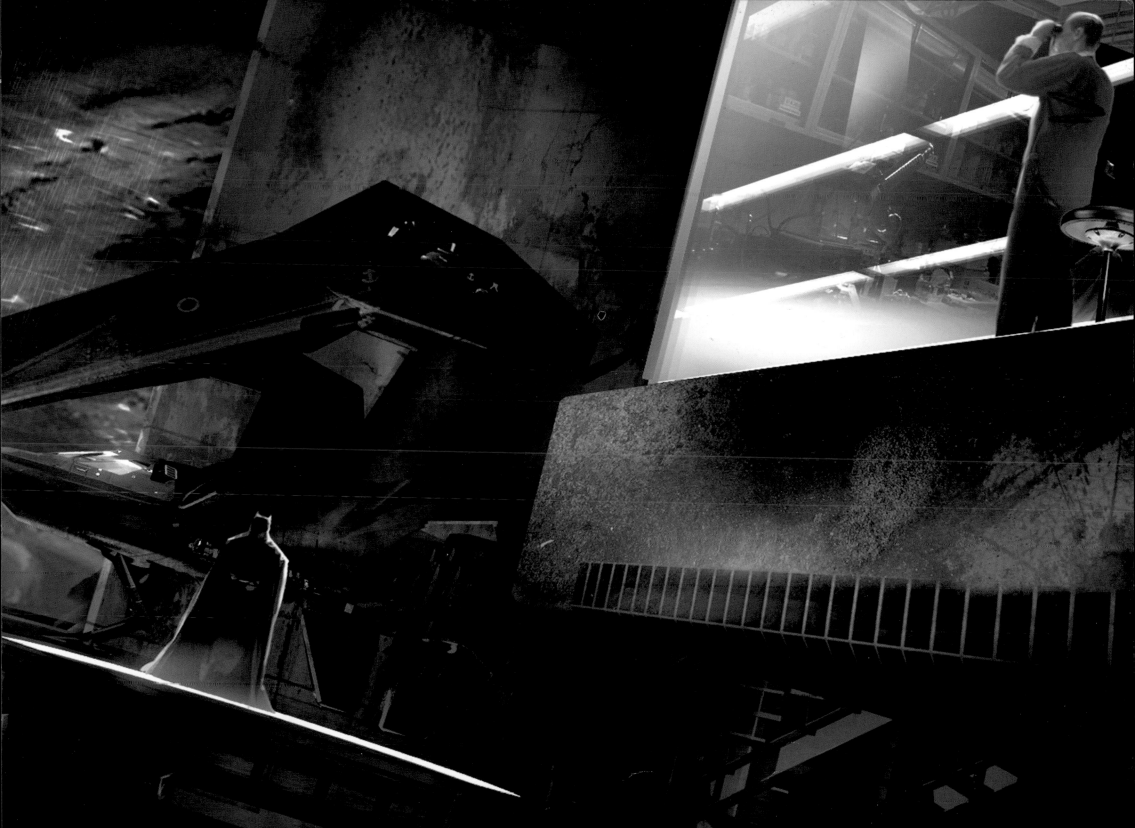

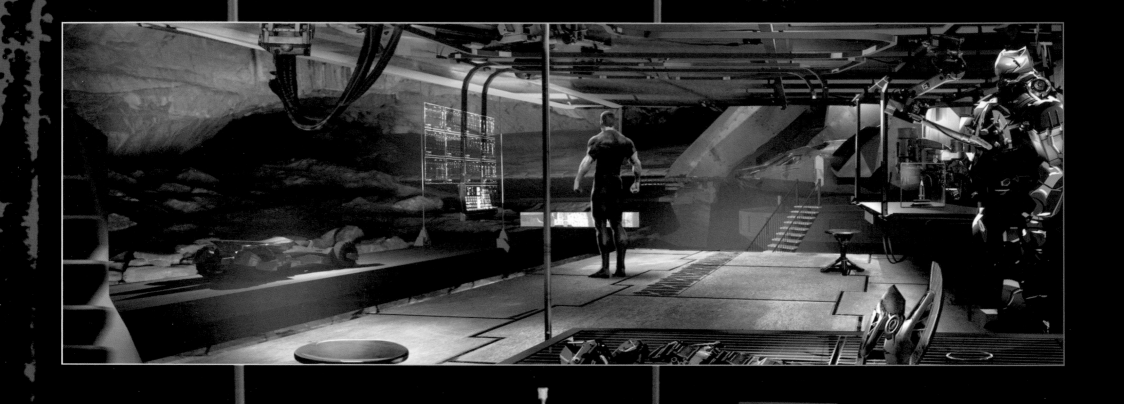

RETRACTABLE SURFACES

CHEST PAD

CHEMICAL ANALYSIS STATION

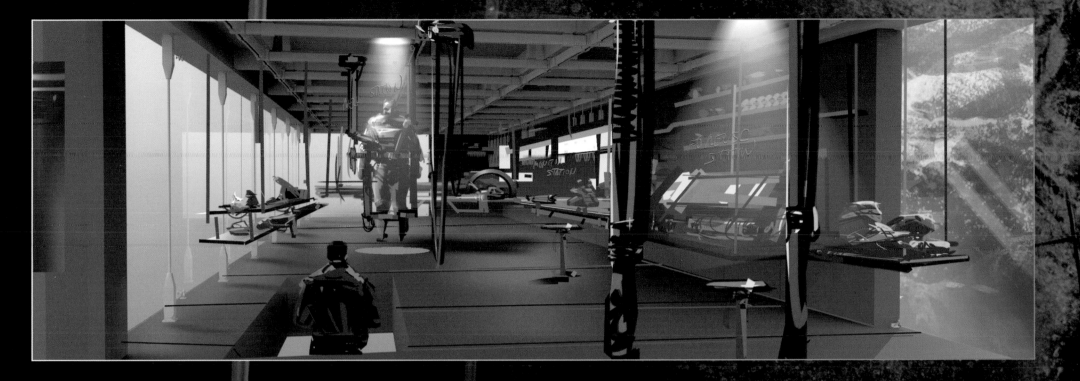

UTILTY SINK

Another innovative feature was that almost every manmade thing in the cave hangs from the ceiling. "We're in the bat world," says Tatopoulos. "So, the big concept for the cave is that everything is suspended. There is nothing with structural support from underneath. This happens inside the shop as well. Every workstation is hanging... The only thing that actually touches the ground is the chair."

Finally, connecting all the workspaces are bridges, stairs, and catwalks that look downright unsafe—and they would be for normal people. "The 'no railing' has always been a major issue for me. I really wanted to make sure that Batman doesn't look like he needs railings. The man flies, bounces around, jumps—why would he have railings?" asks Tatopoulos.

Rather than carve rooms out of the rock, Bruce Wayne built his own modular working spaces—gym, lab, armory, turntable for the Batmobile, etc.—all within the natural layout of the cave.

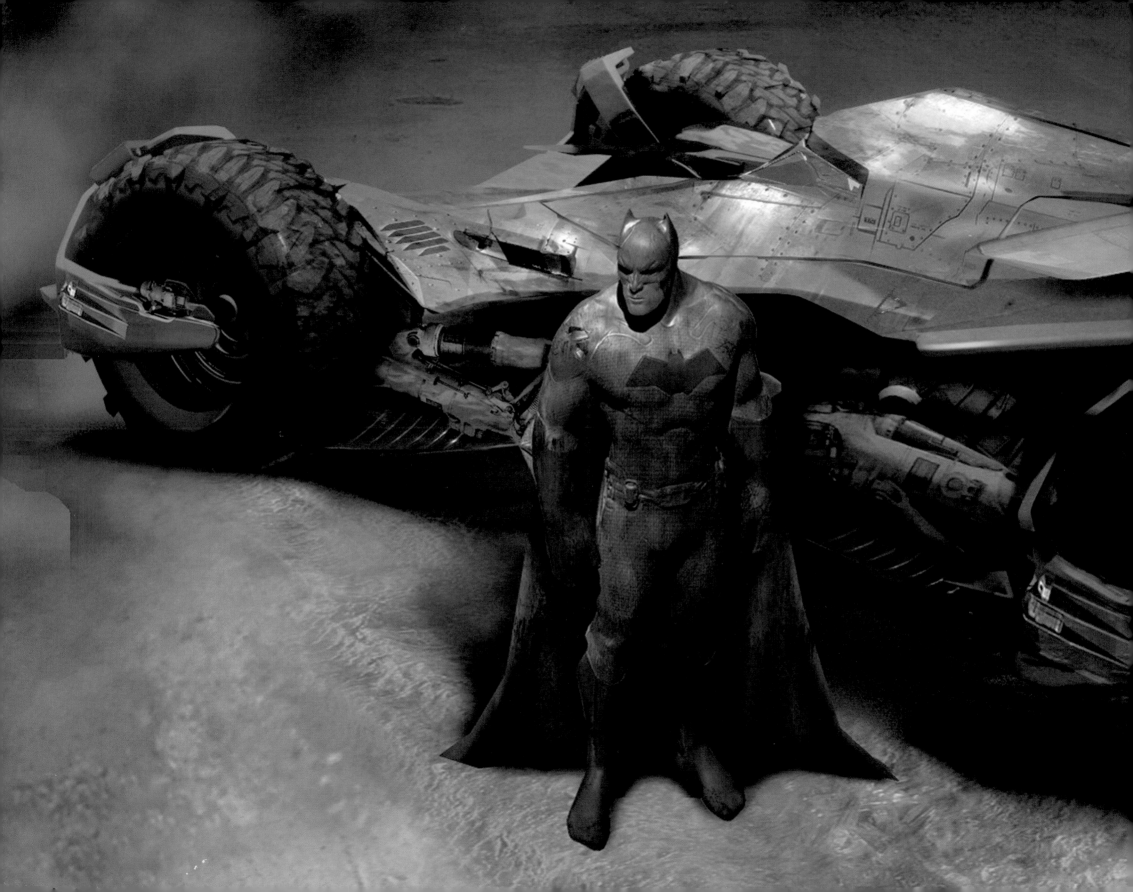

VEHICLES

"IT'S REALLY HARD, BECAUSE SO MANY OF THESE VEHICLES WERE SUPER COOL THAT HAVE BEEN DONE IN THE PAST, AND HOW DO YOU TOP IT? BUT THEY MANAGED TO TOP IT."

DEBORAH SNYDER

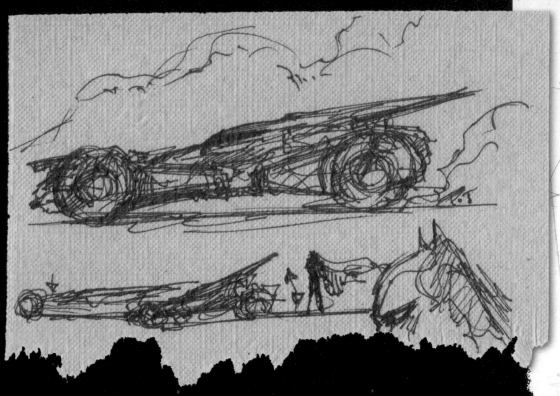

BATMOBILE

"FUNCTIONAL AND TOUGH AND
POWERFUL... IT'S AN AMAZING CAR.
I FEEL SO HONORED THAT I HAD THE
CHANCE TO DO IT."
STUNT DRIVER MIKE JUSTUS

Redesigning the most iconic car in cinema history was a huge draw for production designer Patrick Tatopoulos. "It all started with a little sketch on a napkin in a coffee shop. I'm a big motorcycle guy, and the first drawing I did also looks almost like a motorcycle from the profile," says Tatopoulos. The idea was to remain true to Bruce Wayne's love for classic lines, giving it an almost retro feel. "The Batmobile in the first drawing is the Batmobile of today," he explains. "It hasn't changed, except now it's working and the detail is stunning."

To build the actual Batmobile (two of them, as a matter of fact), the filmmakers engaged the services of veteran picture car coordinator Dennis McCarthy (*Man of Steel*, *Furious Seven*). "Dennis does off-road racing, and his knowledge in this has really helped us," says Tatopoulos. "This is a car that goes and works as an off-road car when needed; it looks like a Formula 1 when he needs to do that as well. Our car now can go low when it needs to get speed, and it can go high."

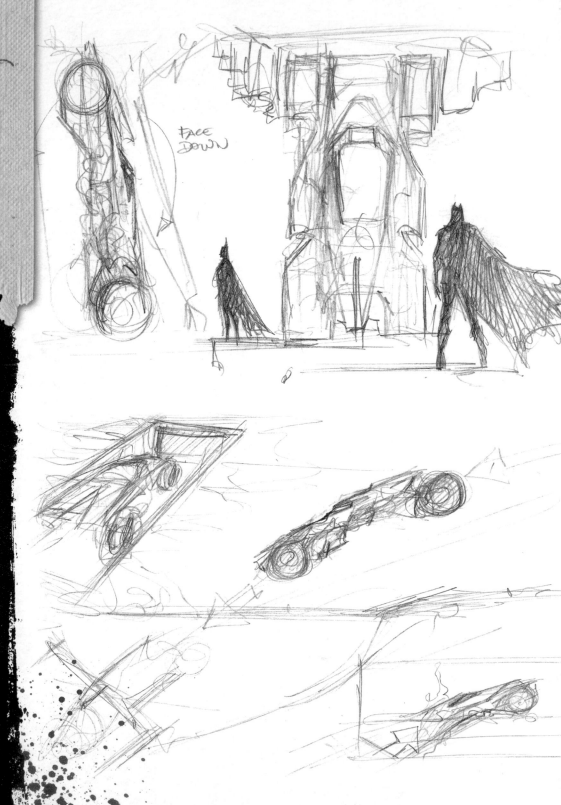

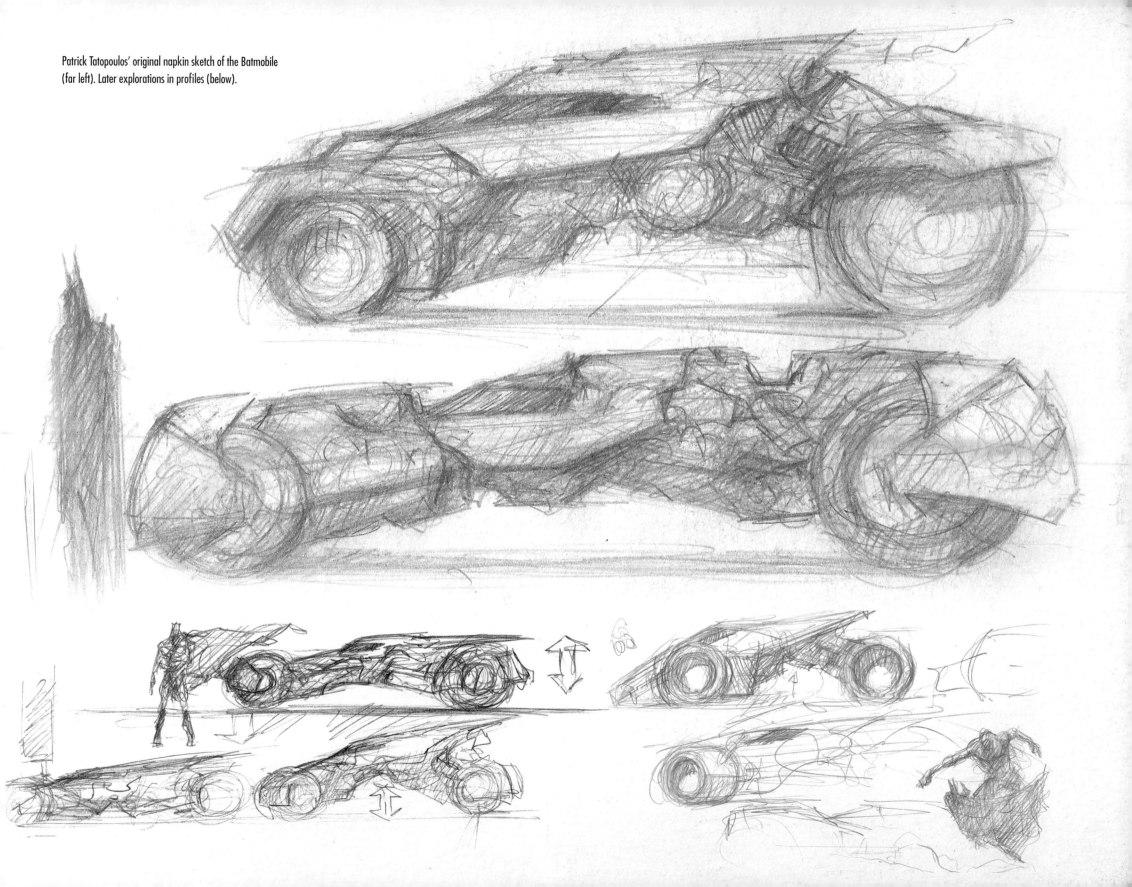

Patrick Tatopoulos' original napkin sketch of the Batmobile (far left). Later explorations in profiles (below).

In its first stage of development, when it was just a metal chassis with a 550-horsepower engine, stunt driver Mike Justus described it as a nimble combination of "sand rail and monster truck." Under the supervision of art director Kevin Ishioka, a fiberglass and carbon fiber body with all the extras was added—bumping the weight up from 6,000 to 8,800 lbs. A 707-horsepower Hellcat engine was then necessary to get it to handle and move like the racecar it needed to be. It also needed to be tough. "That's really one of the key elements of that car: durability factor. Just everything on it is overbuilt," says McCarthy.

There was no denying the breathtaking marriage of form and function they achieved, but even the Batmobile needed a stunt double. "We call it the proxy car," explains Justus. "It's basically a Dodge Ram 3500 Dooley that the special effects team rigged up with a tubular chassis to protect it. They welded up plates... and it almost looked like it had a snowplow on the front. It's just a big monster." So, when the script called for the Batmobile to crash through walls or into other vehicles—or to be struck itself—they would cue the proxy car. The visual effects team would later paint the image of the Batmobile over the proxy. "It'll look like the Batmobile's doing all the heavy-duty stuff, but it's not," says Justus.

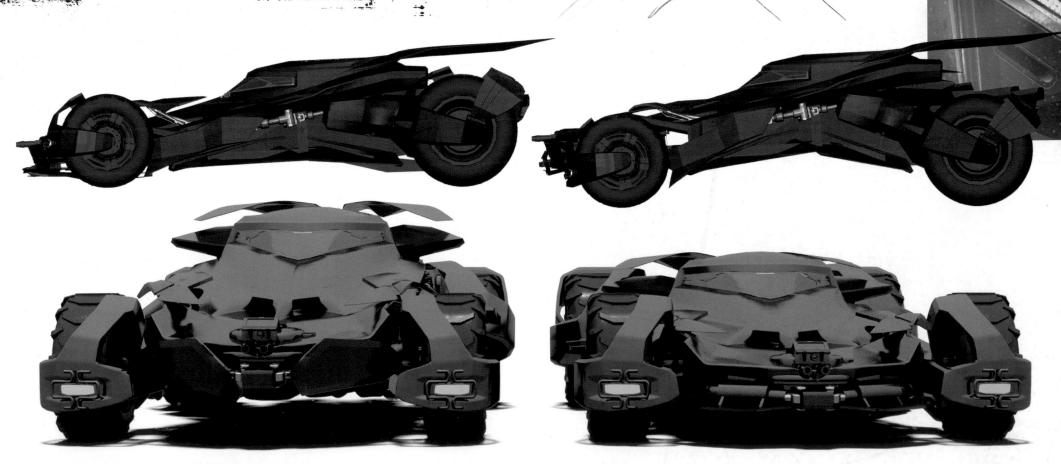

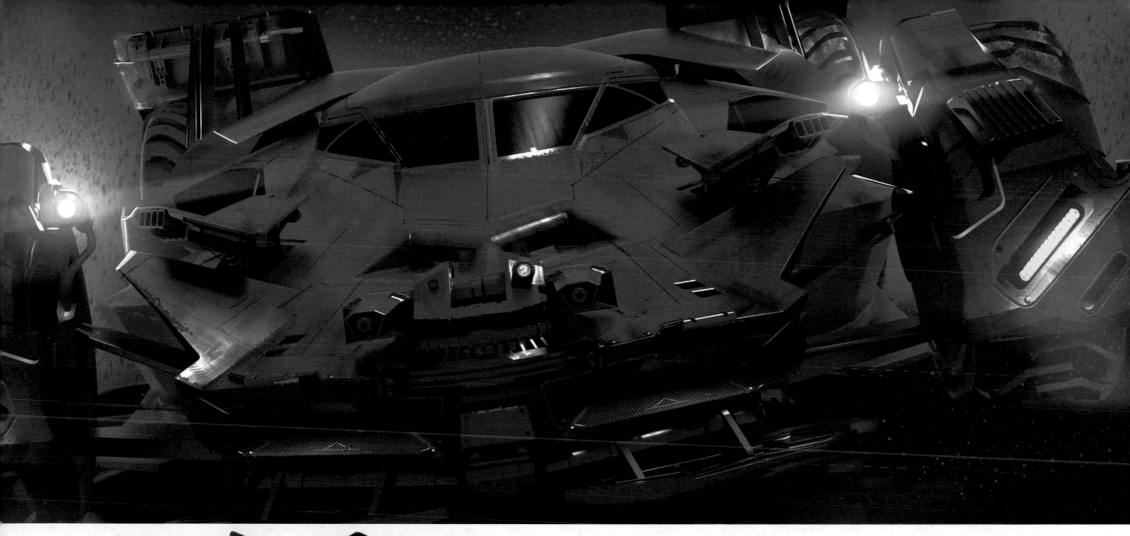

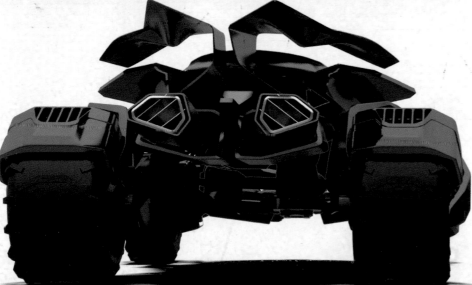

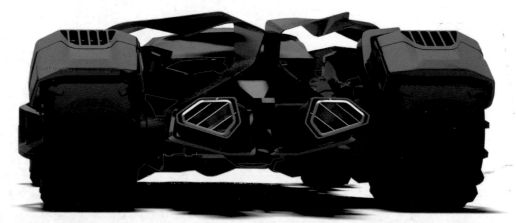

3D modeling demonstrating the Batmobile's versatility and mutability.

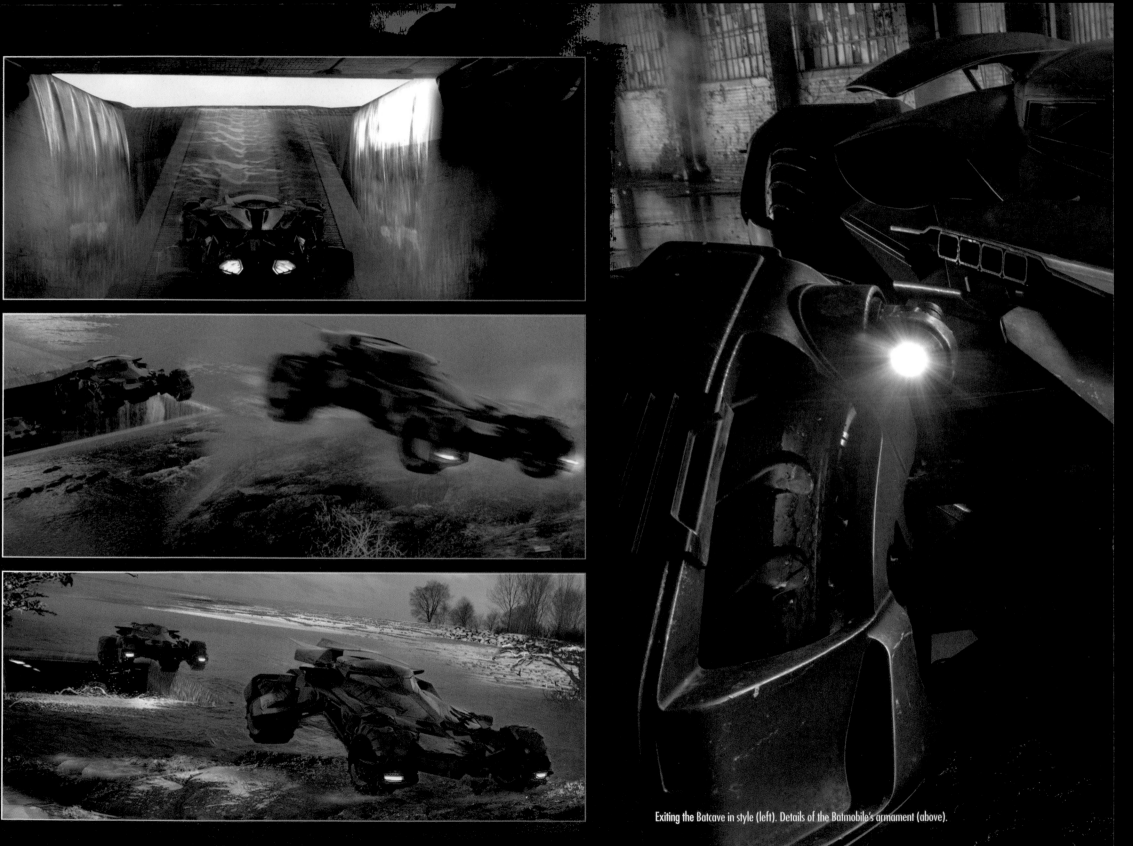

Exiting the Batcave in style (left). Details of the Batmobile's armament (above).

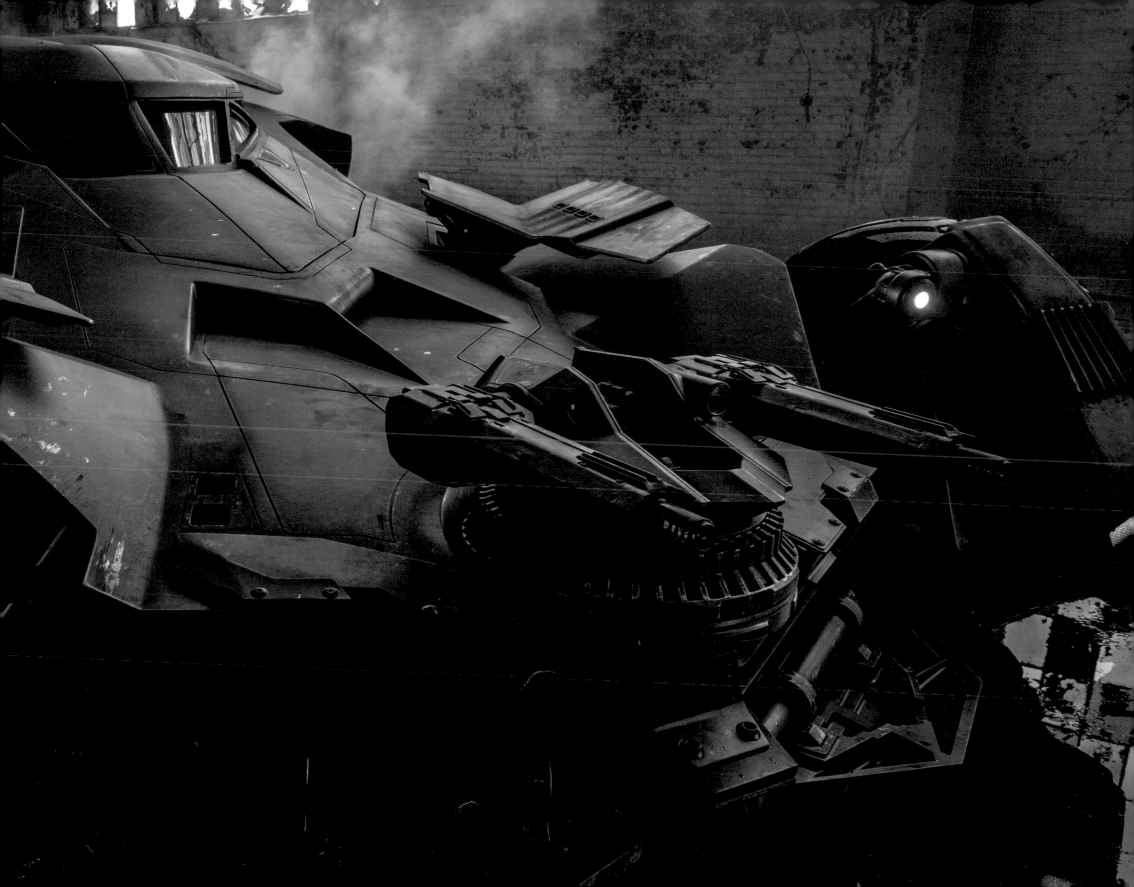

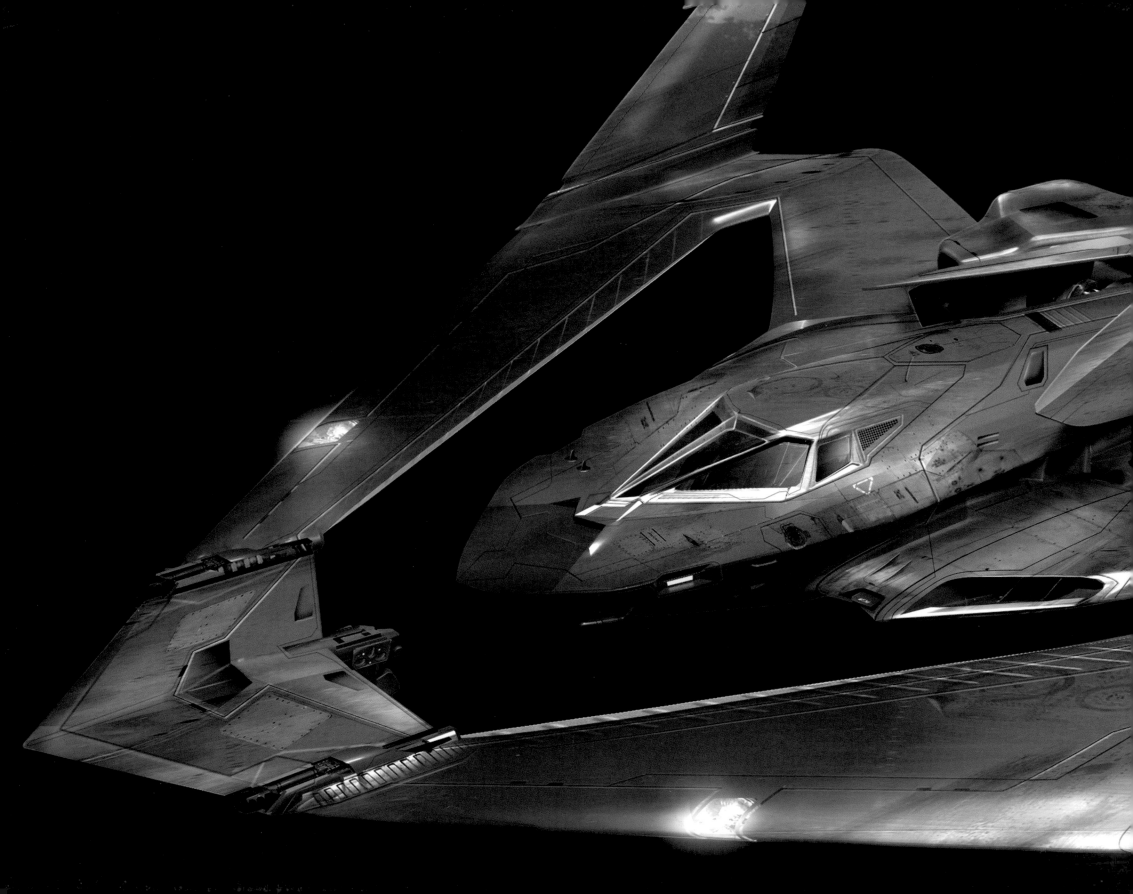

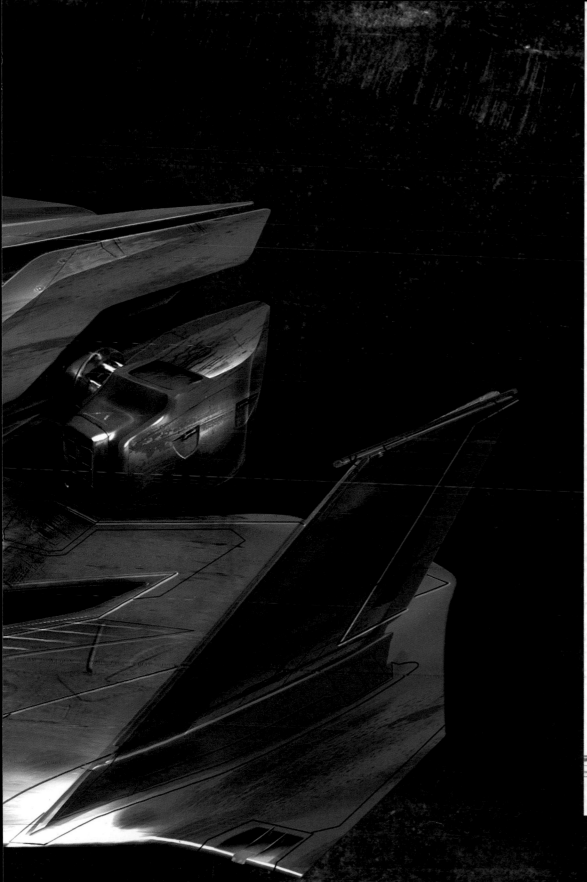

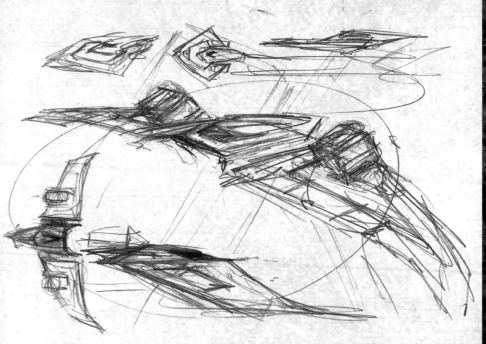

BATWING

The design of the Batwing also followed in the tradition of many of Batman's earlier aircraft, but with a twist. "The previous incarnations were almost silhouettes of a bat symbol," explains concept artist Ed Natividad. "In this case, we used the bat motif in the negative space of the wings. More of a silhouette approach, but still keeping it bordering on fantasy."

For the places the Batmobile can't access or get to quick enough, having a vertical take-off and landing (VTOL) aircraft like the Batwing is essential. Its wings can retract vertically for takeoffs straight up and out of the Batcave and it has an impressive weapons array. Additionally, the fact that it can be controlled remotely from a console in the Batcave increases its utility and versatility by leaps and bounds, allowing Batman to strike directly at his target while the Batwing lays down covering fire.

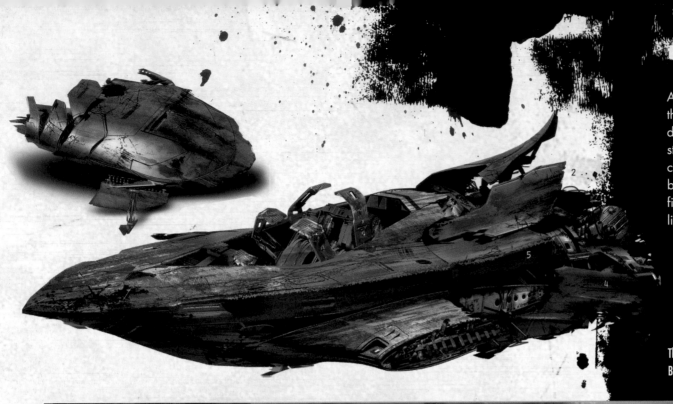

As the Batmobile was established first, many of the design cues for the Batwing came directly from the car, such as the canopy and the dual air scoops. Like the Batmobile, it doesn't feel too futuristic; its styling and technology exist entirely within the constraints of what is currently plausible for military aircraft. "It looks like an offshore race boat," says art director Beat Frutiger. "It's a mix between aluminum, fiberglass, there is some carbon fiber in it, some honeycomb. So, it's as lightweight as possible, and as sturdy as possible."

The Batwing after undergoing considerable damage (left and below). Awaiting takeoff in the Batcave (opposite).

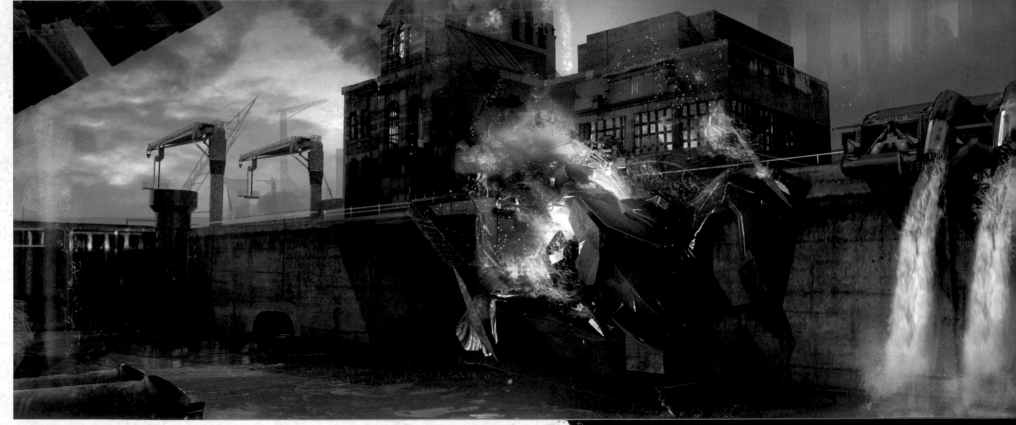

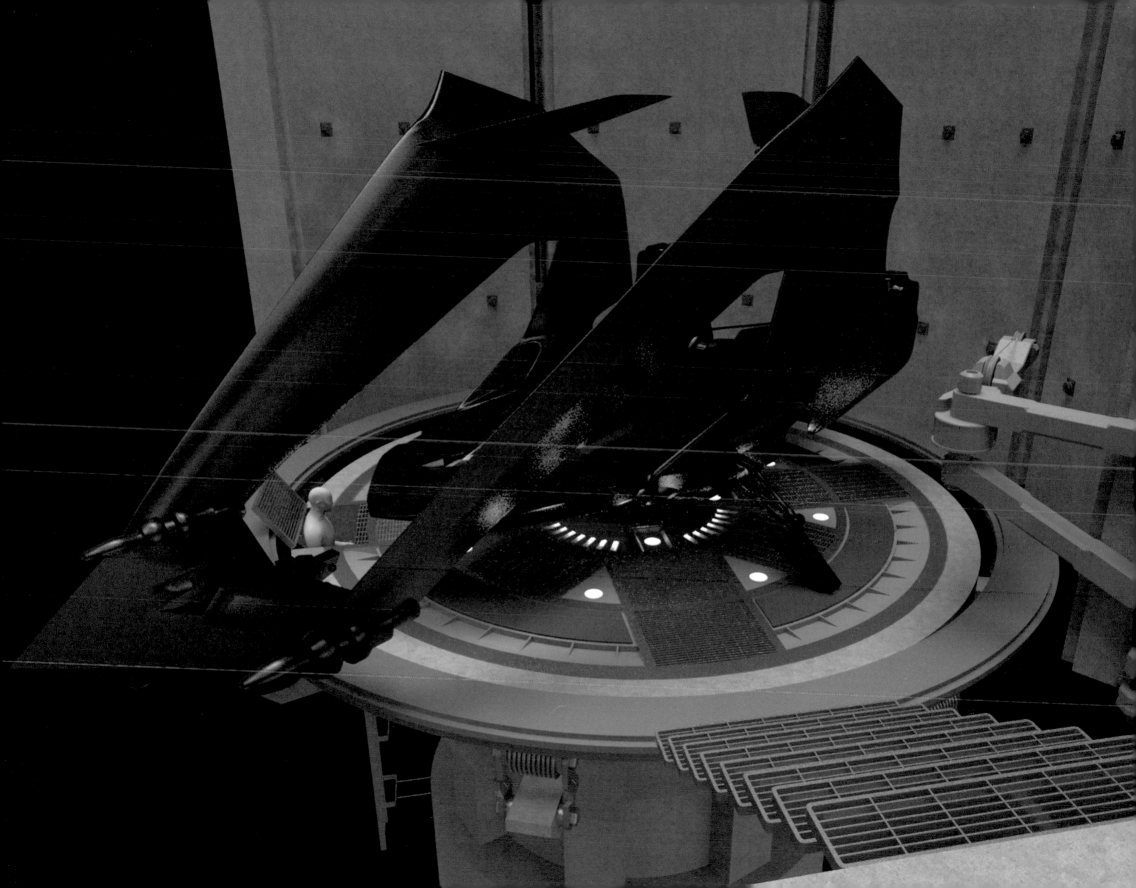

GOTHAM CITY

"OUR GOAL WITH THESE FILMS IS TO TAKE THESE SUPER HEROES AND PUT THEM IN REAL LIFE SITUATIONS, TO PUT THEM IN OUR WORLD, TO MAKE THEM AS RELATABLE AS POSSIBLE."

DEBORAH SNYDER

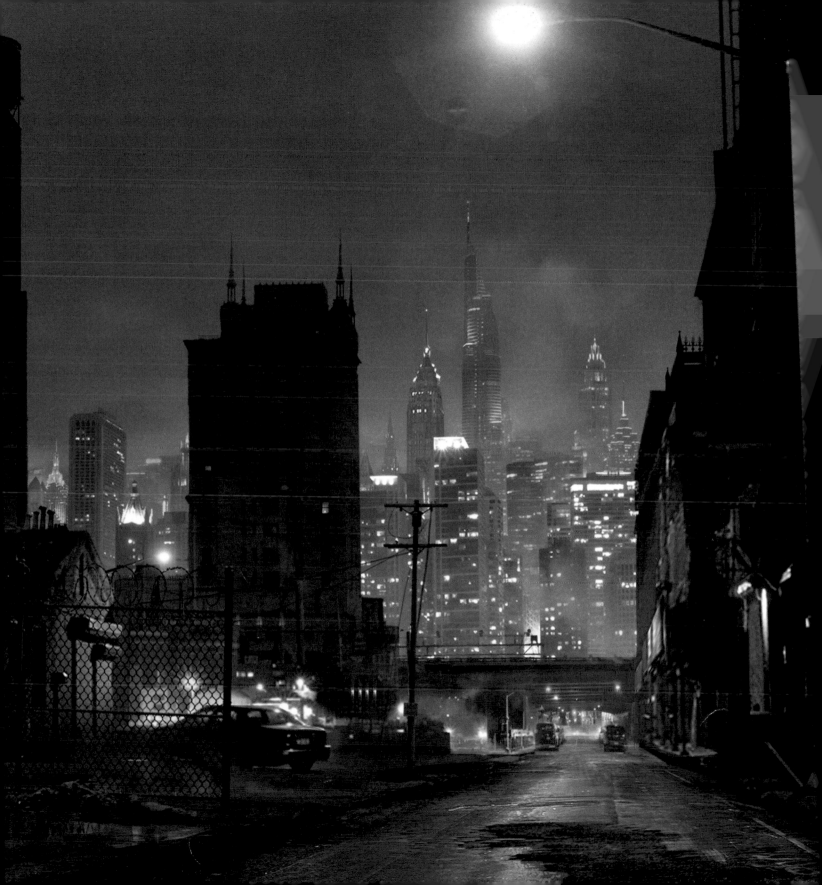

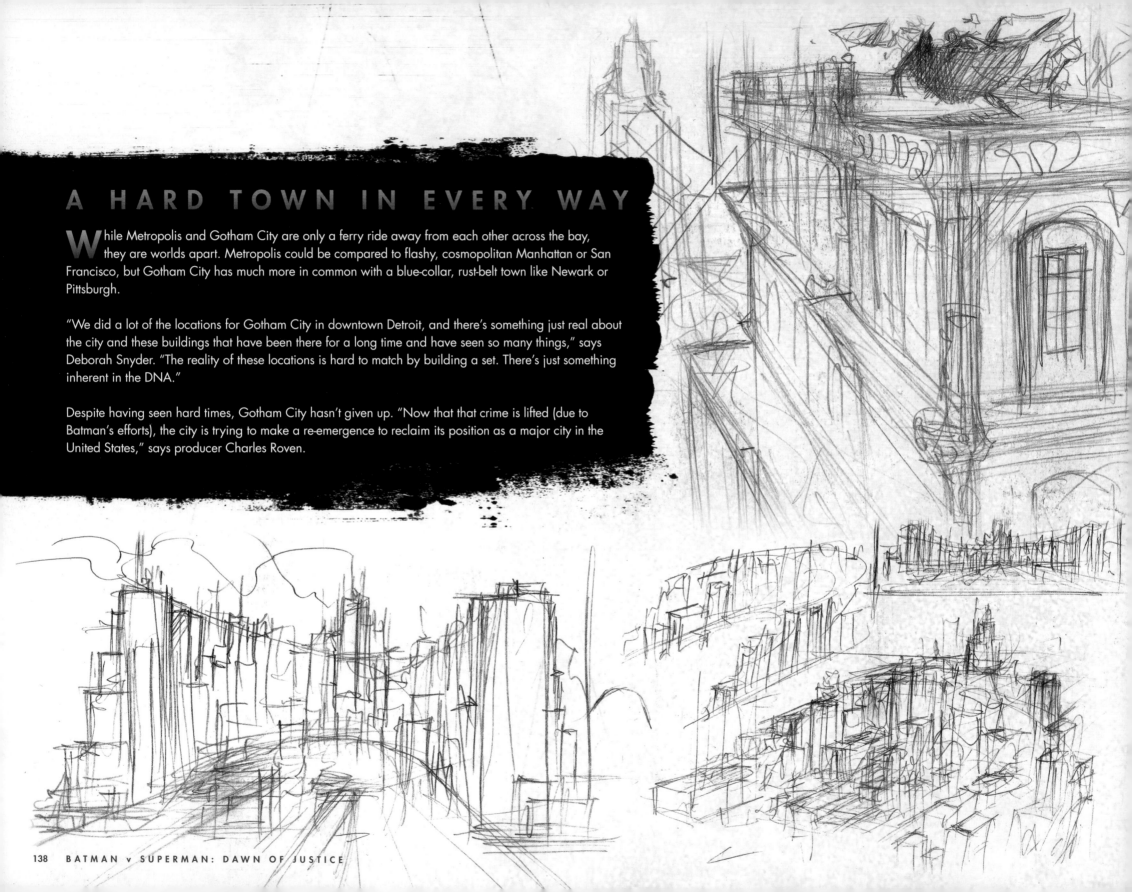

A HARD TOWN IN EVERY WAY

While Metropolis and Gotham City are only a ferry ride away from each other across the bay, they are worlds apart. Metropolis could be compared to flashy, cosmopolitan Manhattan or San Francisco, but Gotham City has much more in common with a blue-collar, rust-belt town like Newark or Pittsburgh.

"We did a lot of the locations for Gotham City in downtown Detroit, and there's something just real about the city and these buildings that have been there for a long time and have seen so many things," says Deborah Snyder. "The reality of these locations is hard to match by building a set. There's just something inherent in the DNA."

Despite having seen hard times, Gotham City hasn't given up. "Now that that crime is lifted (due to Batman's efforts), the city is trying to make a re-emergence to reclaim its position as a major city in the United States," says producer Charles Roven.

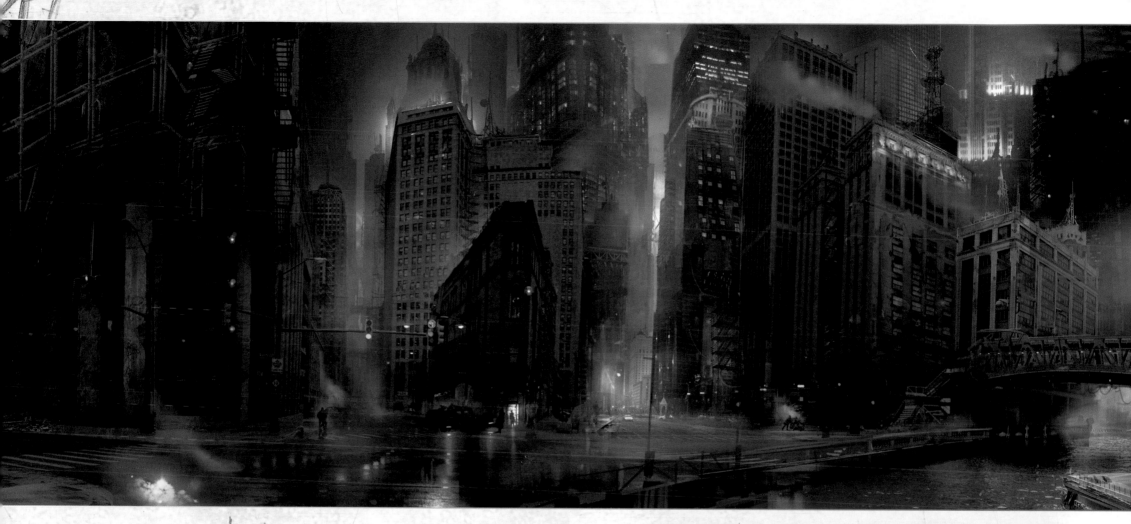

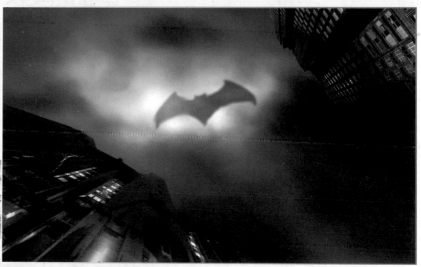

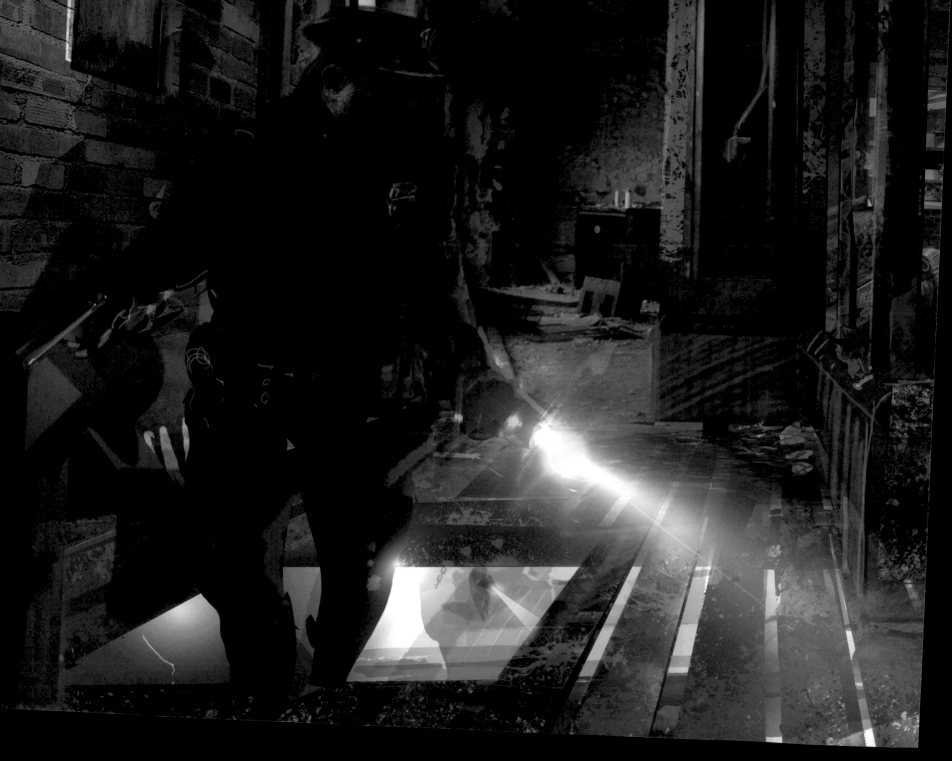

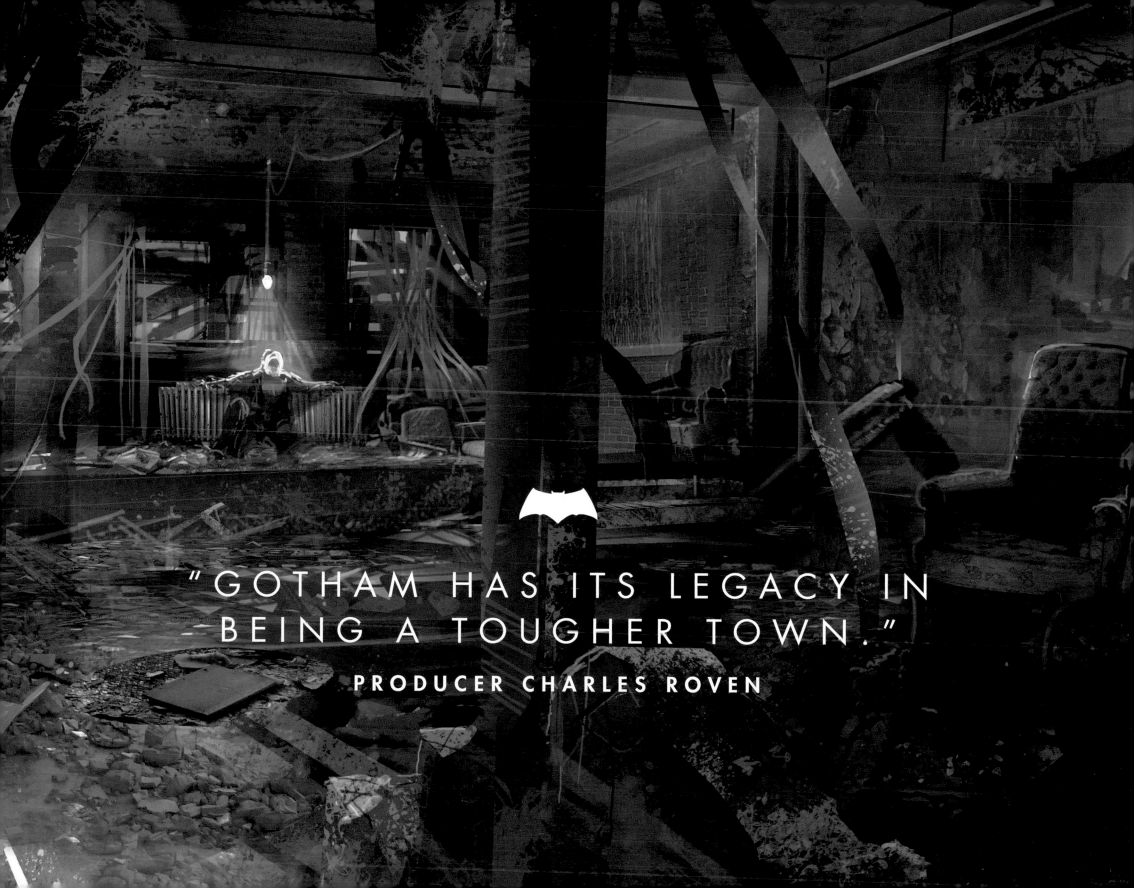

"GOTHAM HAS ITS LEGACY IN BEING A TOUGHER TOWN."

PRODUCER CHARLES ROVEN

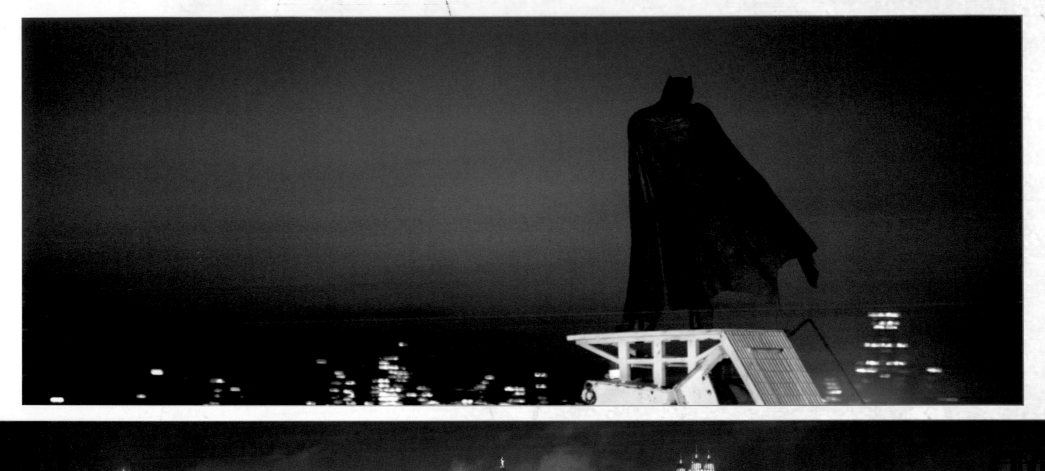

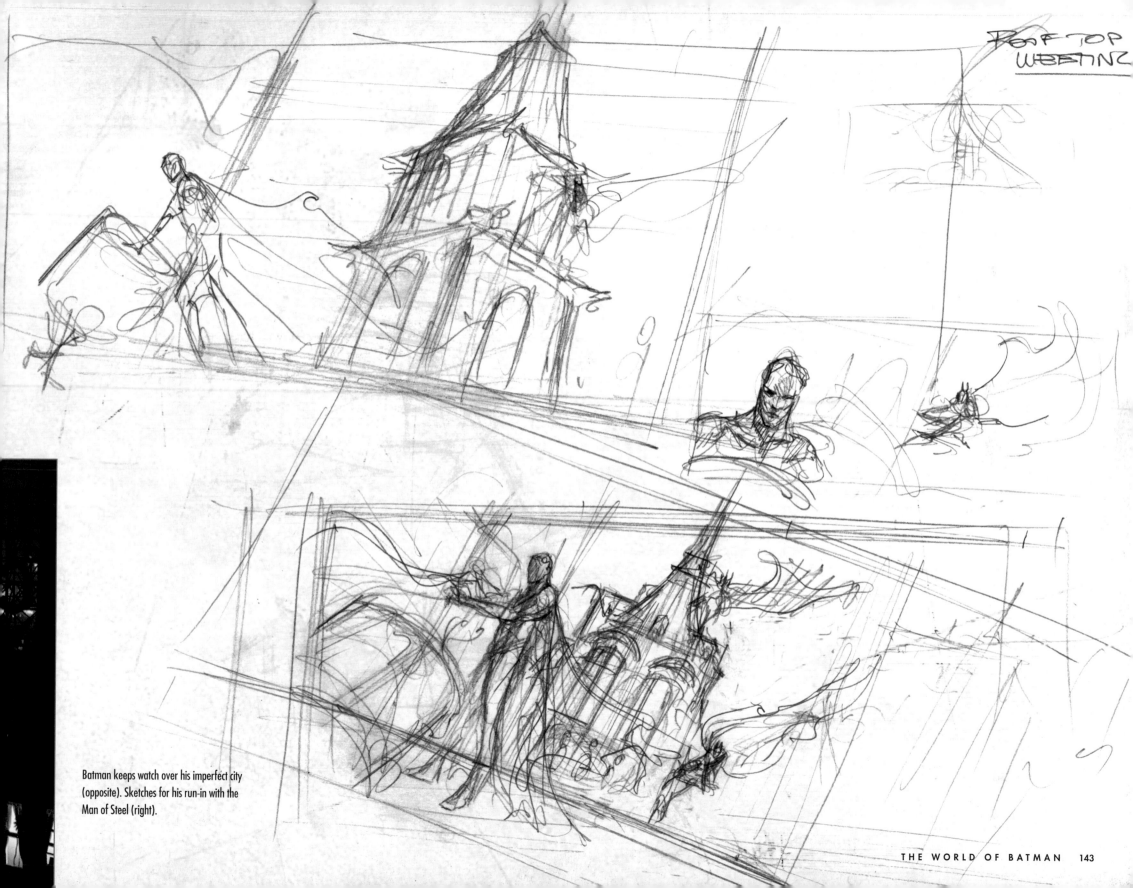

Batman keeps watch over his imperfect city (opposite). Sketches for his run-in with the Man of Steel (right).

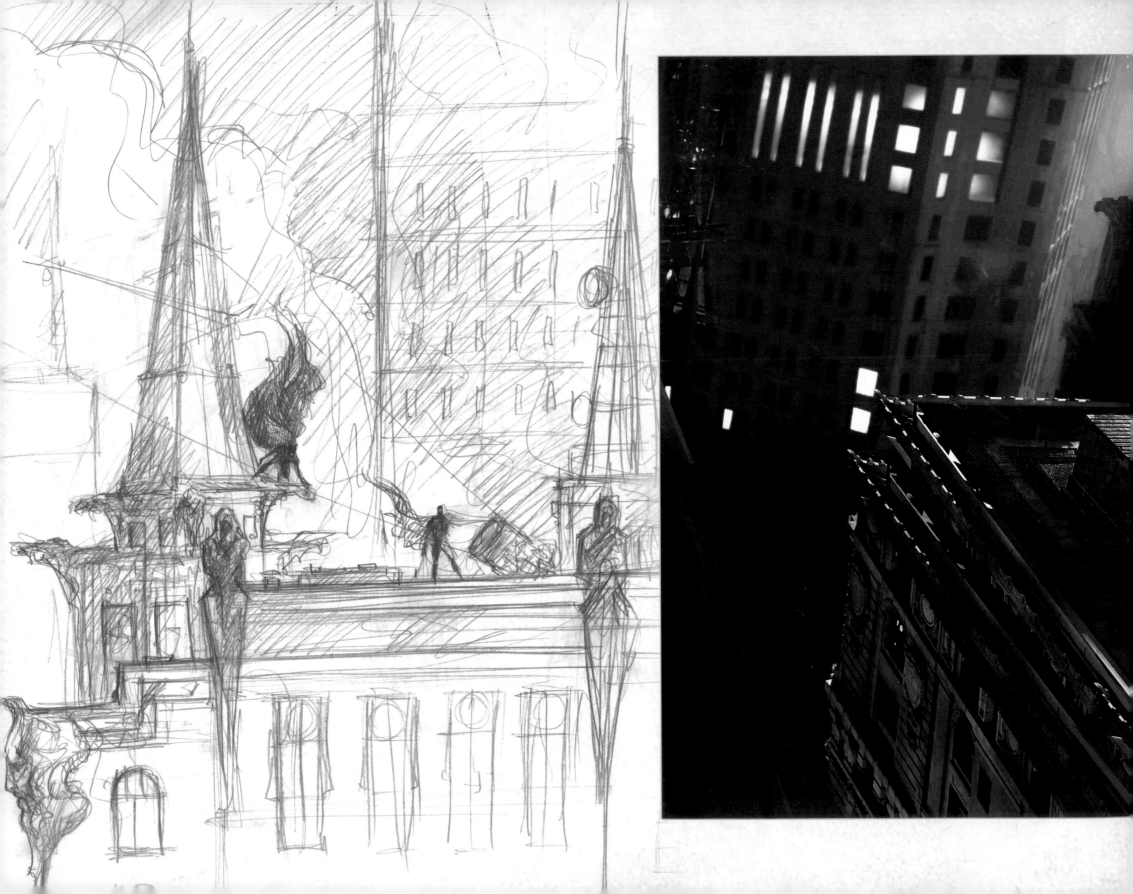

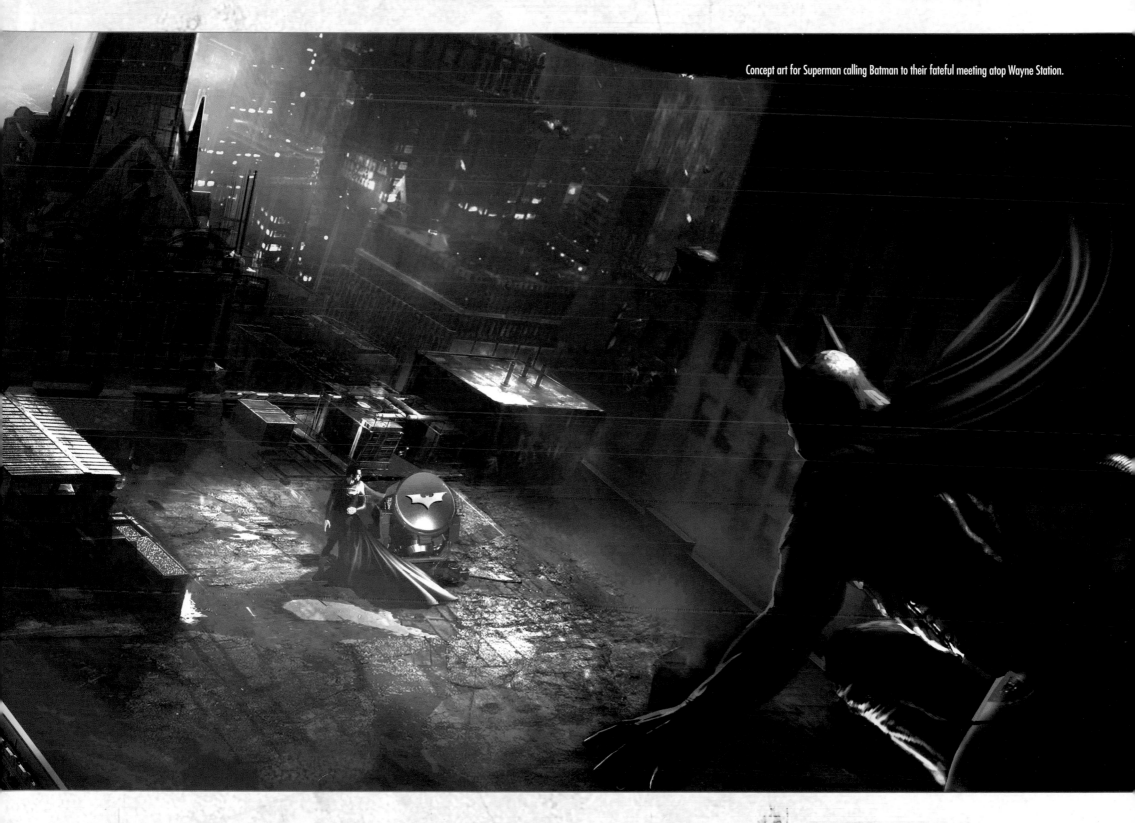

Concept art for Superman calling Batman to their fateful meeting atop Wayne Station.

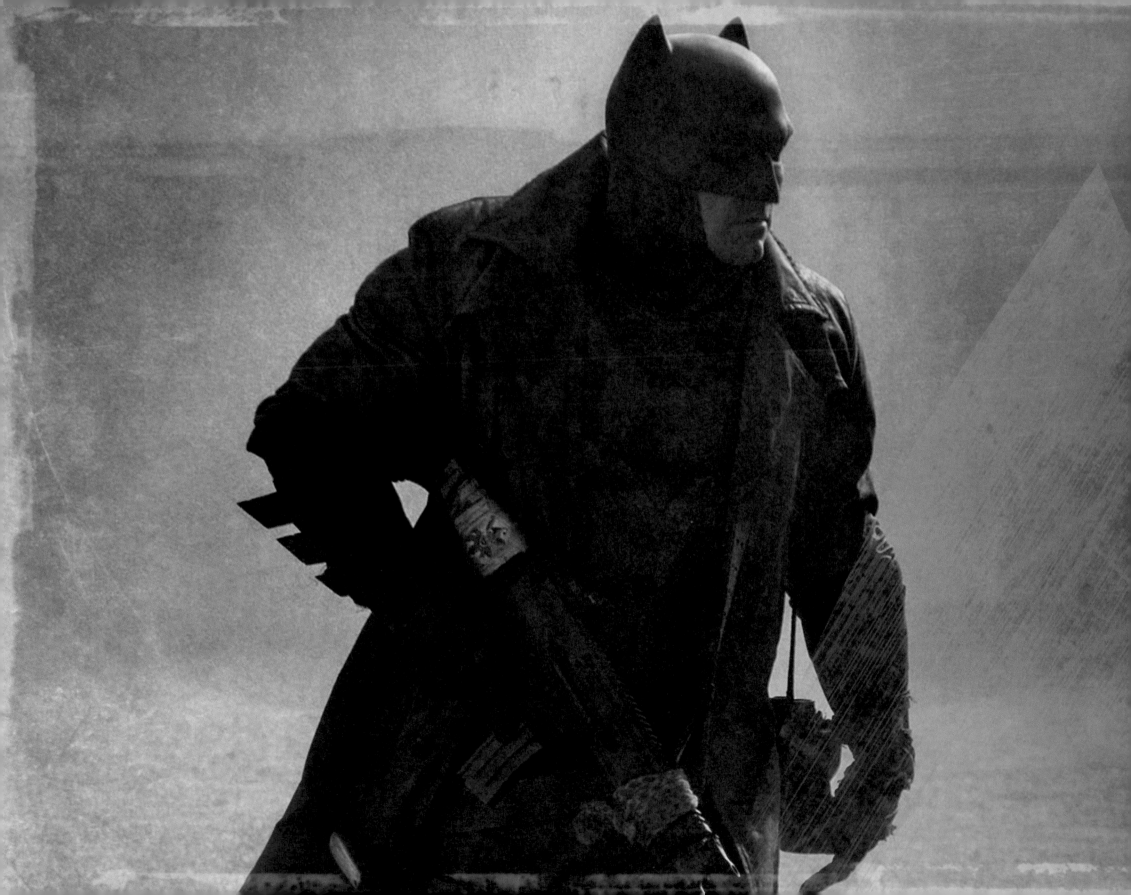

KNIGHTMARE BATMAN

"HE ANSWERS TO NO ONE. NOT EVEN, I THINK, TO GOD."

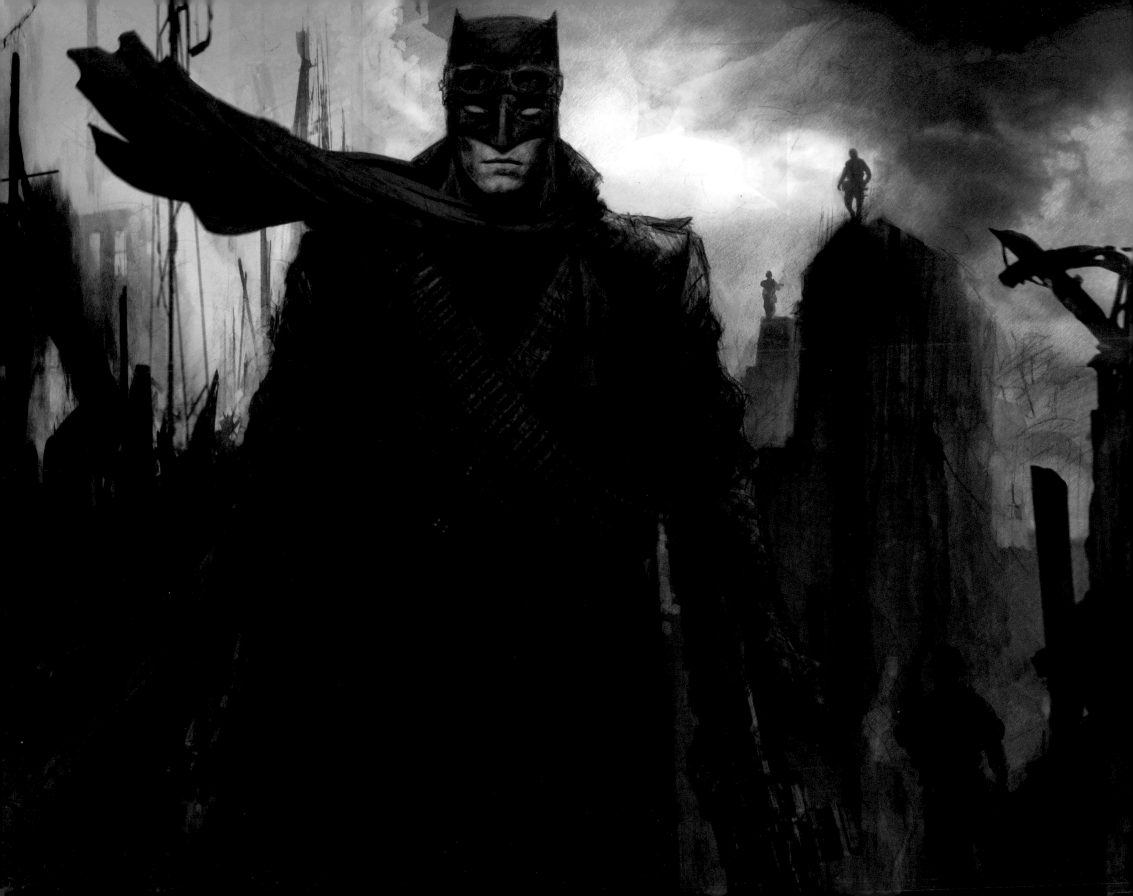

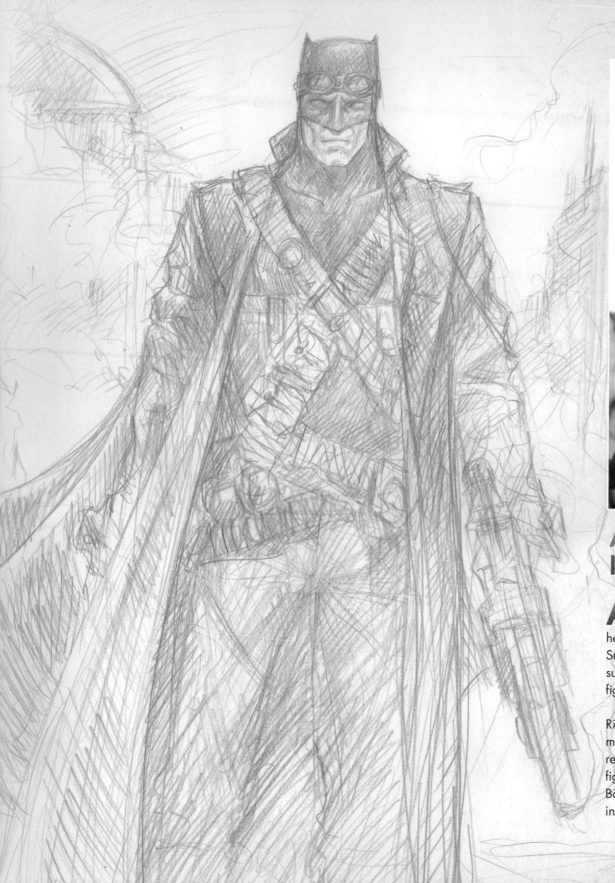

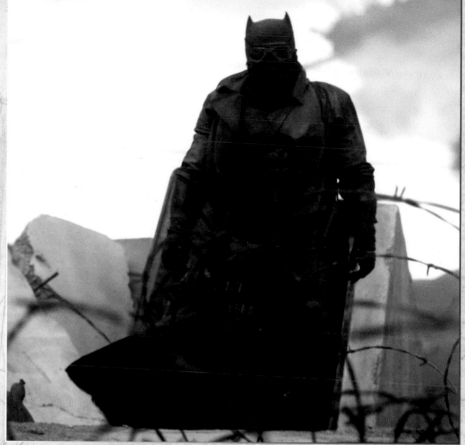

A POST-APOCALYPTIC NIGHTMARE

As Bruce Wayne's concerns about the alien known as Superman blossom into outright fears, they begin to trouble his sleep with terrifying visions of a hellish world utterly dominated by the Man of Steel. Benevolent protector no more, Superman has become a despot who demands absolute obedience from his earthling subjects. Batman and a few loyal followers in a desert bunker are all that remain to fight back against the regime of this power-mad god.

Rich Cetrone, who doubled Ben Affleck as Batman, had to complete over 100 moves in a sequence to take down 24 opponents. "We wanted to make this guy really dynamic," says Cetrone. "When he's fighting, he's in charge. He may be fighting five, six, seven, eight guys at once, but he doesn't cower from anyone… Batman is a technical fighter. He can slug when he has to but can take you down in a number of ways."

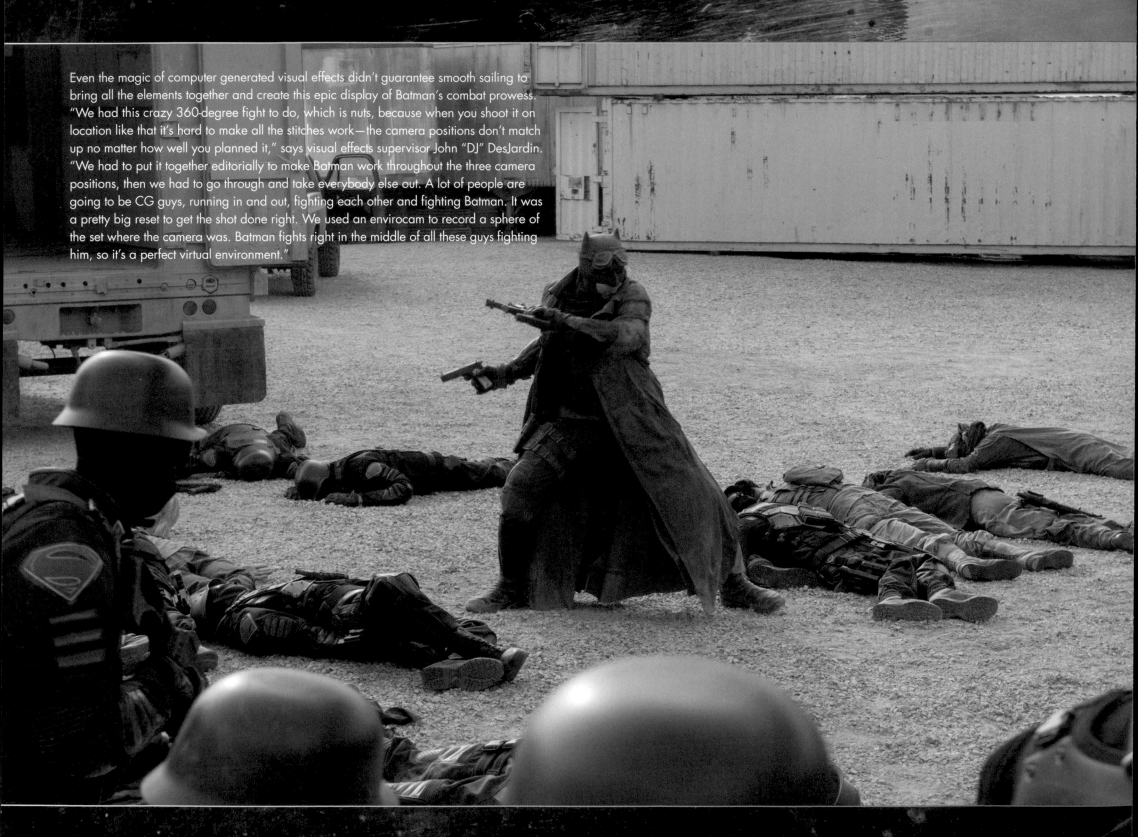

Even the magic of computer generated visual effects didn't guarantee smooth sailing to bring all the elements together and create this epic display of Batman's combat prowess. "We had this crazy 360-degree fight to do, which is nuts, because when you shoot it on location like that it's hard to make all the stitches work—the camera positions don't match up no matter how well you planned it," says visual effects supervisor John "DJ" DesJardin. "We had to put it together editorially to make Batman work throughout the three camera positions, then we had to go through and take everybody else out. A lot of people are going to be CG guys, running in and out, fighting each other and fighting Batman. It was a pretty big reset to get the shot done right. We used an envirocam to record a sphere of the set where the camera was. Batman fights right in the middle of all these guys fighting him, so it's a perfect virtual environment."

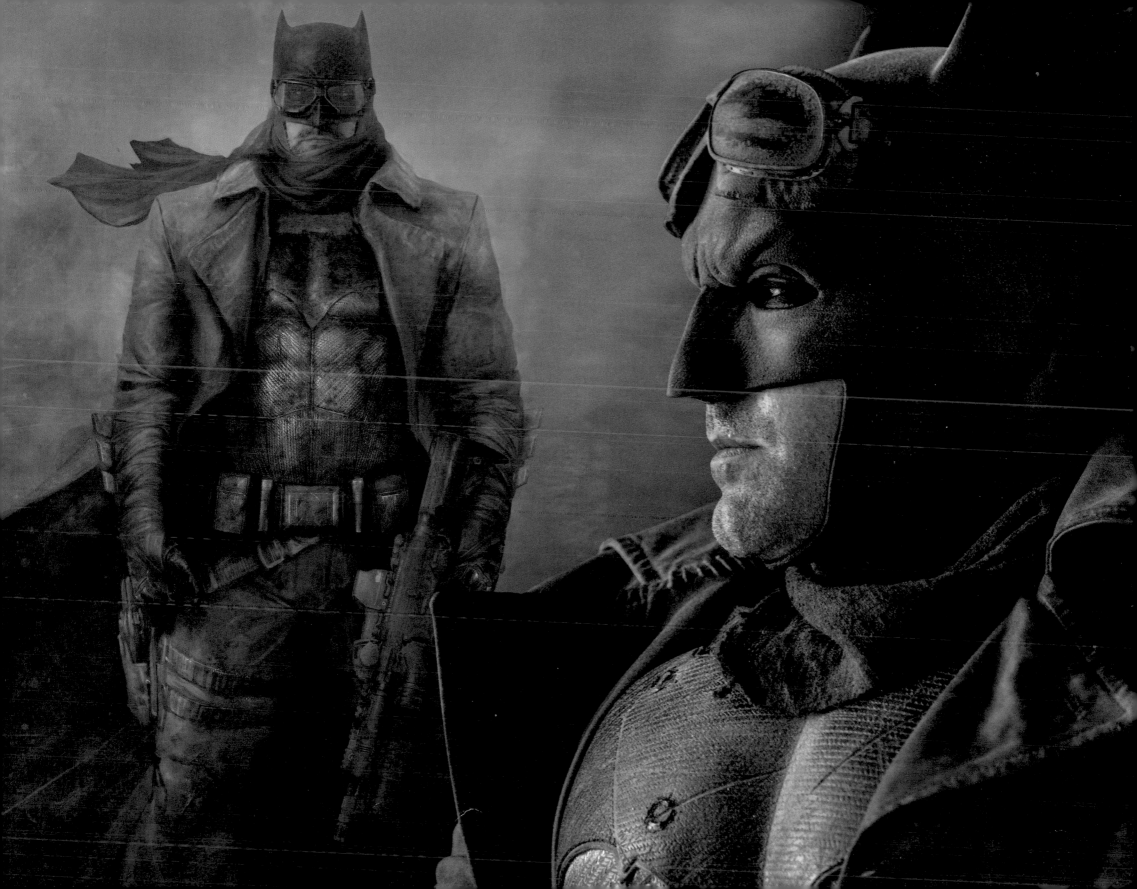

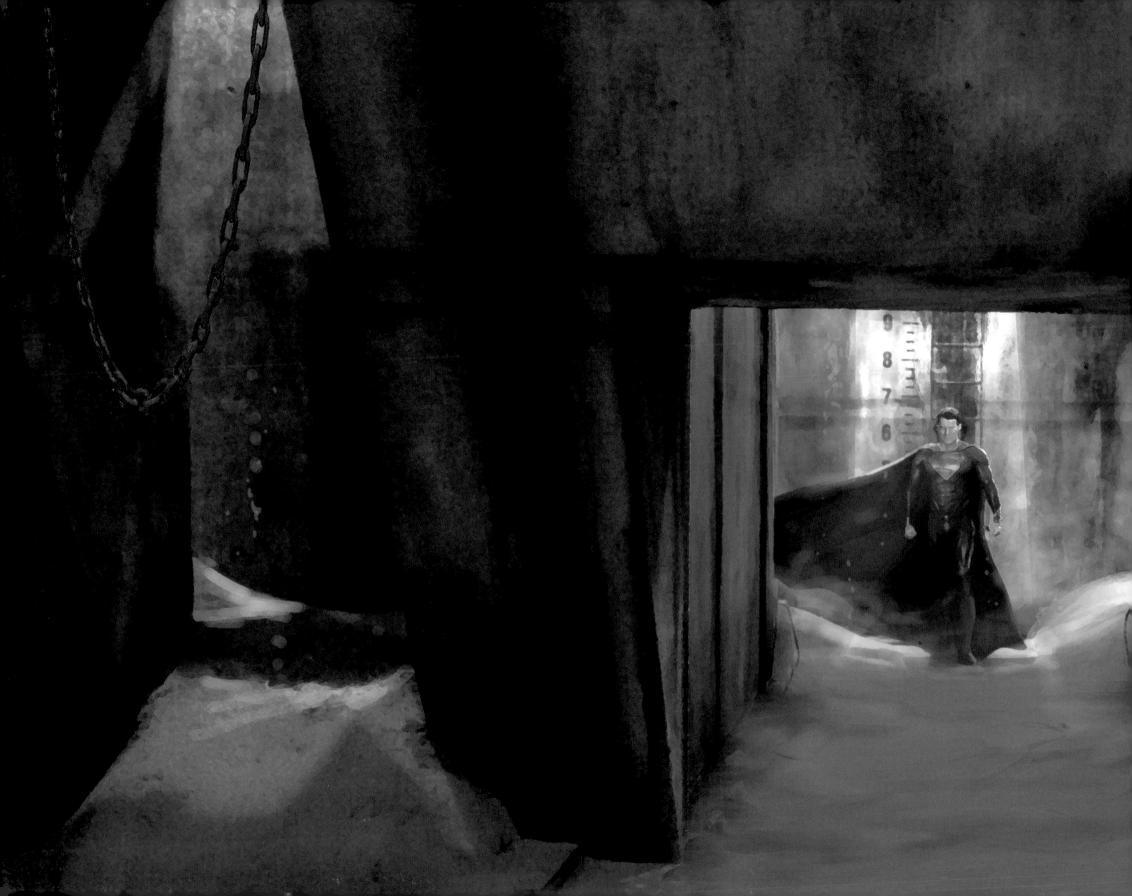

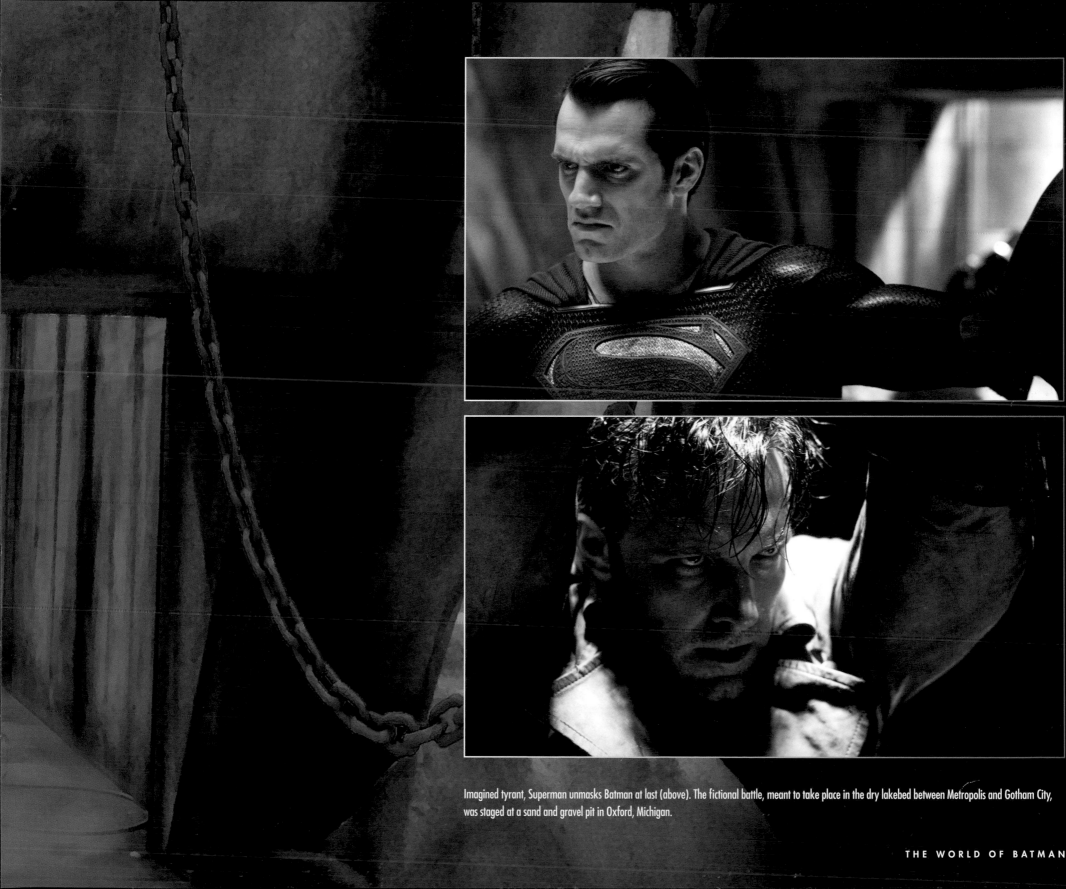

Imagined tyrant, Superman unmasks Batman at last (above). The fictional battle, meant to take place in the dry lakebed between Metropolis and Gotham City, was staged at a sand and gravel pit in Oxford, Michigan.

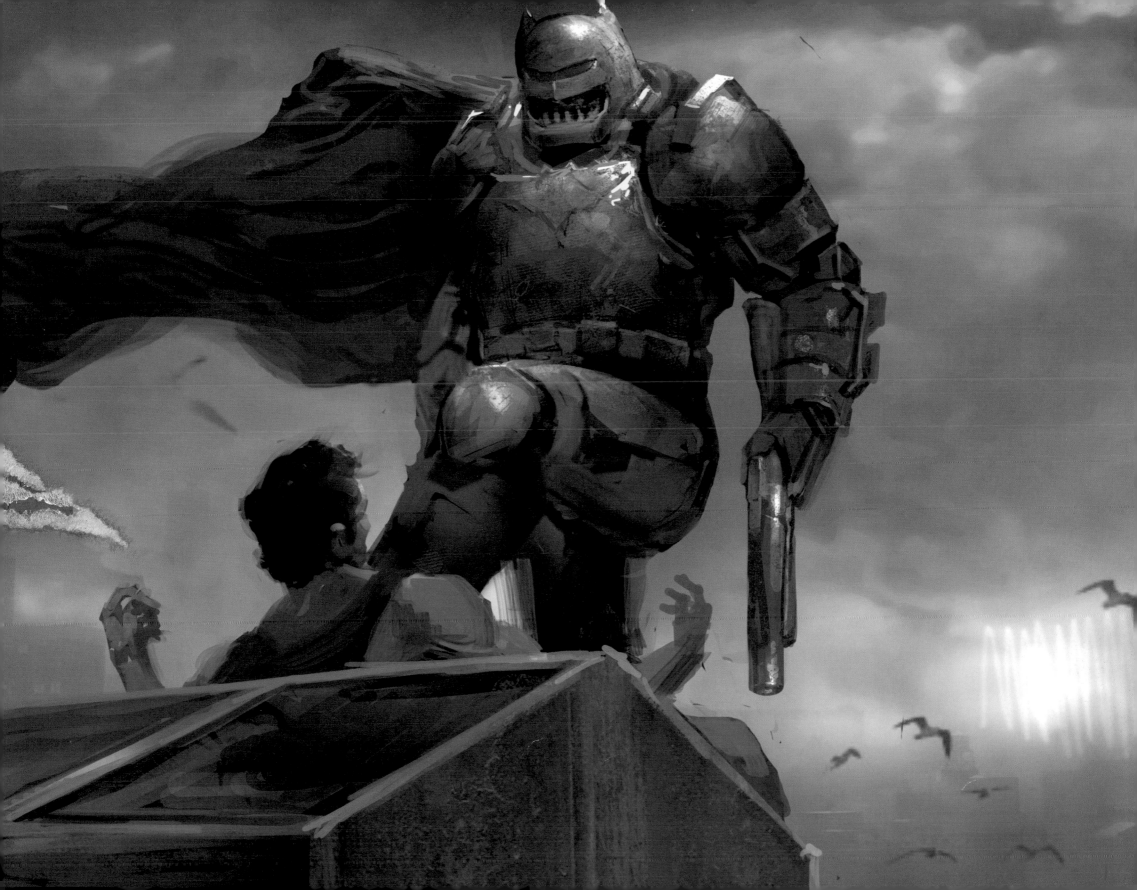

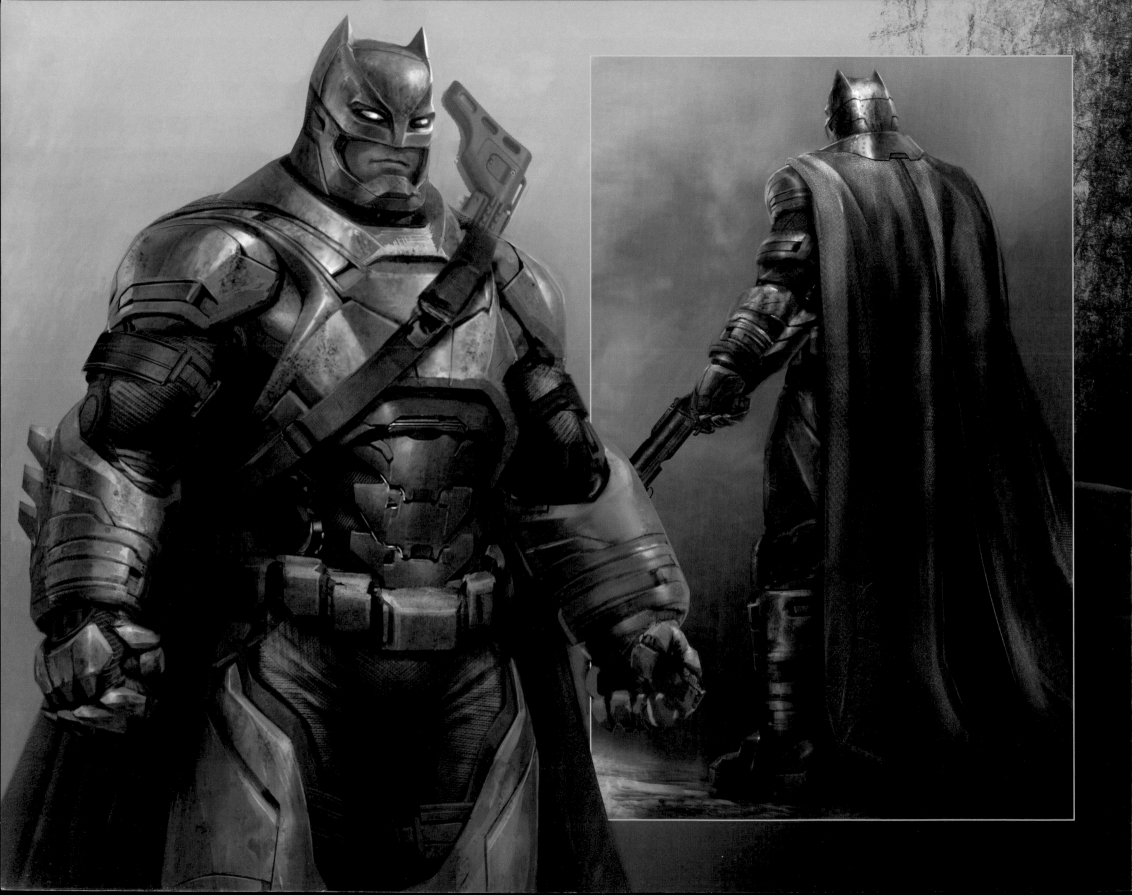

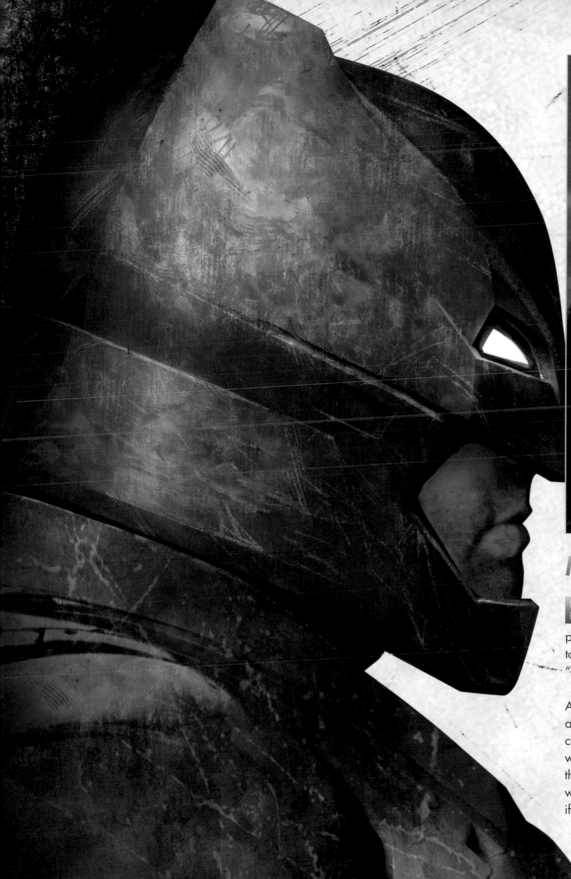

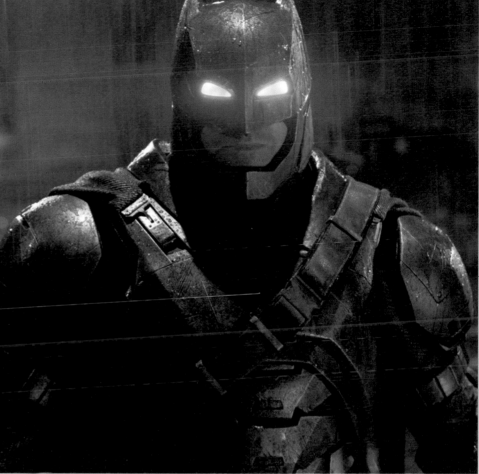

MECH SUIT

Batman's main line of defense against the might of Superman is his specially designed suit of armor. Like the Batsuit, Batman's armor needed to fit his character and his personality as he goes into the fight. "You get the sense that it's something a guy has put together, welded, prototyped in his work room," says costume designer Michael Wilkinson. "It's kind of unfinished and raw and oversized and kind of brutish."

Although certain shots of Batman in the mech suit were created via motion capture and CGI when showcasing his speed and mobility was of the essence, an actual suit constructed of foam and nylon under a fiberglass shell was worn at other times, such as when the two combatants come into contact with each other. "We made a determination that we wanted to use the real mech suit whenever possible," says Deborah Snyder. "The way that Henry (Cavill) reacts to Ben (Affleck) when he's in that suit I think is different than if it was a mocap suit."

LEAD & KRYPTONITE GRENADES
AND GRAPPLING GUN

Bruce Wayne has discovered two of Superman's weaknesses, and he's incorporated them both into grenades he can fire from a launcher (opposite). The lead grenades create a smoky haze that even Superman's x-ray vision can't penetrate, allowing for the stealthy getaways Batman is known for. The kryptonite grenades not only weaken the Kryptonian, but they also make him vulnerable to damage from Batman's steel-encased fists. Considering that Superman hasn't had much training in martial arts—owing to a complete lack of suitable opponents—this makes it more than a fair fight.

Batman uses a couple of different models of grappling guns in the film, as seen in the Batcave armory. His newest design, made of carbon fiber and various metals, accompanies him to his battle with Superman; besides being a means of quick, vertical travel, it's also an effective weapon.

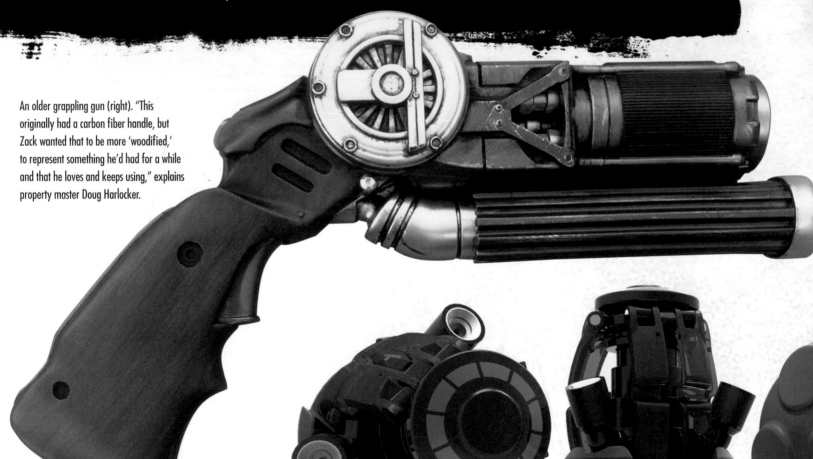

An older grappling gun (right). "This originally had a carbon fiber handle, but Zack wanted that to be more 'woodified,' to represent something he'd had for a while and that he loves and keeps using," explains property master Doug Harlocker.

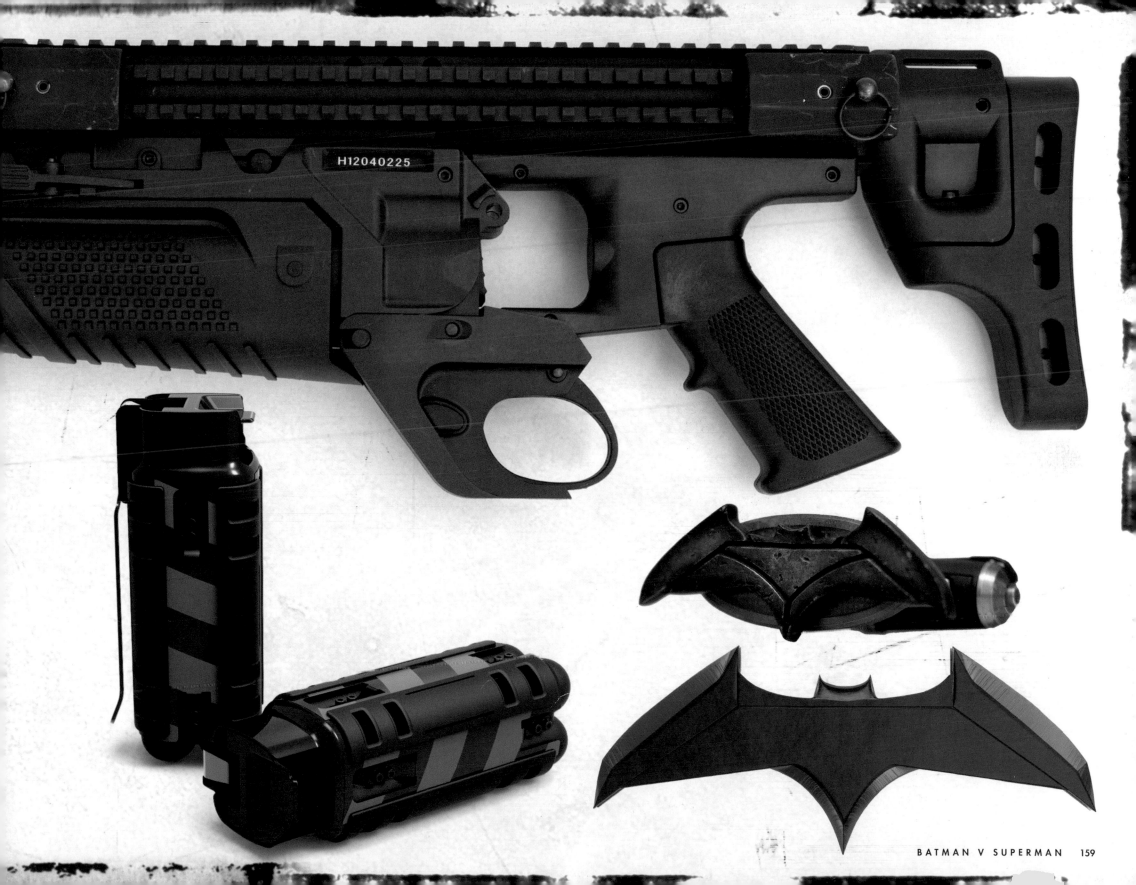

H12040225

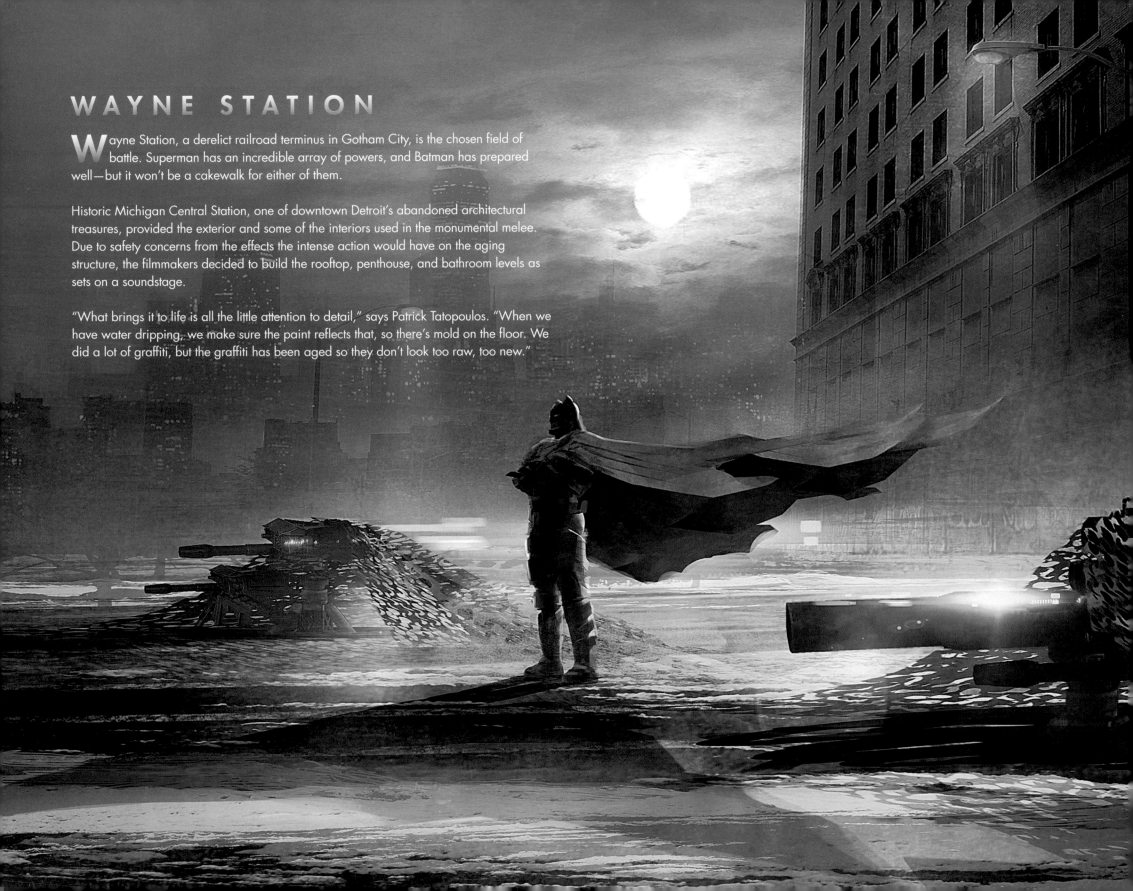

WAYNE STATION

Wayne Station, a derelict railroad terminus in Gotham City, is the chosen field of battle. Superman has an incredible array of powers, and Batman has prepared well—but it won't be a cakewalk for either of them.

Historic Michigan Central Station, one of downtown Detroit's abandoned architectural treasures, provided the exterior and some of the interiors used in the monumental melee. Due to safety concerns from the effects the intense action would have on the aging structure, the filmmakers decided to build the rooftop, penthouse, and bathroom levels as sets on a soundstage.

"What brings it to life is all the little attention to detail," says Patrick Tatopoulos. "When we have water dripping, we make sure the paint reflects that, so there's mold on the floor. We did a lot of graffiti, but the graffiti has been aged so they don't look too raw, too new."

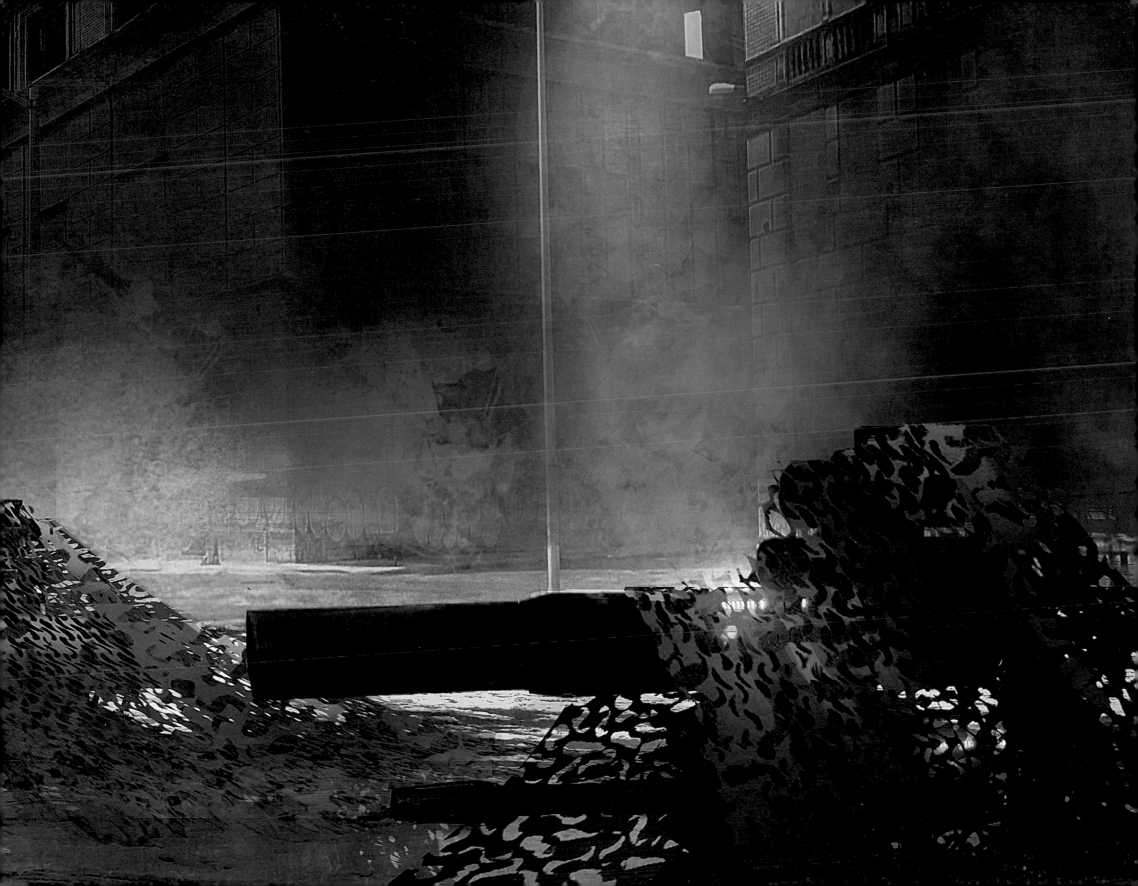

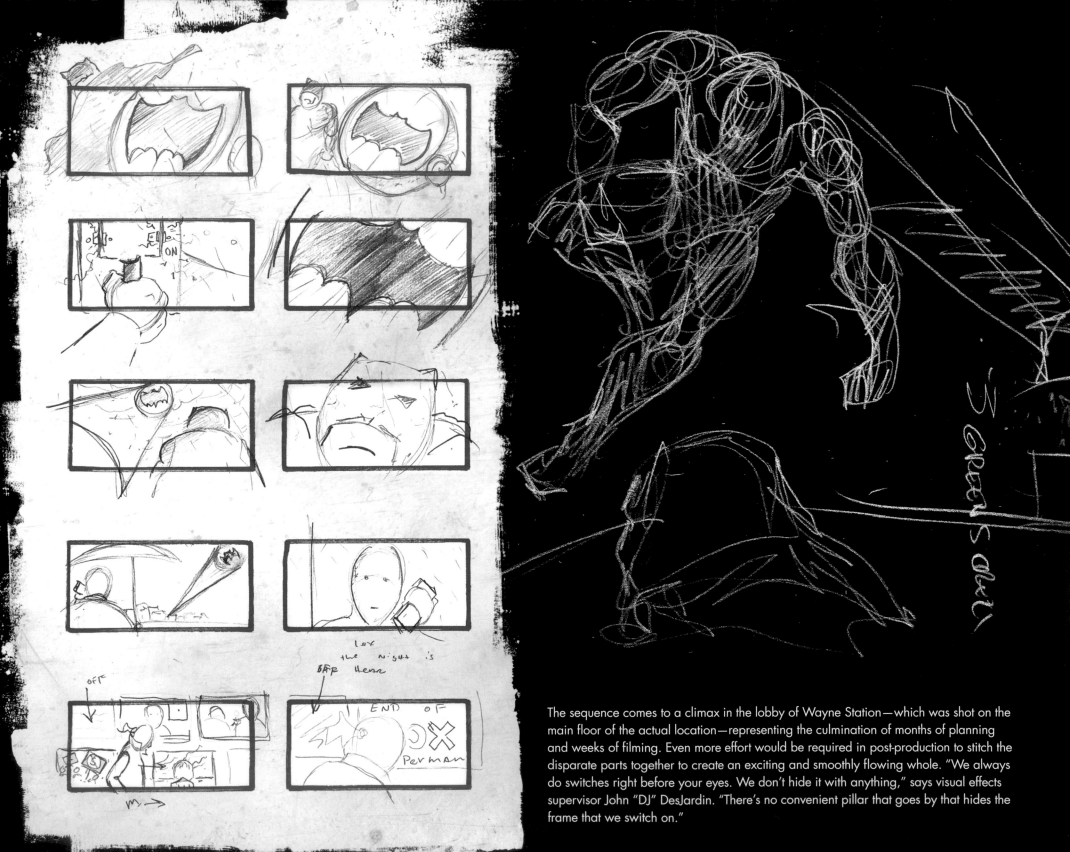

The sequence comes to a climax in the lobby of Wayne Station—which was shot on the main floor of the actual location—representing the culmination of months of planning and weeks of filming. Even more effort would be required in post-production to stitch the disparate parts together to create an exciting and smoothly flowing whole. "We always do switches right before your eyes. We don't hide it with anything," says visual effects supervisor John "DJ" DesJardin. "There's no convenient pillar that goes by that hides the frame that we switch on."

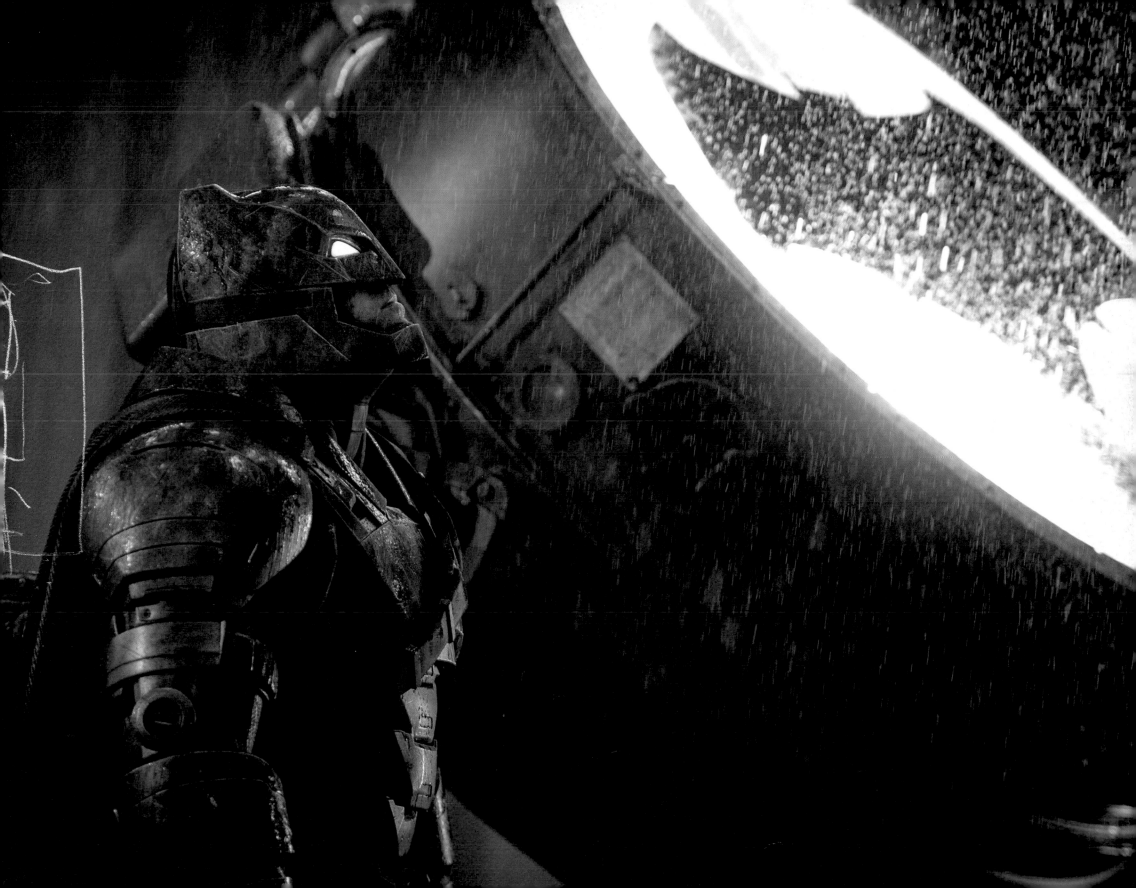

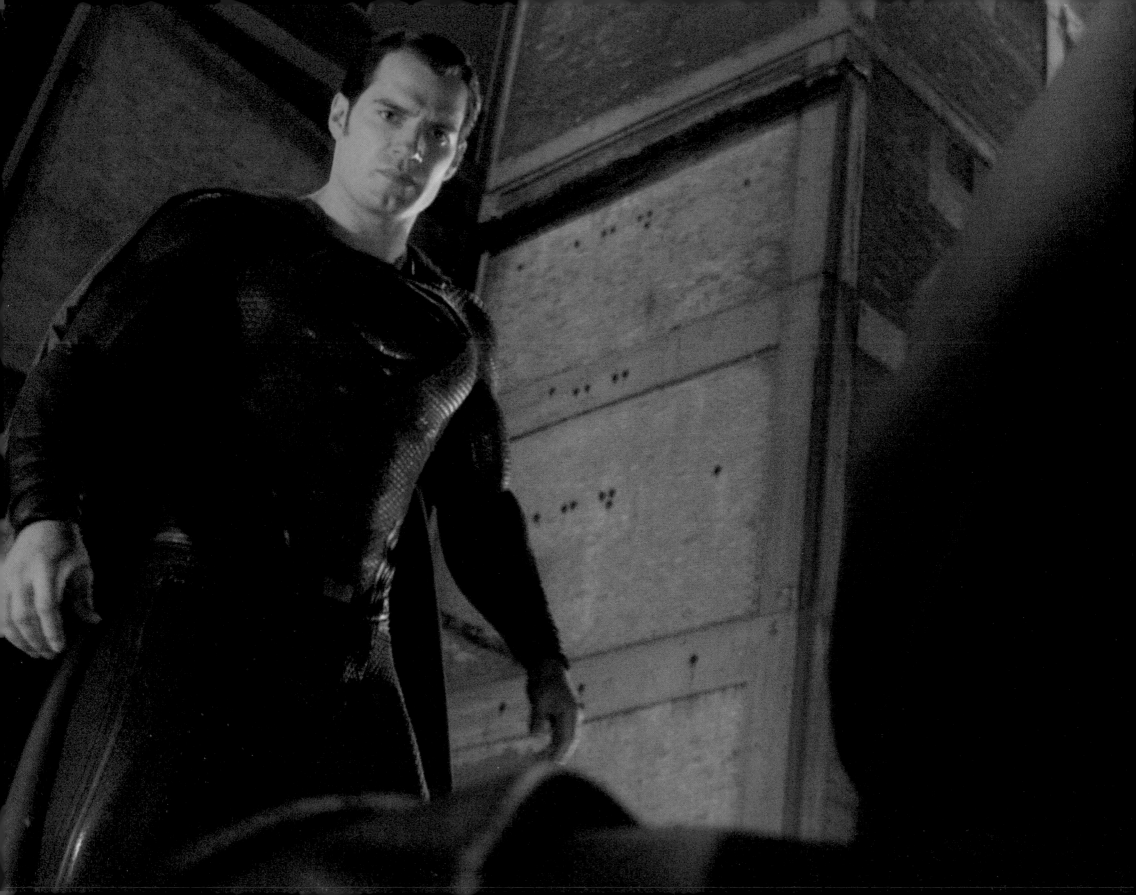

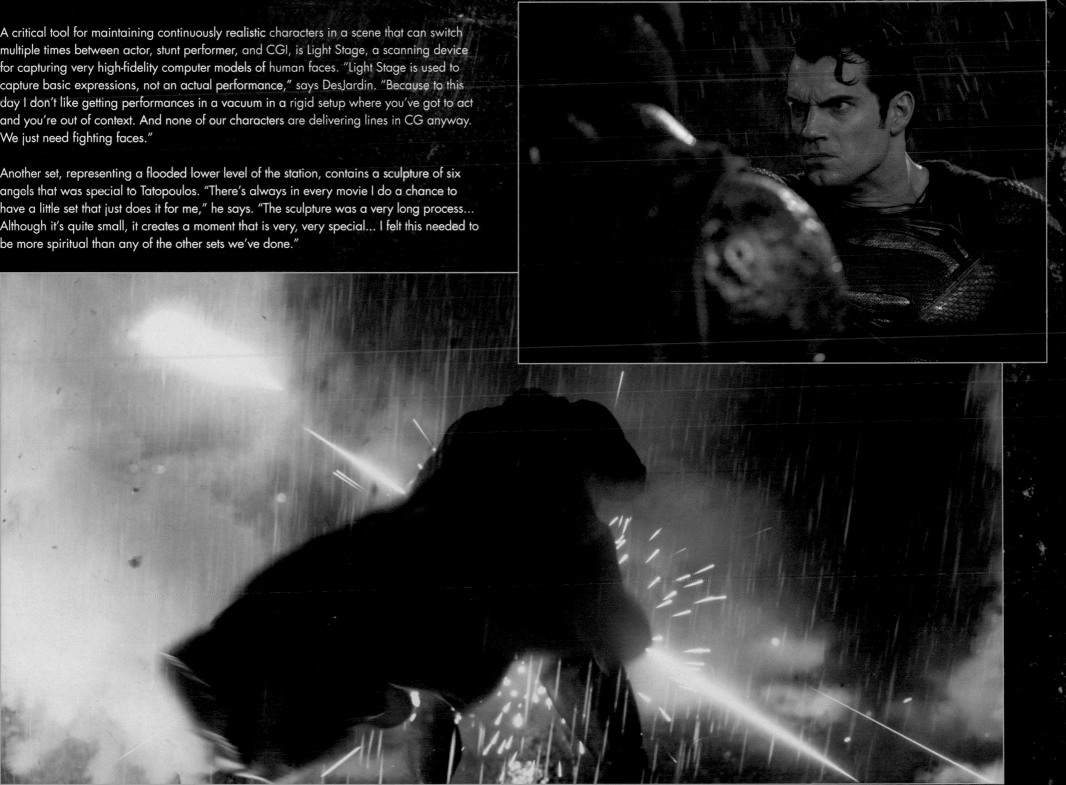

A critical tool for maintaining continuously realistic characters in a scene that can switch multiple times between actor, stunt performer, and CGI, is Light Stage, a scanning device for capturing very high-fidelity computer models of human faces. "Light Stage is used to capture basic expressions, not an actual performance," says DesJardin. "Because to this day I don't like getting performances in a vacuum in a rigid setup where you've got to act and you're out of context. And none of our characters are delivering lines in CG anyway. We just need fighting faces."

Another set, representing a flooded lower level of the station, contains a sculpture of six angels that was special to Tatopoulos. "There's always in every movie I do a chance to have a little set that just does it for me," he says. "The sculpture was a very long process... Although it's quite small, it creates a moment that is very, very special... I felt this needed to be more spiritual than any of the other sets we've done."

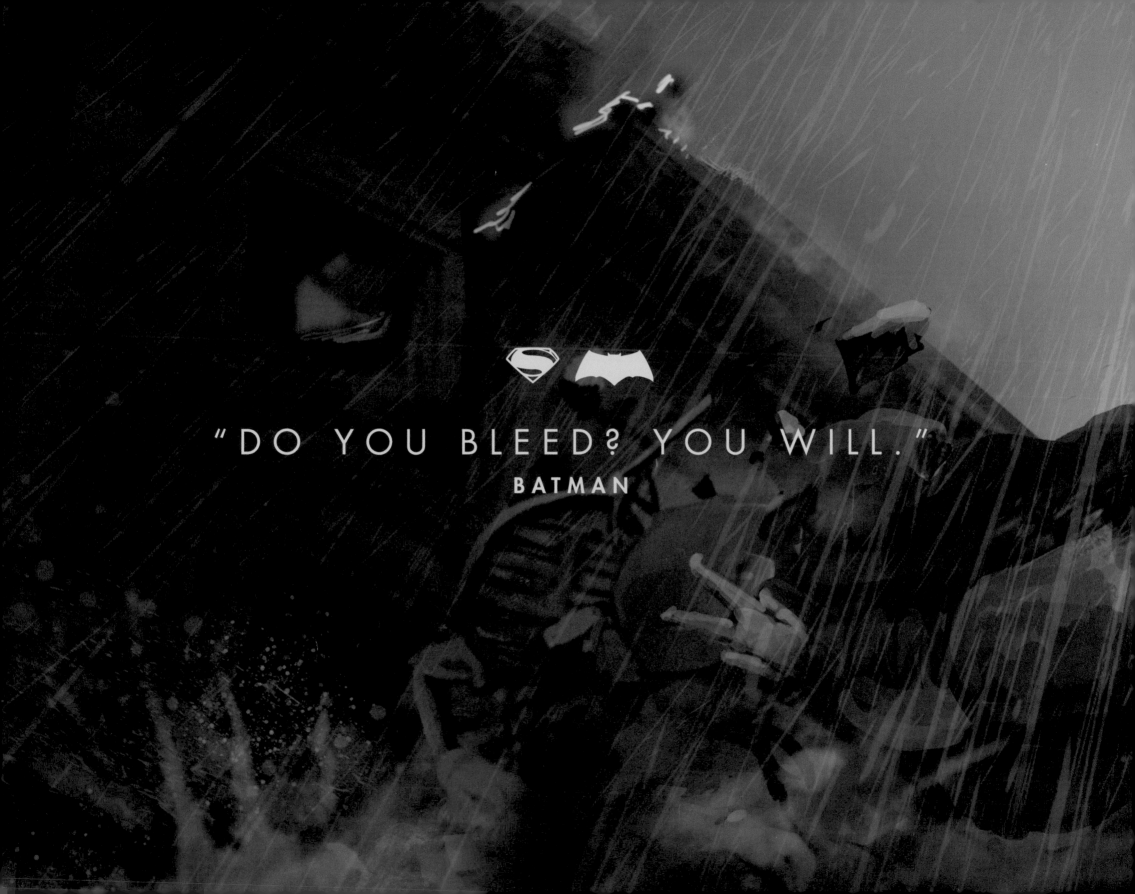

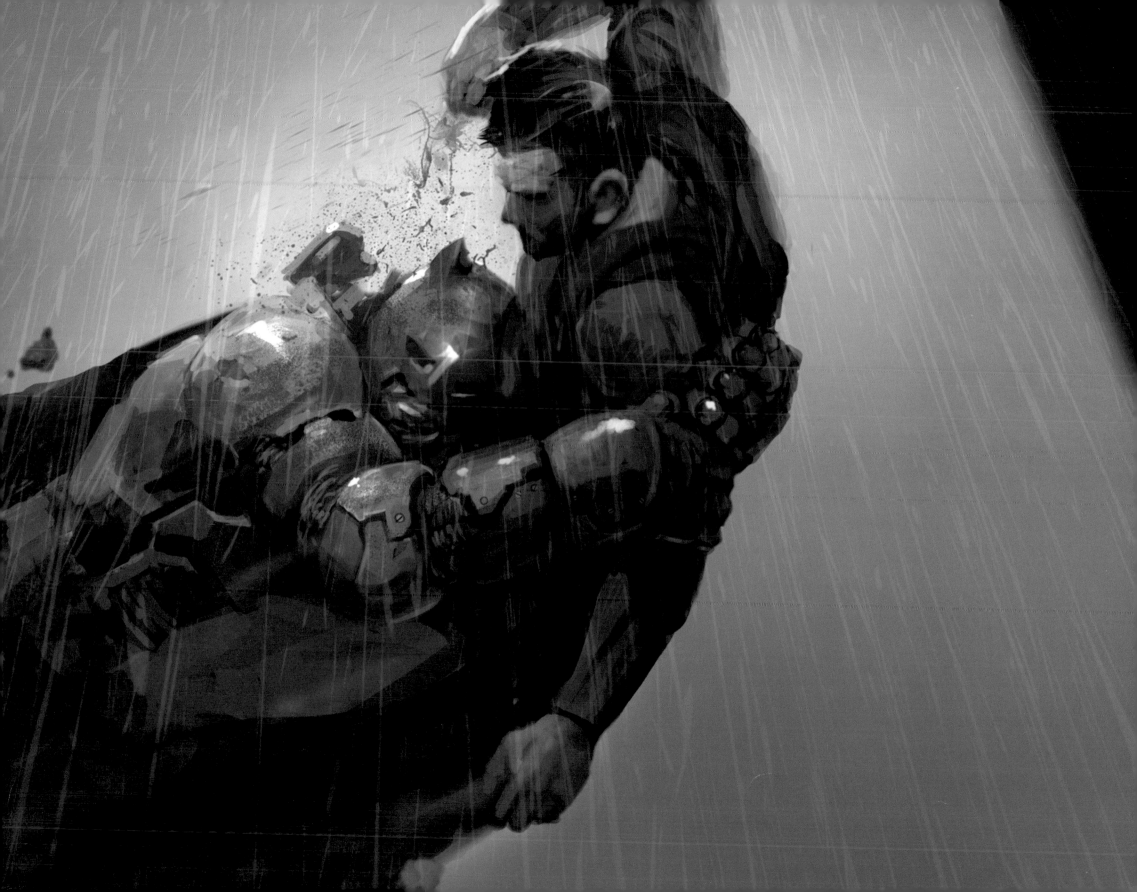

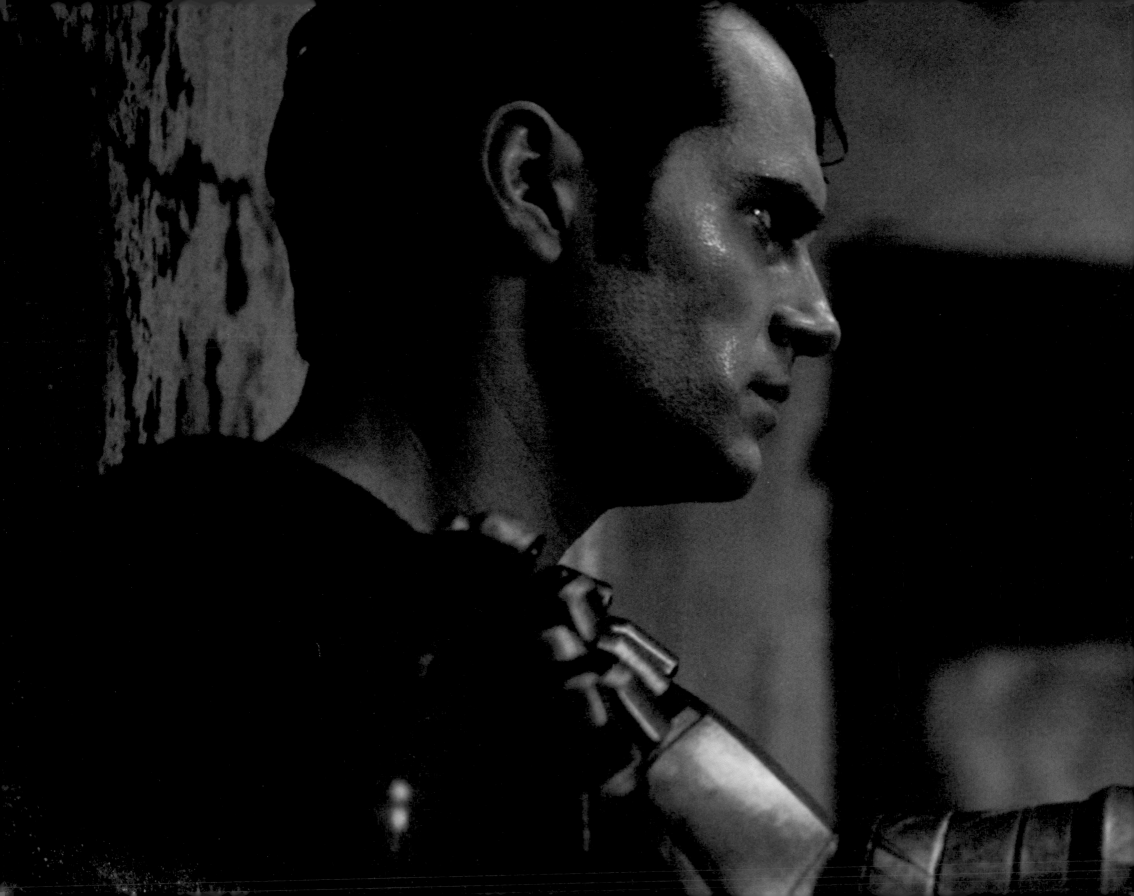

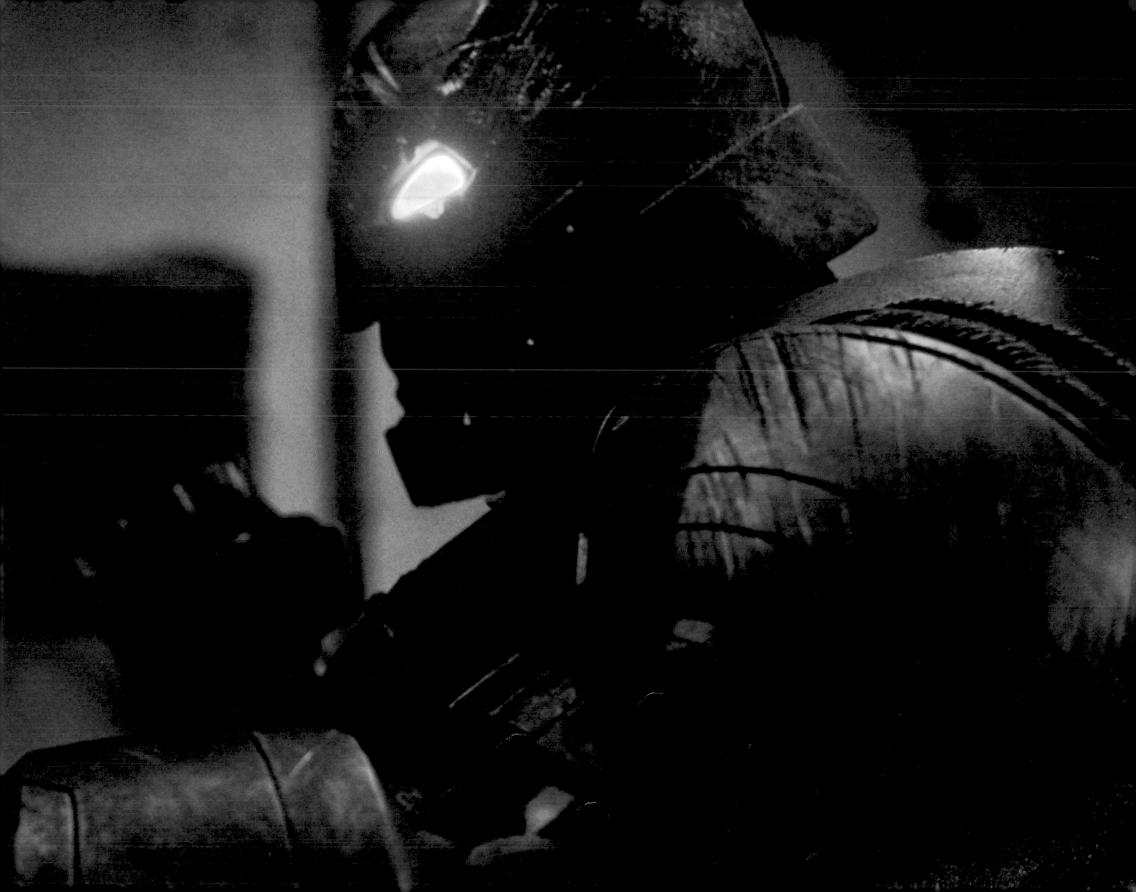

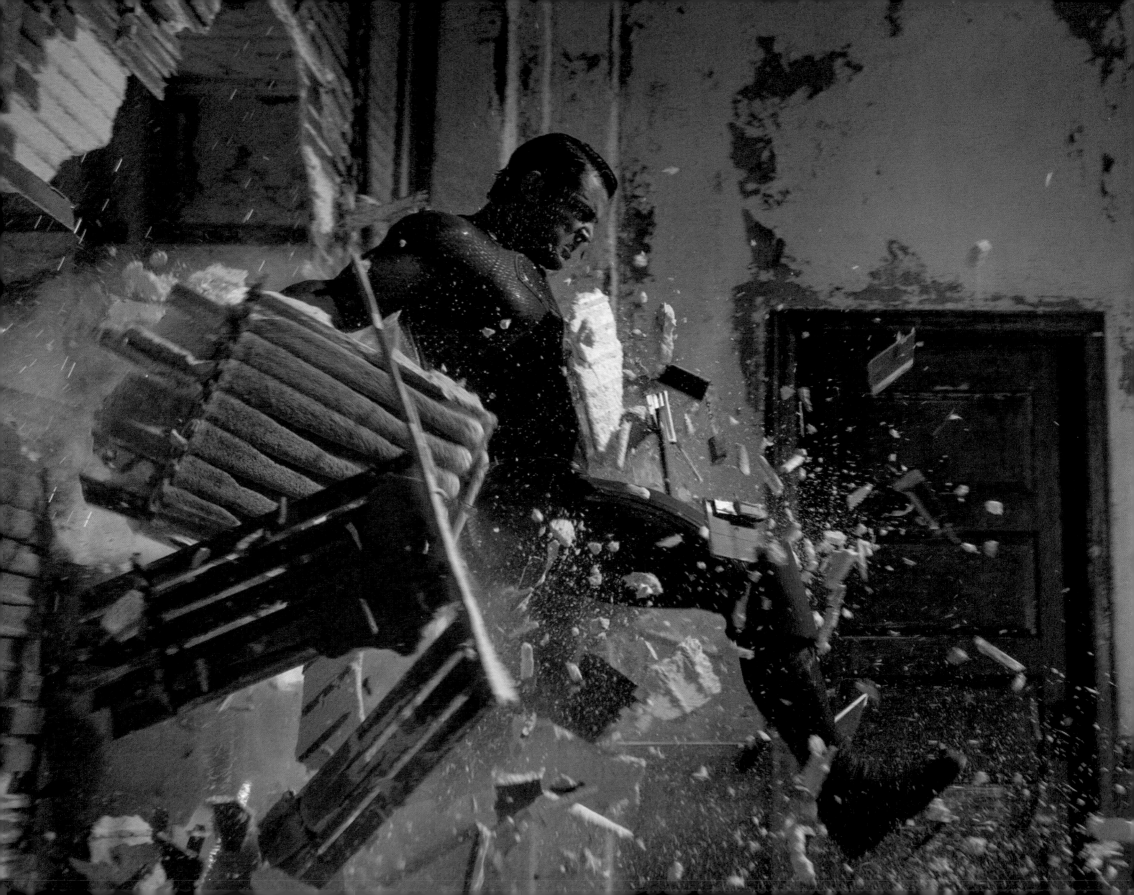

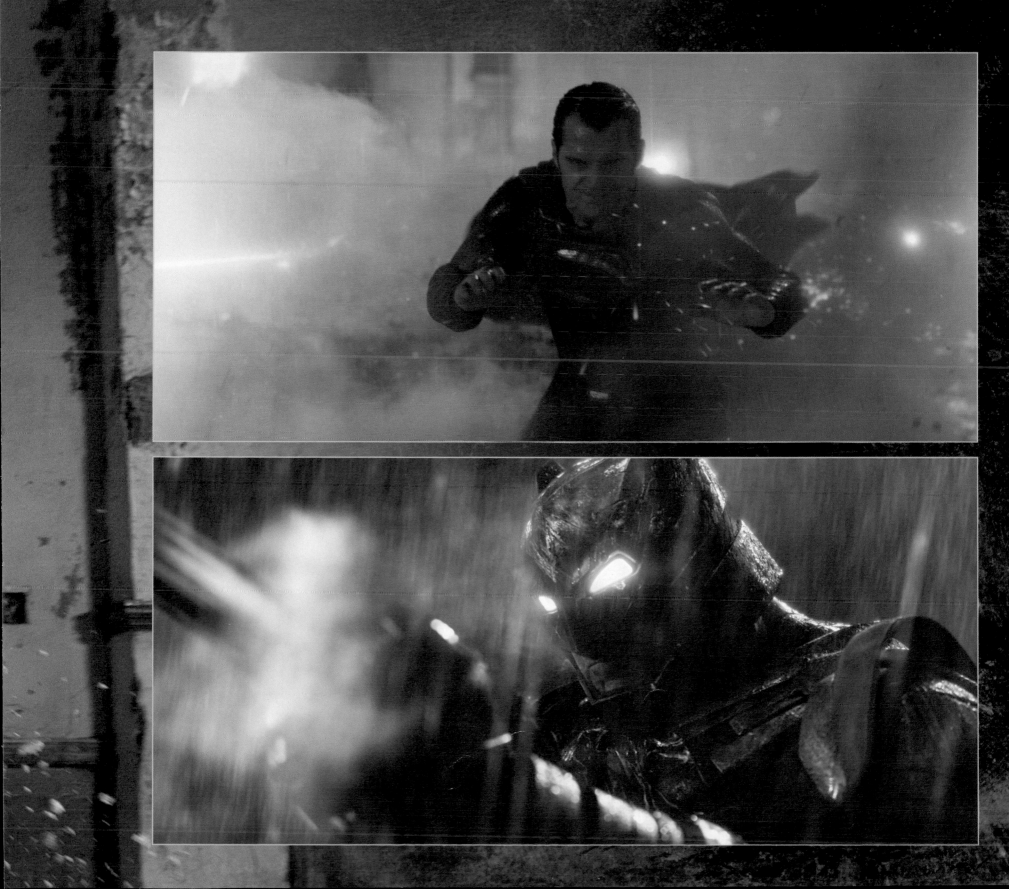

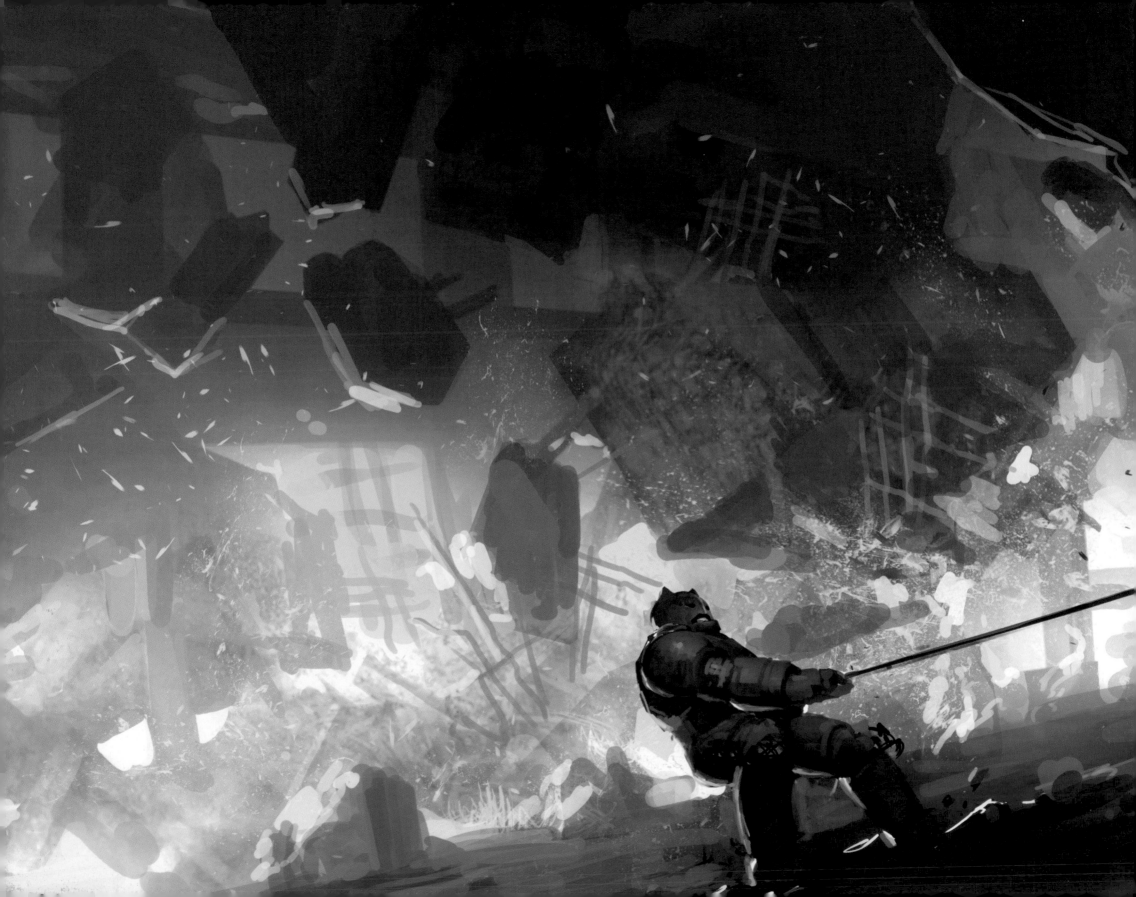

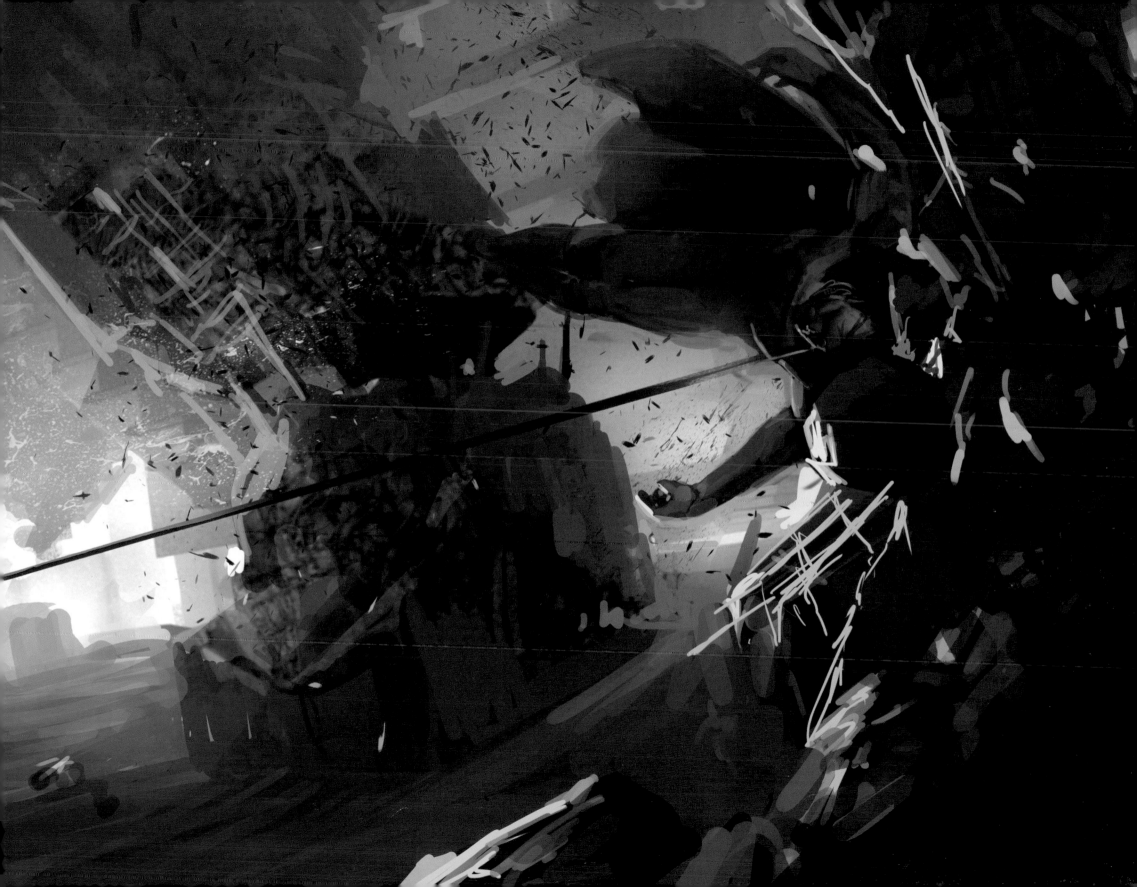

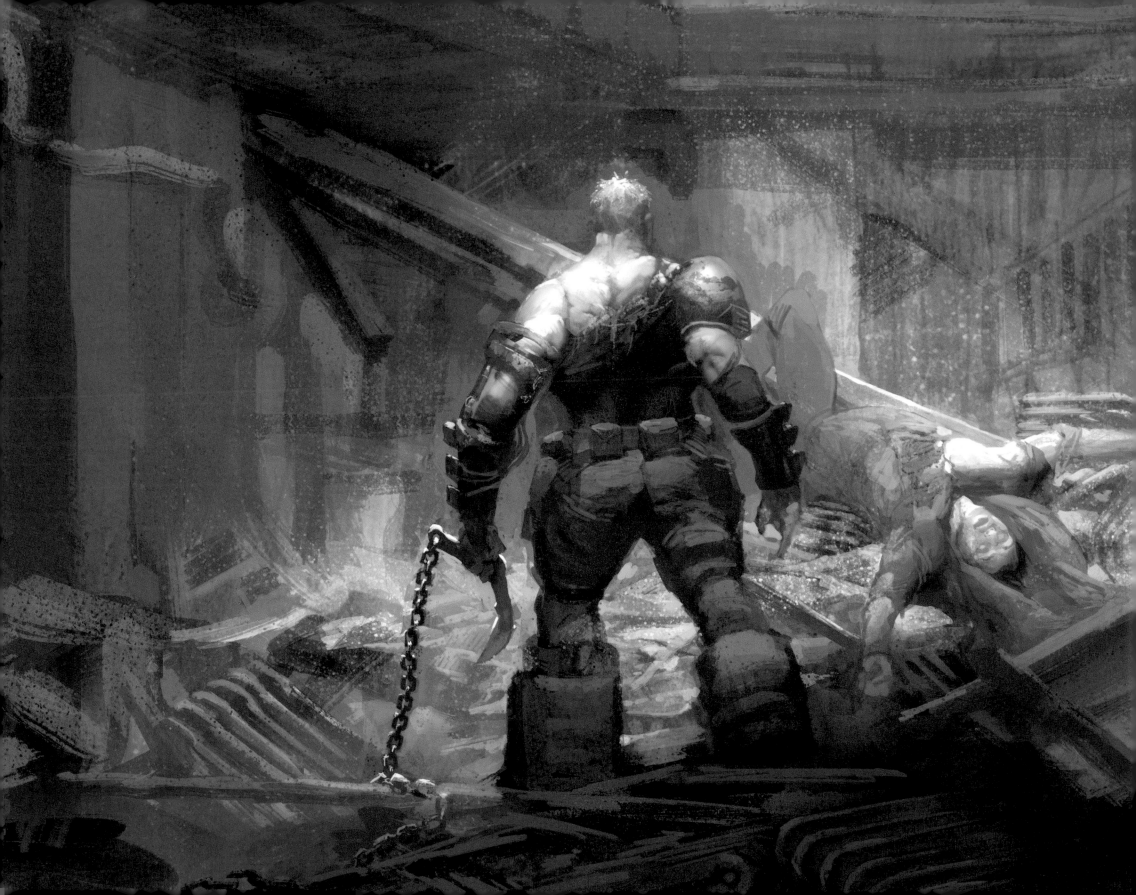

"THE OVERALL PLOT OF THIS MOVIE IS A VIEW ON THE HUMAN WORLD, AND HOW IT HAS REACTED TO THE EXISTENCE OF AN ALIEN WHO IS SEEMINGLY INVULNERABLE."

HENRY CAVILL

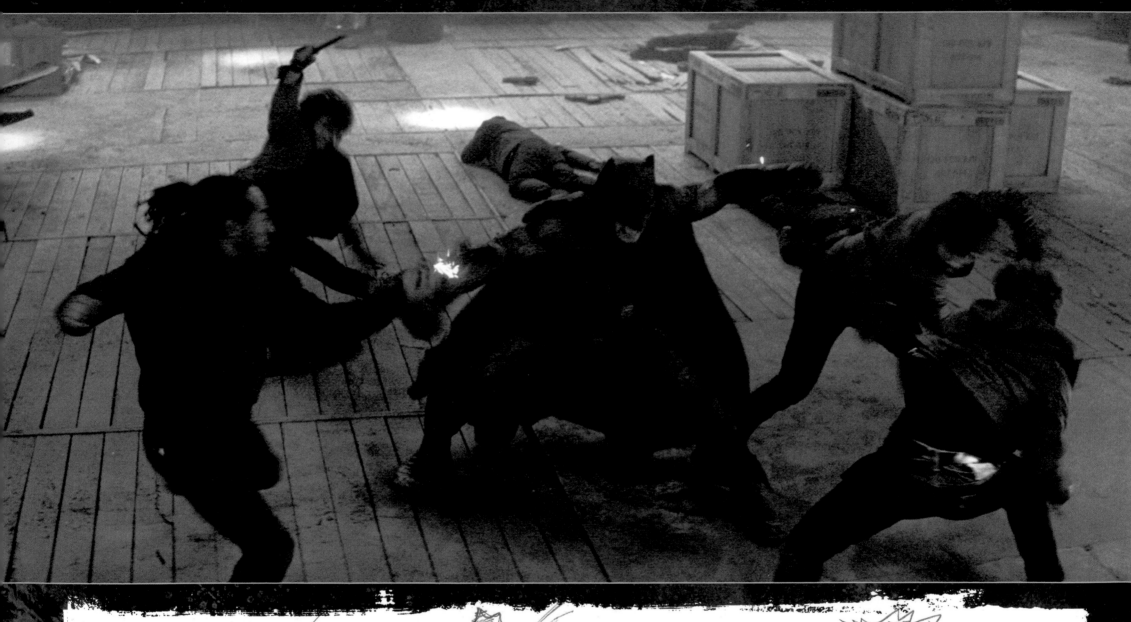

MARTHA KENT: HOSTAGE

Batman learns that Superman's mother is being held prisoner in a warehouse in Gotham City. With Superman otherwise occupied, it's up to the Caped Crusader to fight his way through a building full of mercenaries and rescue Martha Kent.

As with Wayne Station, the warehouse was based on an actual location in Detroit filmed as the exterior; the interior set was built to accommodate the extreme stunts that would occur. "I'm creating a playground for them," says Tatopoulos. "This is a time where I need to take a little step back. I'm not going to put my little things everywhere the way I usually do. This is now becoming a space for those guys to create what they have to create." That meant lots of breakaway walls and floors, strategically placed padding, and plenty of crates and other furniture for Batman to smash into the bad guys.

To prepare for a complicated stunt sequence such as this, Zack Snyder and his team utilize a technique they call 'stunt-vis'. "It's not a commonly used process," says stunt coordinator Damon Caro. "We choreograph and work out the action needed for specific fight scenes, then we'll shoot it." Once the sequence is edited, Snyder explains that, "We add some crude visual effects to get a sense of what shots will be vfx and what won't, and get a sense of how the action's going to flow."

Snyder's detailed storyboards helped them plan
each shot of the complex action scene (opposite).

WONDER WOMAN

"OH, I DON'T THINK
YOU'VE EVER KNOWN
A WOMAN LIKE ME."

DIANA PRINCE

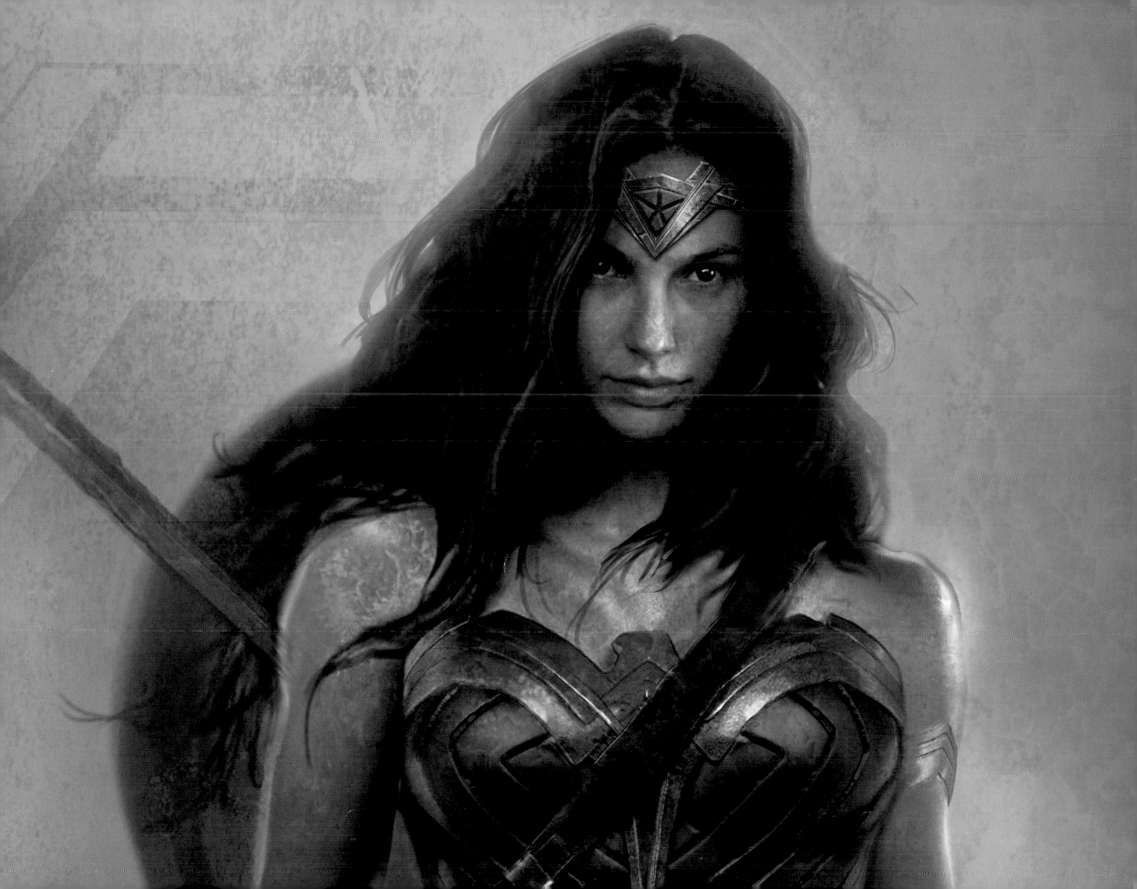

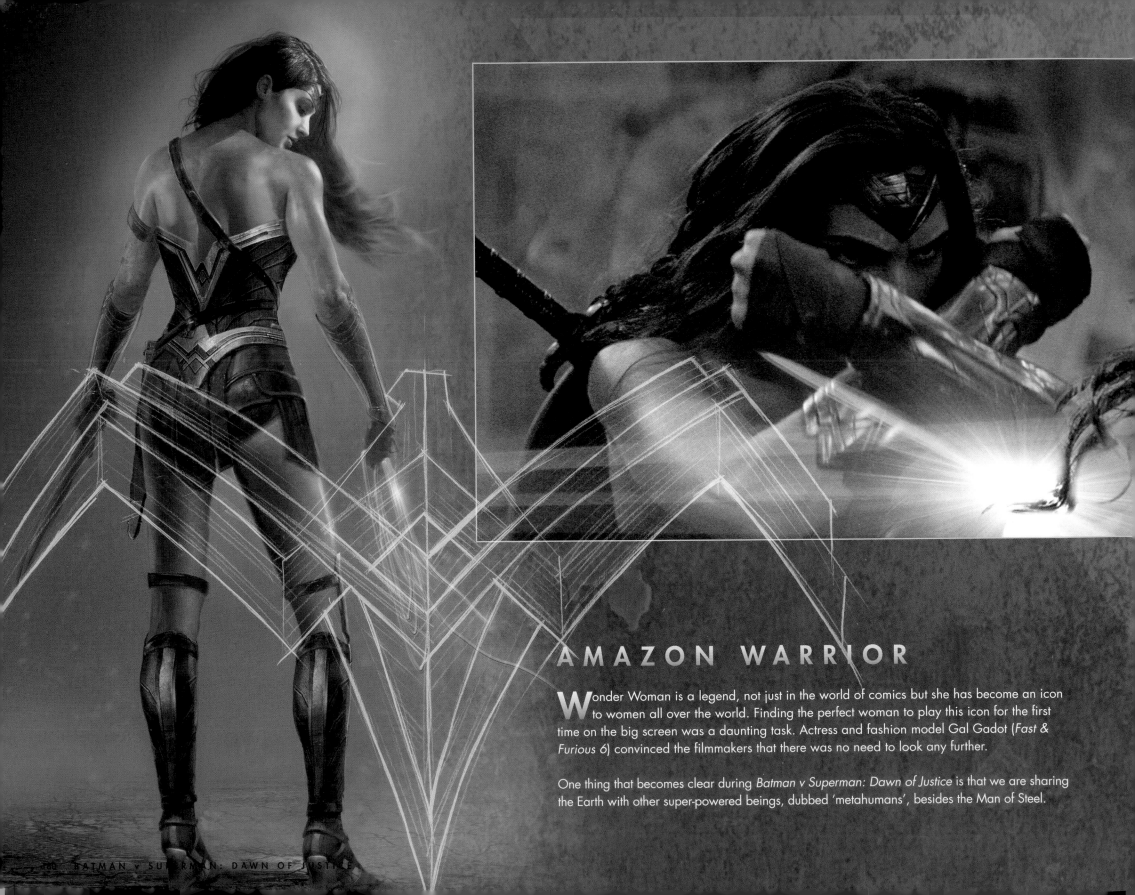

AMAZON WARRIOR

Wonder Woman is a legend, not just in the world of comics but she has become an icon to women all over the world. Finding the perfect woman to play this icon for the first time on the big screen was a daunting task. Actress and fashion model Gal Gadot (*Fast & Furious 6*) convinced the filmmakers that there was no need to look any further.

One thing that becomes clear during *Batman v Superman: Dawn of Justice* is that we are sharing the Earth with other super-powered beings, dubbed 'metahumans', besides the Man of Steel.

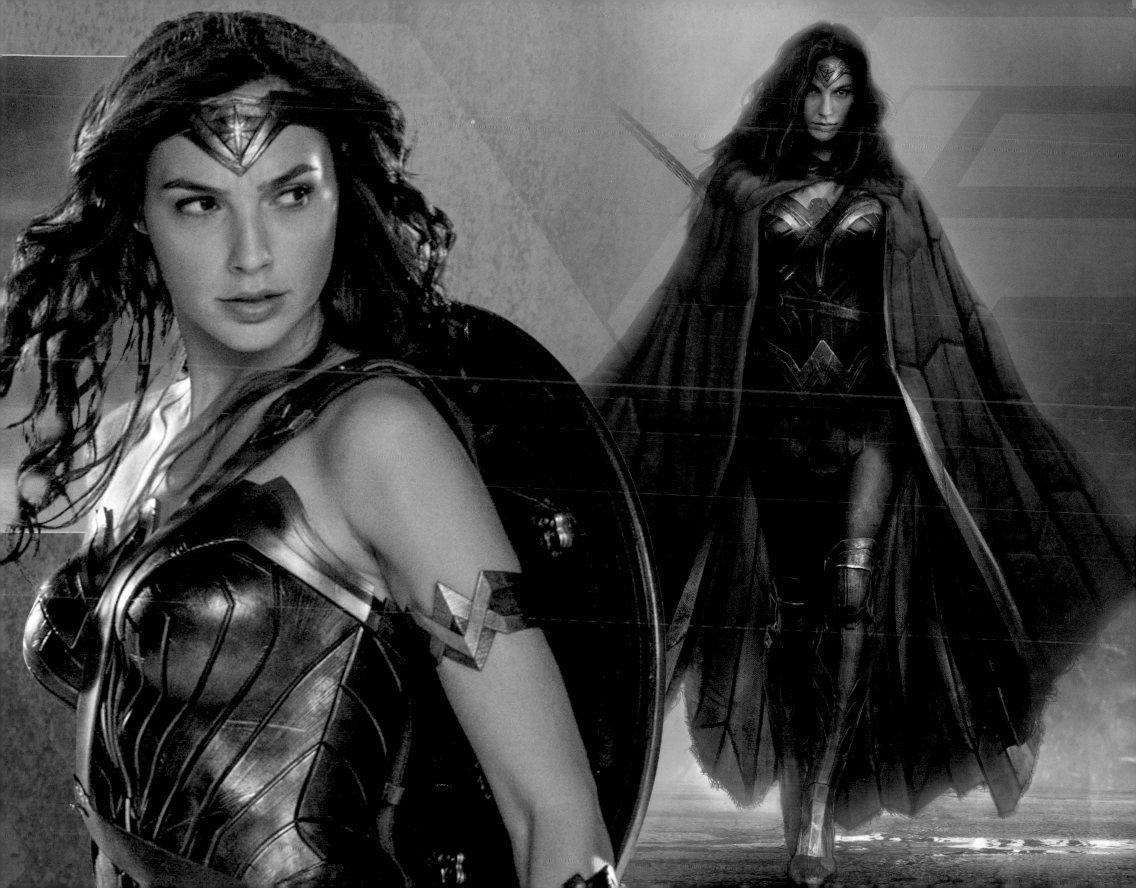

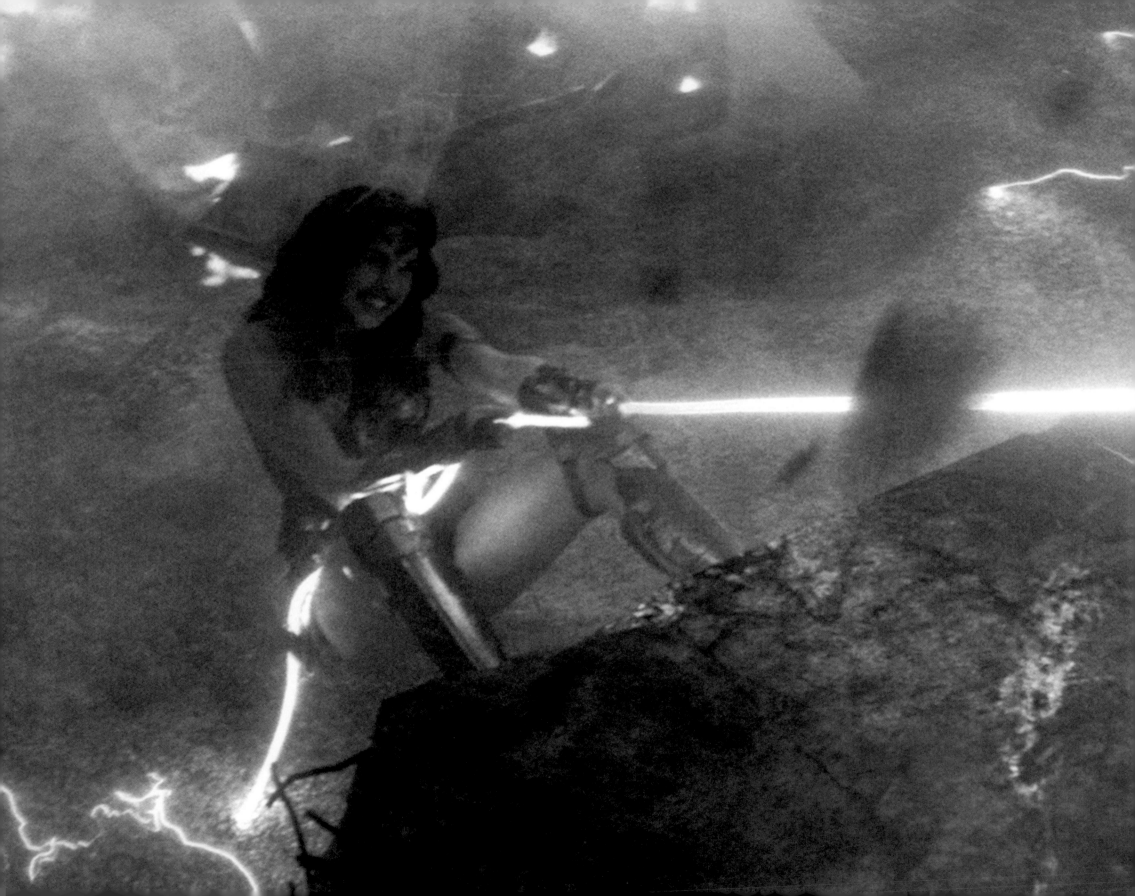

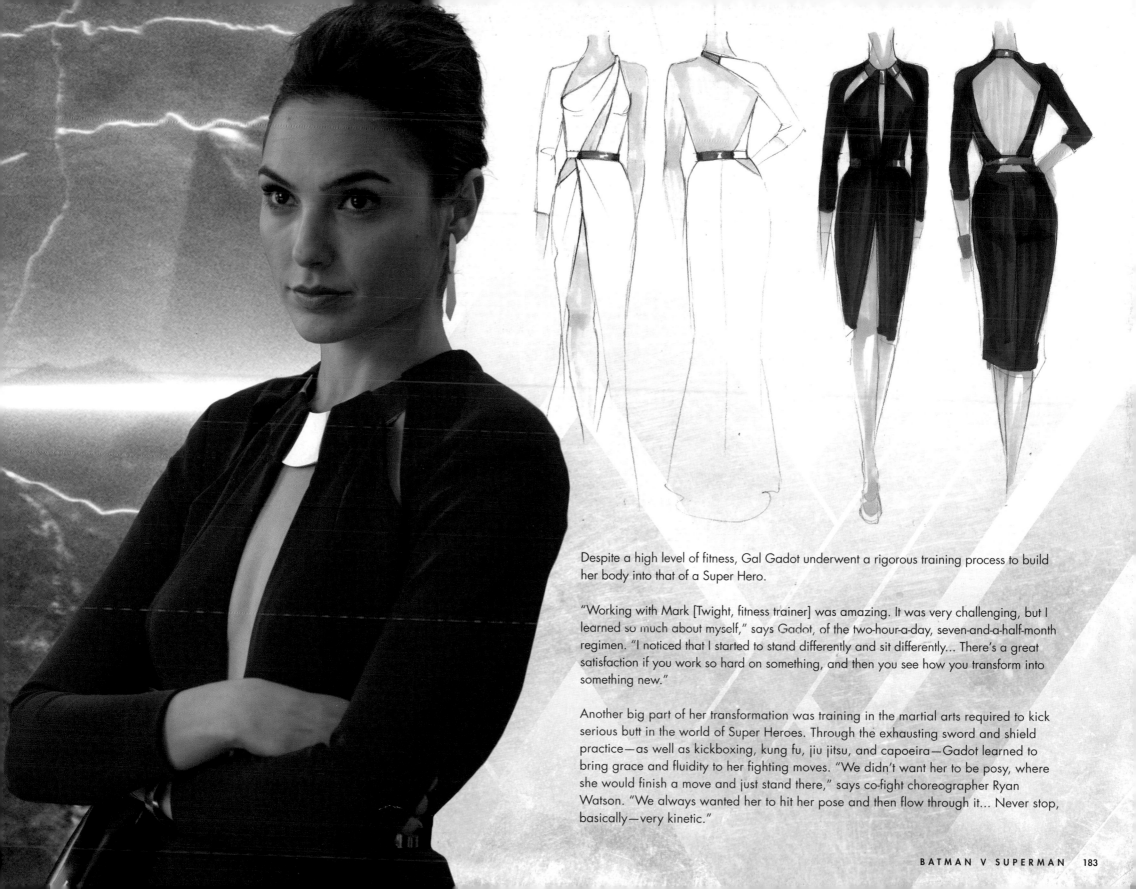

Despite a high level of fitness, Gal Gadot underwent a rigorous training process to build her body into that of a Super Hero.

"Working with Mark [Twight, fitness trainer] was amazing. It was very challenging, but I learned so much about myself," says Gadot, of the two-hour-a-day, seven-and-a-half-month regimen. "I noticed that I started to stand differently and sit differently... There's a great satisfaction if you work so hard on something, and then you see how you transform into something new."

Another big part of her transformation was training in the martial arts required to kick serious butt in the world of Super Heroes. Through the exhausting sword and shield practice—as well as kickboxing, kung fu, jiu jitsu, and capoeira—Gadot learned to bring grace and fluidity to her fighting moves. "We didn't want her to be posy, where she would finish a move and just stand there," says co-fight choreographer Ryan Watson. "We always wanted her to hit her pose and then flow through it... Never stop, basically—very kinetic."

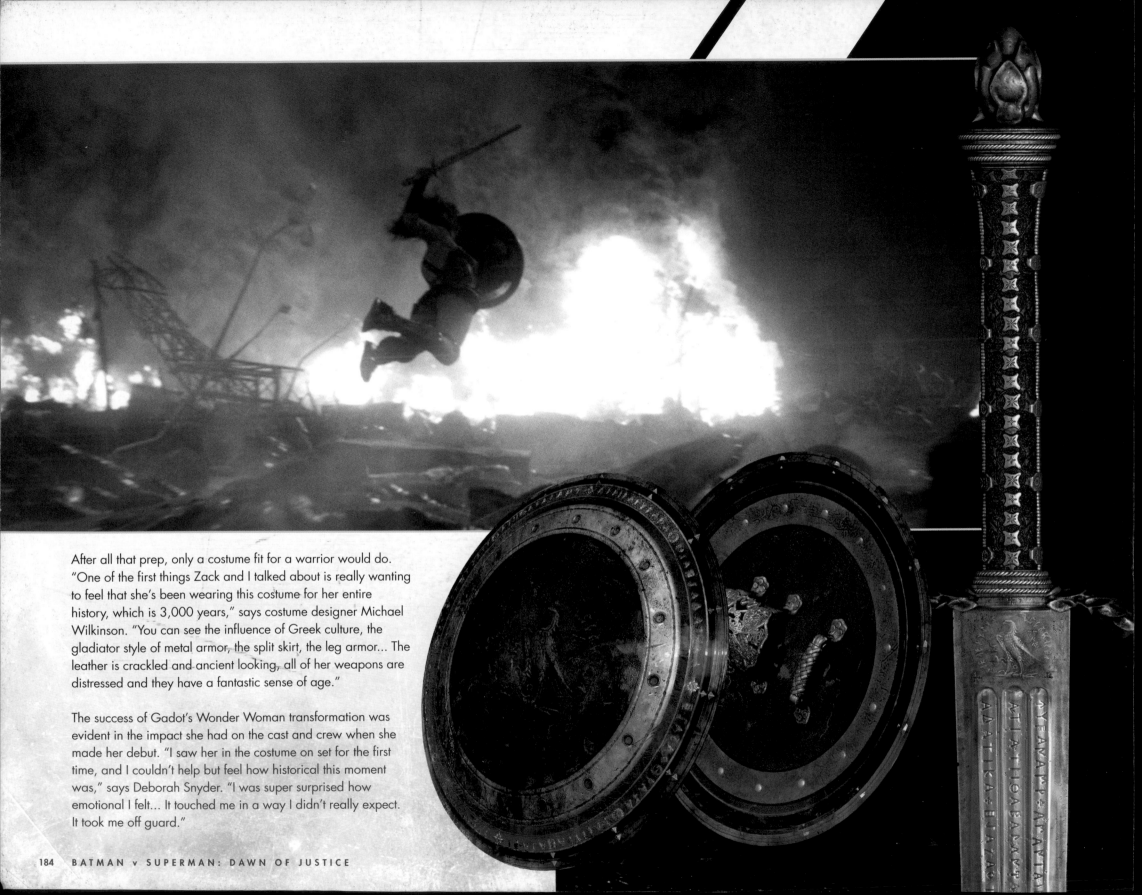

After all that prep, only a costume fit for a warrior would do. "One of the first things Zack and I talked about is really wanting to feel that she's been wearing this costume for her entire history, which is 3,000 years," says costume designer Michael Wilkinson. "You can see the influence of Greek culture, the gladiator style of metal armor, the split skirt, the leg armor... The leather is crackled and ancient looking, all of her weapons are distressed and they have a fantastic sense of age."

The success of Gadot's Wonder Woman transformation was evident in the impact she had on the cast and crew when she made her debut. "I saw her in the costume on set for the first time, and I couldn't help but feel how historical this moment was," says Deborah Snyder. "I was super surprised how emotional I felt... It touched me in a way I didn't really expect. It took me off guard."

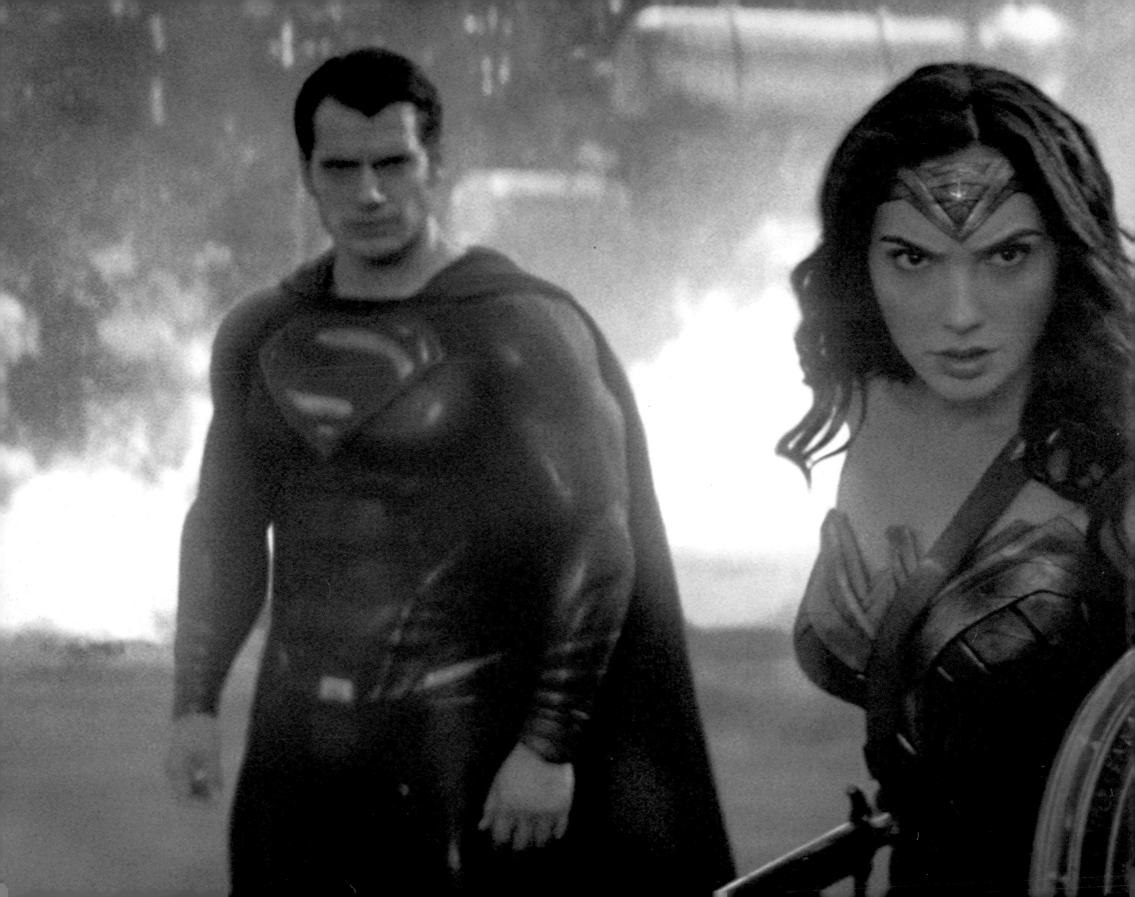

"IT WAS TOO GOOD OF AN OPPORTUNITY TO PASS UP, TO HAVE THIS IMAGE OF THE TRINITY—BATMAN, SUPERMAN, AND WONDER WOMAN—STANDING TOGETHER. THAT HAD TO BE IN THE MOVIE."

ZACK SNYDER

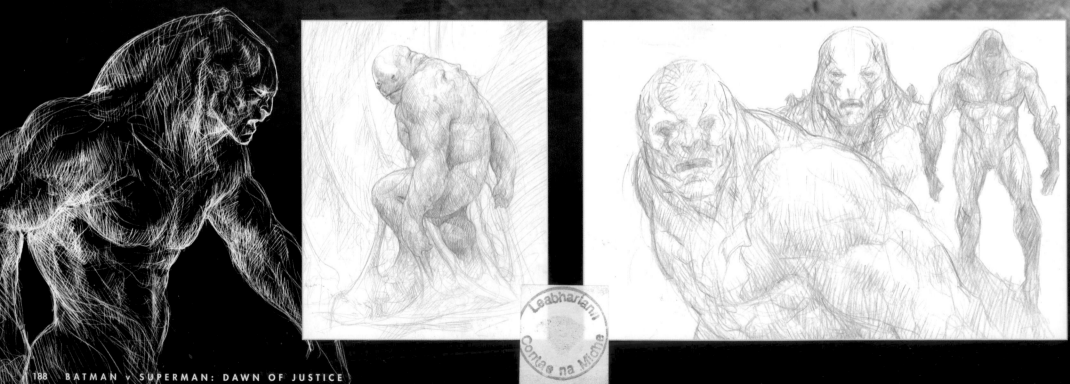

DOOMSDAY

"IF MAN WON'T KILL GOD, THE DEVIL WILL DO IT."

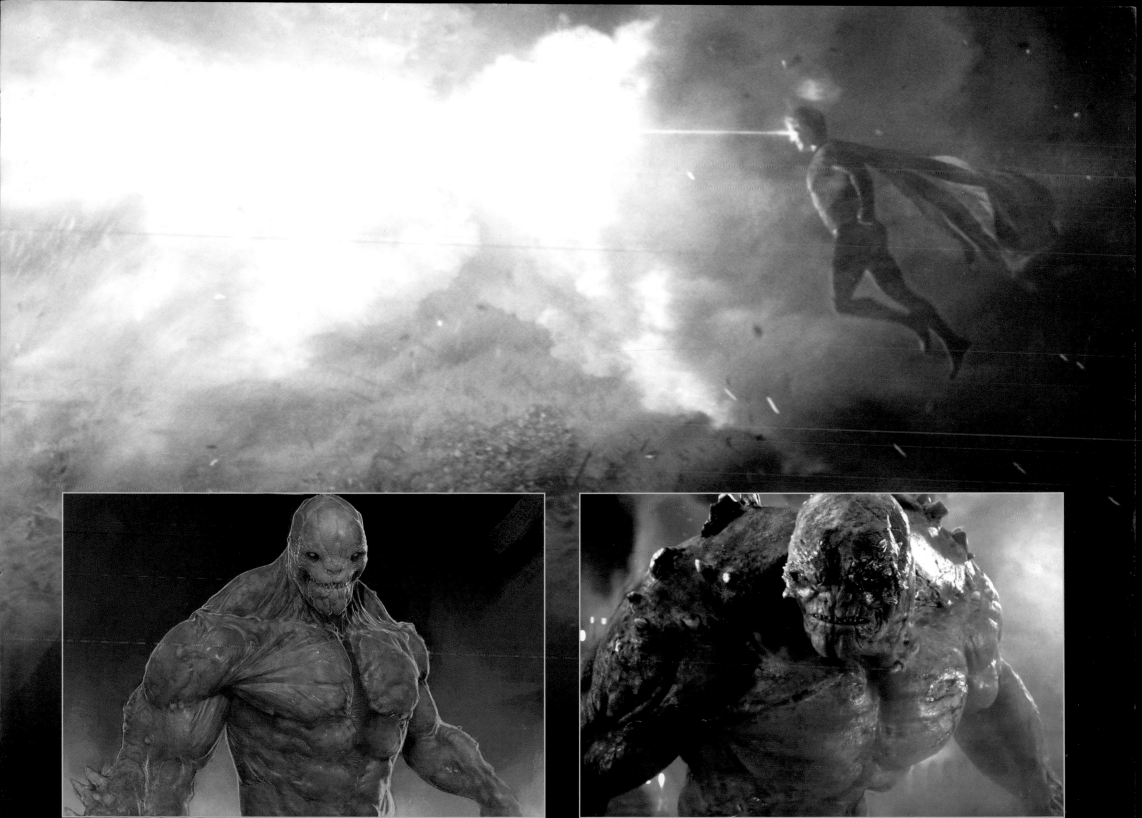

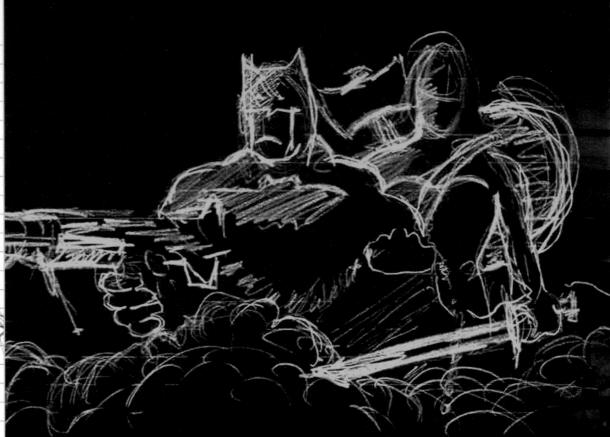

AFTERWORD
BY ZACK SNYDER

Batman v Superman: Dawn of Justice marks our 10th "making of" book. I find myself humbled by the opportunity to present this book to fans of design and the craft of creating films. It is a privilege to be able to share the journey we undertook while making *BvS* with others who also find the process interesting and compelling.

In my early dreams of a life in film it was subject matter like that which fills the pages of this book that fueled my passion—"art of" books full of text and images that inspired and challenged me as a young student of film. It is an honor to now be able to share my own experiences of creating films with like-minded lovers of the dream that is movie making.

Thank you.
Zack Snyder

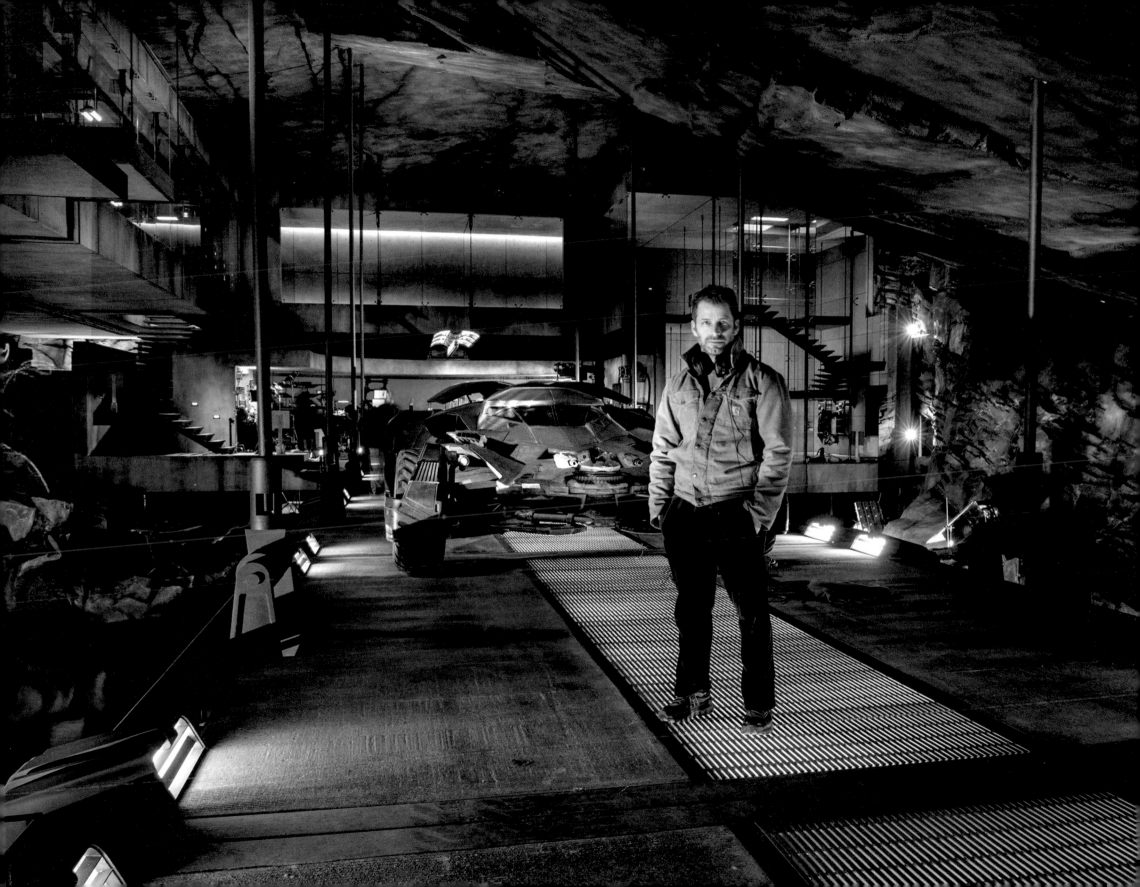

ACKNOWLEDGMENTS

The author would like to thank the crew of Buddha Jones for conducting and transcribing the vast bulk of the dozens and dozens of interviews that went into making this book.

Titan Books wishes to thank the many amazing people who helped make this book a reality, in particular, Wes Coller, Curt Kanemoto, Spencer Douglas, Shane Thompson, Alisha Stevens, Adam Forman, Elaine Piechowski, Josh Anderson, Nik Primack, and of course, Charles Roven and Zack and Deborah Snyder.

The filmmakers wish to extend their thanks to the crew who made the movie, including but not limited to:
Warren Manser, Jay Olivia, Jared Purrington, Michael Meyers, Vance Kovacs, Victor Martinez, Robert McKinnon, Christian Scheurer, Ed Natividad, Tim Earls, Charles Roven, Deborah Snyder, Chris Terrio, Wesley Coller, Geoff Johns, David S. Goyer, Bob Kane, Bill Finger, Jerry Siegel, Joe Shuster, Steve Mnuchin, Christopher Nolan, Emma Thomas, Benjamin Melniker, Michael E. Uslan, Gregor Wilson, Jim Rowe, Curt Kanemoto, Bruce Moriarity, Misha Bukowski, Damon Caro, David W. Paris, David Nowell, Scott Hecker, Chris Jenkins, Michael Keller, Tim Rigby, Andrea Wertheim, Trevor J.W. Christie, Troy Sizemore, Lorin Flemming, Beat Frutiger, Greg Hooper, Kevin Ishioka, Tom Frohling, Tom Castronovo, Justin Lang, Shari Ratliff, Carolyn Loucks, John Clothier, William Dalgleish, Mark Twight, Michael Blevins, David Brenner, Josh Jaggers, Tricia Mulgrew, Lora Kennedy, Kristy Carlson, Chuck Michael, Margit Pfeiffer, Zahida Bacchus, Kimi Webber, Michael McGee, Gladys Tong, Bob Morgan, Jennifer Jobst, Jr Hawbaker, Stephanie Porter, Victoria Down, Kristin Berge, Jim Grce, Gary Dodd, Kevin Erb, Eric Matthies, Mitchell Rubinstein, Erick Donaldson, Larry Hubs, Robert Johnson, Bria Kinter, Jeff Markwith, Anshuman Prasad, Richard Reynolds, Scott Schneider, Tony Bohorquez, Jeff Frost, Joe Hiura, Kelly Rae Hemenway, Jason Sweers, Deborah Jurvis, Allison Klein, Chris Strother, Joel Whist, Arnand Kularajah, Brady Endres, Adam Forman, Alisha Stevens, Celeste Coller, Jackie Levine, Joanne Lazarus Grobe, Eric Wolf, Madison Weireter, Nicholas Boak, Bradley Elliot, Bradley Good, Kevin McClo, Michael Papac, Jonas Kirk, Bryan Holloway, Frank Piercy, Carmine Goglia, Eric Rhodes, Lee Rhadigan, Michael Scot Risley, Scott Denis, Brent Godek, Scott Grace, Jonathan Miller, Patrick Velasquez, Bobby Griffon, Lee Anne Muldoon, Hans Zimmer, Junkie Xl, Stefan Sonnenfeld, Guillaume Rocheron, David P.I. James, Harry Mukhopadhyay, Keith F. Miller, Joe Letteri, Kyle Robinson, Bryan Hirota, Julie Orosz, Ben Breckenridge, Paul Becker, Chad Cortvriendt, Company 3, Mpc, Scanline, Weta Digital Limited, Double Negative, Method Studios, Shade, Perception, Panic, Mova, Mocap Design, Gentle Giant Studios, Gardiner Consulting, 4dmax, Pictorvision, Gener8, Teamworks Digital, The Resistance Vfx, Shane Thompson, Spencer Douglas, Josh Anderson.

The filmmakers would also like to thank the team at Titan Books for all their hard work - Beth Lewis, Simon Ward, Amazing 15, Nick Landau, and Vivian Cheung.